W9-BXV-128

Beyond Portraiture

Beyond Portraiture
Creative People Photography

BRYAN PETERSON

AMPHOTO BOOKS

AN IMPRINT OF WATSON-GUPTILL PUBLICATIONS
NEW YORK

Page 1: 12–24mm lens at 12mm, *f*/6.3 for 1/160 sec.
Pages 2–3: 80mm, *f*/8
Pages 6–7: 200–400mm lens, *f*/22 for 1/40 sec.
Page 9: 160mm, *f*/5.6
Page 11: 70–200mm lens, *f*/4 for 1/500 sec.
Pages 12–13: 17–55mm lens at 17mm, *f*/9 for 1/320 sec.
Pages 30–31: 17–55mm lens, *f*/16 for 1/100 sec.
Pages 60–61: 17–55mm lens, *f*/16 for 1/125 sec.
Pages 78–79: 17–35mm lens at 28mm, *f*/3.5 for 1/30 sec.
Pages 116–117: 17–55mm lens at 38mm, *f*/4 for 1/640 sec.

Editorial Director: Victoria Craven
Senior Development Editor: Alisa Palazzo
Designer: Bob Fillie, Graphiti Design, Inc.

First published in 2006 by Amphoto Books
an imprint of Watson-Guptill Publications, Crown Publishing Group,
a division of Random House, Inc., New York
www.crownpublishing.com
www.amphotobooks.com
www.watsonguptill.com

Text and illustrations copyright © 2006 Bryan Peterson

Typeset in Frutiger Light

Library of Congress Cataloging-in-Publication Data
Peterson, Bryan F.
 Beyond portraiture : creative people photography / Bryan Peterson.
 p. cm.
 Includes index.
 ISBN-13: 978-0-8174-5391-6 (pbk.)
 ISBN-10: 0-8174-5391-1 (pbk.)
 1. Portrait photography. I. Title.

 TR575.P468 2006
 778.9'2--dc22

 2006005309

All rights reserved.

Printed in China

2 3 4 5 6 7 8 9 / 14 13 12 11 10 09

To my daughter Chloë, eyes so deep brown

Laughing, smiling, seldom a frown

Sunset to sunrise, night turns to day

I'll always love you, I'll always say!

Contents

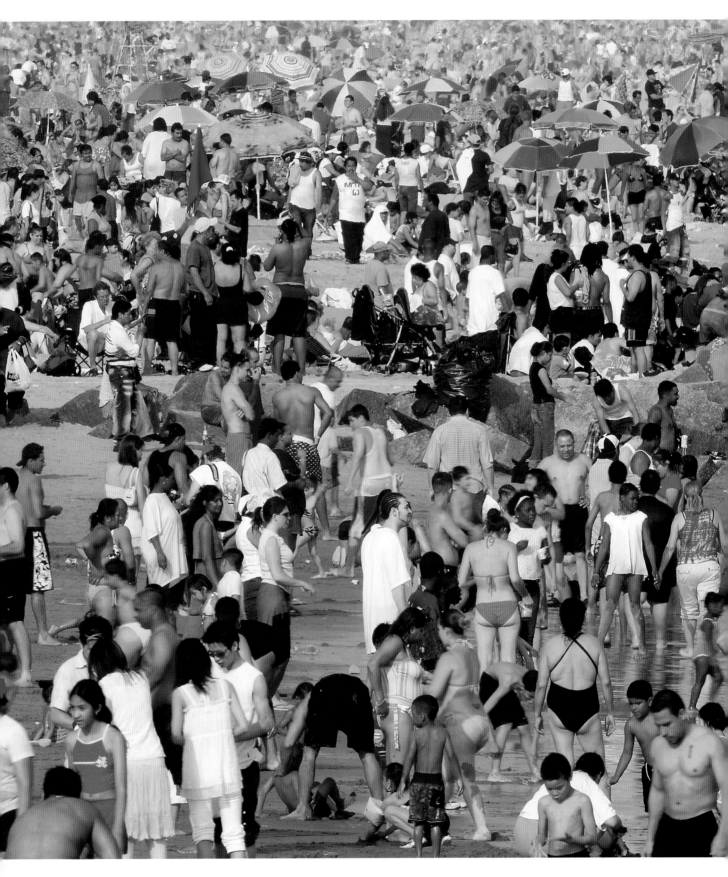

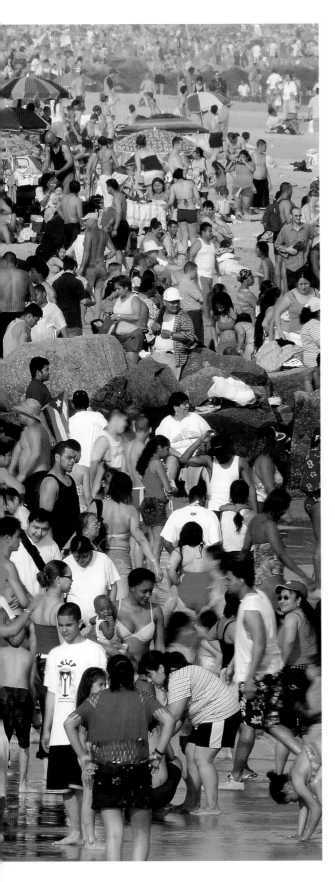

Introduction

People are the most photographed subjects in the world because pictures of people tug at our hearts and they are, in many ways, pictures of ourselves. A full-frame portrait of a sad and teary-eyed three-year-old will touch most of us. We may not know the specific reasons for the tears, but we can feel the pain. Conversely, three elderly people sitting on a front porch laughing hysterically may generate a number of interpretations, but one thing is certain: everyone can understand and appreciate the meaning of laughter. In addition, most of us have someone to "thank"—a mother, father, relative, or friend who had a camera in hand—for forever preserving small yet revealing vignettes of our personal histories.

Unlike photographs of snowcapped mountains, autumn landscapes, or colorful sunsets, photographs of family, friends, acquaintances, and even strangers trigger much deeper emotions. Many people are reminded of their youth as they look back on images of yesterday; that a photo reminds people of an "easier" time is the most often-heard response from viewers. Your children, just as you were with your parents, are amused by pictures of you with your beehive hairdo, white bobby socks, miniskirts, or bell-bottom jeans. You tell your children that *you had to be there* when explaining your appearance *back then* and are quick to remind them that they, too, will look back with both nostalgia and perhaps even embarrassment at the pictures you took of them just last week. *Whatever possessed me to wear baggy jeans around my knees and have orange hair?* your son or daughter might say.

At other times, photographs of people taken last year—or even today—give pause for reflection. You sigh and wonder where the time goes as you look at ten-year-old photographs of yourself and those you love. You are moved to tears and laughter as you stare at your photo album when your daughter of eighteen years, two months, and four days is about to leave for college halfway across the country.

How you photograph your loved ones, friends, and even strangers can reveal something about you. Do you find that your favorite pictures show people in a vast landscape, causing them to appear small and diminished? Perhaps compositions of this type reflect your own feelings of being overwhelmed by life at times or of just how lonely life can be or even, still, of how "small" you feel. On the other hand, do you find most often that you are filling the frame with just the face of your subjects? Such compositions might reflect the great compassion you feel

toward people, as well as call attention to your ability to feel free enough to interact with most anyone. The reasons why you do what you do are numerous and, in part, they define who you are; but photography—unlike any other medium—can say volumes about you (by how you shoot your subjects) in a single stroke.

My photography career didn't begin with people as my main interest. Waterfalls and forests, flowers and bees, lighthouses and barns, and sunrises and sunsets drew 99 percent of my attention. This continued for more than ten years until one day I found myself composing yet another snowcapped peak reflected in a still foreground lake. That day proved to be a turning point as I began to reflect on the absence of people not only in my private life, but equally so in my pictures. Spending countless days and weeks in nature was making me lonely!

For the next five years, I found myself making a slow but deliberate transition: I spent less and less time shooting peopleless compositions. I felt a new passion as I realized that the most vast and varied photographic subject was *people*. I felt lucky! As the song goes, "people who need people are the luckiest people in the world." And, I was quick to discover that my camera could be a bridge in introducing myself to people—but I still had one hurdle to overcome.

Whether I spoke the language of my subject or not, I was quick to learn many things about myself. Since I'm normally an outgoing person, I was amazed to discover just how shy I really was. On more than one occasion, I resolved to abandon my interest in people photography. After all, my landscape and close-up photography was already well received by magazine, greeting card, and calendar publishers. And, of course, there was one *big* distinction between nature subjects and people: mountains didn't move, flowers didn't stiffen up (or throw nectar in your face!), and butterflies never once asked for payment.

But try as I might, I couldn't silence the steady voice inside me that kept pushing me to return to people as subjects. The voice would grow louder when I saw particularly striking subjects, such as a lone ice cream vendor in a city square surrounded by hundreds of pigeons, a woman dressed in red walking parallel to a blue wall with her white poodle leading the way, or a white-bearded man of eighty-plus years sitting on a park bench and chuckling as he read an *Archie* comic book. But even during those obviously great picture-taking opportunities, I seldom was courageous enough to raise my camera to my eye and take the picture. That wave of photographic shyness would come over me.

I could only conclude that I was afraid of both rejection and intimacy. Unlike the landscapes I was so familiar with, people can, and oftentimes do, talk back, and they do have something to say. Sometimes, potential subjects would say exactly what I didn't want to hear and refuse to let me take their picture. But when I heard a *yes*

response to my request, my anxiety over being rejected was quickly replaced by the fear of intimacy. Unlike a flower, which needs no coaxing, people require interaction: I had to get involved with my subjects if I had any hope for spontaneity. Otherwise, if I just simply raised the camera to my eye and took the picture, my subjects would immediately become self-conscious. It was as if I were the doctor with a huge hypodermic needles about to administer the shot of their life.

As the weeks and months unfolded, I began to further analyze my feelings, as well as the meanings behind my usually excited responses to people and the settings in which I viewed them. It wasn't the surroundings or even the colors of the light that caused my emotions to stir the most, but rather the *person* in that scene. Remove the main subject and the "sentence" would lose its impact; the people were like a exclamation point.

I was soon approaching subjects with the "truth." I would say, *I don't know if you're aware of it, but right now you are at the heart of a truly wonderful picture! Or, I don't know if you're aware of it, but there are some really wonderful things going on just over there, and all that's missing is a person in the scene—and you really are the person who can make that scene a truly wonderful and compelling composition!* Today, this "simple" approach often continues to get me the permission I seek, but experience has also taught me that some situations require more diplomacy while others need much less. But one thing above all else is the importance of showing a genuine interest in the people you are photographing. You will achieve a greater degree of cooperation and spontaneity when your tone and intent are sincere.

No one will argue that every successful landscape shot or close-up relies in large measure on its ability to evoke both mood and emotion, and that quite often a bit of luck and opportune timing played a major role. But I've also learned that luck is seldom a factor when you try to shoot good images of people. Every successful photographer possesses a combination of creative and technical skills, as well as the ability to anticipate the often-decisive moment. But I continue to maintain that beyond *f*-stops, shutter speeds, great light, the right lens, the right environment, and the right subject lies the most important element of all: the ability to relate to, and understand what motivates, the people you wish to photograph. If public relations aren't your forte, then perhaps a quick read of Dale Carnegie's book *How to Win Friends & Influence People* is in order.

Having said that, one of the greatest "public relations tools" *digital* photographers have at their disposal is that "television screen" on the back of the digital camera. It has been more than two years now since I switched to digital, and I can't stress enough just how much easier it has become to overcome the photographic hurdles of people photography. My subjects and I are now able to

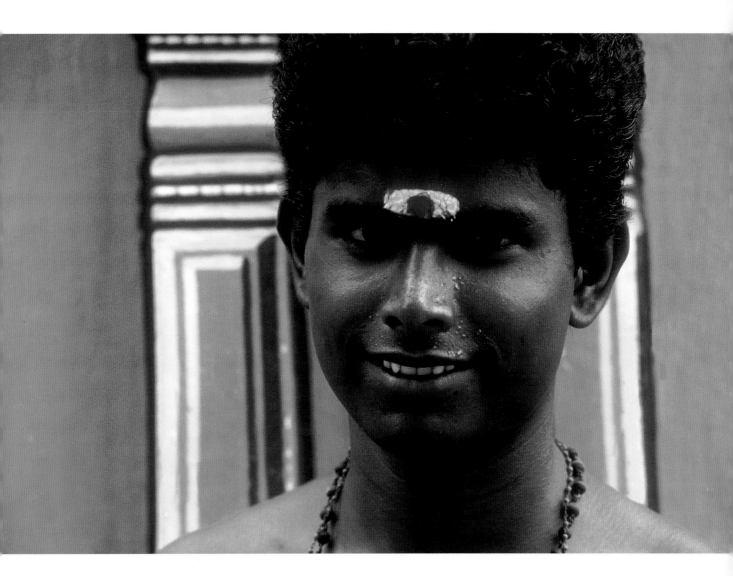

enjoy the instant gratification of seeing an image within seconds of taking it, an advantage that only a digital camera can provide. This adds to people's willingness and enjoyment of posing.

But whether you shoot digital or film, sometimes you'll need to be able to pose, direct, and ask your subjects to dress or look a certain way. These tasks may seem relatively easy to accomplish with family and friends, but they can prove quite challenging when you need the cooperation of someone you met only ten minutes ago. Throughout this book, I address many different situations, locations, and cultures with people (of course) as the central theme. I also start off by discussing the psychology of people—not just your subjects but yourself, as well—in great depth. For example, when I photograph people, it is never my intention to embarrass them or to call attention to a particular flaw in their physical appearance. Unfortunately, the temptation to exploit or embarrass a subject is, at times, so great that some photographers succumb to it, and rather than gaining a subject's trust,

they turn the camera into an enemy. I'm also not a big fan of shooting from the hip or using a wide-angle lens to distort faces. Perhaps these are necessary photographs, but they're not the theme of this book.

I firmly believe that taking photographs of people is the most challenging and rewarding of all the photographic opportunities available to the photographers working out there today. No other subject is as vast and varied. "People" can range from babies to great-grandparents. Youthful skin or weathered skin, blue-eyed and blond or brown-eyed and brunettte, short or tall, fat or thin, big hair or no hair, clothed or nude, male or female—when you combine these physical characteristics with the seemingly infinite choices for surroundings (urban or rural, forest or desert, international locale or your own backyard), the possibilities are truly enormous. And because people are the subjects, it is paramount that you embrace what is, perhaps, the greatest rule governing the human condition: You rarely, if ever, get a second chance to make a first impression.

Understanding People

Psychology 101

Lucky is the photographer who has a sound understanding of human psychology and the patterns of human behavior. If you're going to be able to motivate anybody to be a subject (family members included), you had better be prepared to answer the biggest and most immediate question that's either spoken or inferred by your subject(s): *What's in it for me?* This is a fundamental "law" of human psychology that governs most of what people do. When you look for a job, first and foremost you think, *What's in it for me?* Most of us form relationships and make both small and life-changing decisions based on the what's-in-it-for-me question. And, not surprisingly, photographers are motivated in large measure by what's in it for them.

One can easily argue that there are both *selfish* and *selfless* reasons for taking any given photograph. However, I can only think of one type of selfless photography, and that's what an X-ray technician does. For example, there's nothing selfless about taking a picture of a dying AIDS patient who does not want the picture taken or the starving Sudanese woman with her child who has also made it clear that she *does not* want her picture taken. Like it or not, in these and many other situations, most—if not all—of us are motivated to go forward, to move along, to change, to give up, to strive, to set goals, to achieve for one simple reason: again, simply because we feel there is something in it for us. And as surprising as this may sound, when your subjects *don't* feel that there is anything in it for them, they'll say no, more often than not, to being photographed. And yes, as many of you already know, this even applies to family members.

This doesn't mean that your subjects are holding out for some enormous fee. There are only five pictures in this book for which the subject was actually paid money, and in two of these five cases, the subjects were professional models being paid a fee by my client, Kodak. What I have found is that most people are willing subjects if, first and foremost, your tone and intent are sincere—*and* if you offer to give them several 8 x 10-inch prints *free of charge* in return. The promise of sending several hi-res JPEG files to them via e-mail works, too. From these JPEGs they are free to print all of the copies they want on their own time (an added benefit to me). Most people have a sense about the cost of hiring a professional photographer to do what you are willing to do for free. And as parents can attest, countless ice cream cones and Happy Meals have been bought in exchange for the child's willingness to pose for the family photo album.

(Interestingly, I came upon this beautiful couple in Hong Kong some years ago, and they were quick to agree to have their picture taken as they strode through a park of flowering cherry trees. And just before I was ready to take some shots, I explained I would also send them half a dozen prints and they immediately changed their mind since they were convinced that at some point they would have to pay for them—obviously a language barrier in this case. Fortunately this is still the only time this has happened to me.)

Assuming you are presenting yourself as an aspiring photographer, and even if your experience is truly limited, people are more apt to hear the enthusiasm and passion in your voice and respond to that much quicker than they will to a somewhat reserved, shy, and insecure voice. It's just another side of our human nature: most of us feel "safe" when the tone of voice is self-assured rather than when the tone of voice is indecisive and unsure. Your subjects are more inclined to feel motivated not by what you say, but by how you say it; once again, it's the sincerity of your request.

And, no matter where or who you choose to shoot, you should be, first and foremost, motivated to make images that feed the fires of your creative endeavors. Whether or not an image advances your career or wins a photo contest is truly secondary to the greater reward. People photographers often work inside the fiercely protected psychological boundaries that many subjects possess, but whether it be immediate or several hours later, I often feel enriched by the shared experience and am grateful for that best "high" of all: connecting with others, whether they be family, friends, or strangers.

A question I am often asked deals with my approach to photographing people. First, I seldom approach anyone who I don't find interesting, which of course is very subjective, since what I find interesting may strike another as completely boring. Second, I find that a few minutes spent simply observing a potential subject (sometimes discreetly) goes a long way toward determining how I want to photograph that subject. It is during these several minutes that I make mental notes about specific mannerisms or expressions I may wish to capture. Also, it helps, when I do approach a person, that I explain the reason I am interested in making the photograph.

For example, this older gentle man was taking a break from his recycling business, smoking from his shisha pipe. I observed him for a while, and then only after making my presence known and talking to him for a bit did I begin photographing him.

12–24mm lens at 19mm, *f*/8 for 1/15 sec.

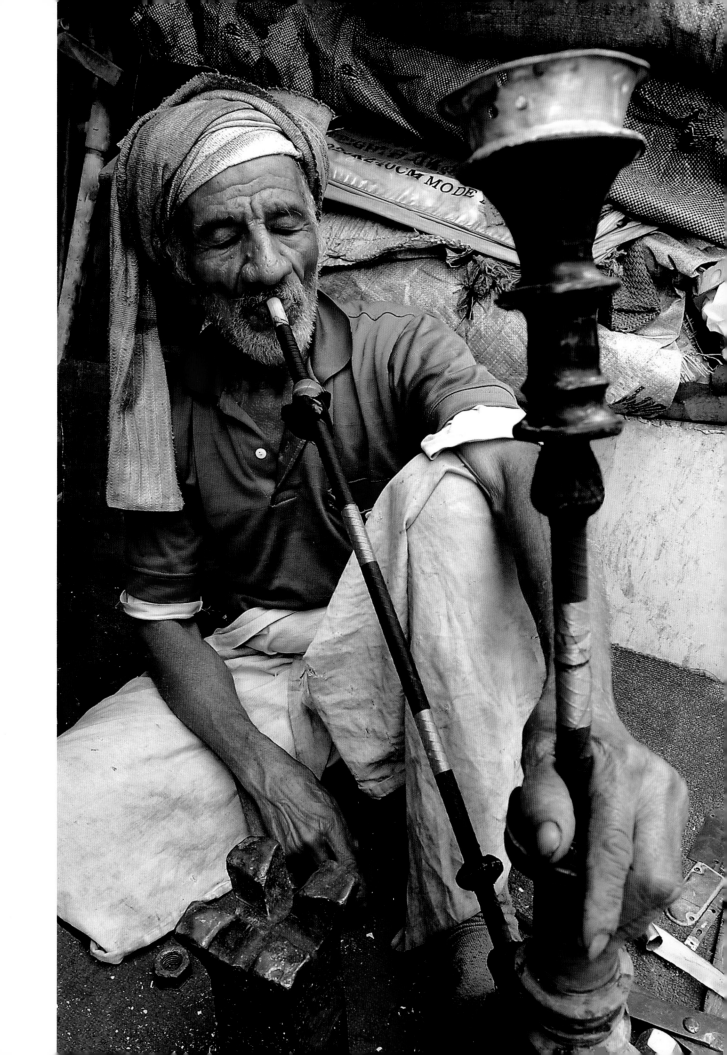

Approaching People

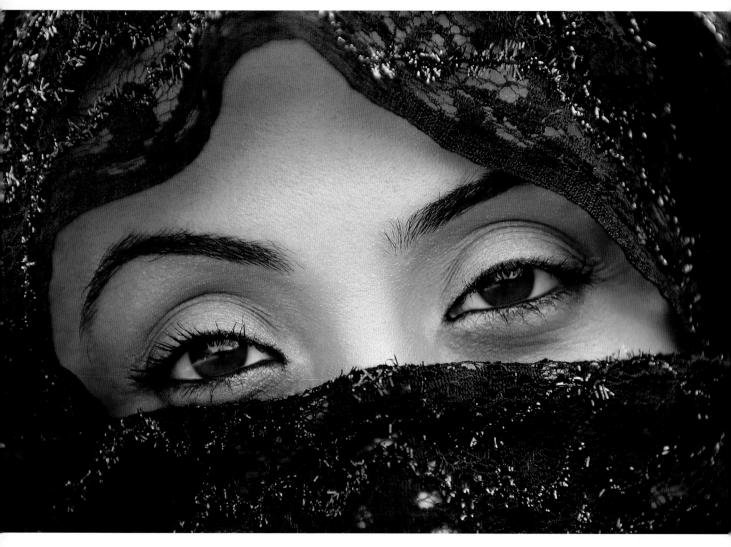

Have you ever sat down in your airplane seat or at a table in a restaurant and discovered that the person sitting next to you is "connected" to you, either personally or professionally? With a bit of surprise in your voice you might even remark, *Wow, what a small world!*

This has happened to me more than a few times, oftentimes when I find myself in places halfway around the world. I was on a plane to Hong Kong some years back to shoot a magazine story about the people who live aboard the junks, those unmistakable brown sailing vessels that can still be seen today in the harbor of Hong Kong (although not in the same number as in days gone by). Several hours into the flight, I began making small talk with the gentleman seated across the aisle from me. I soon learned that he was from Honk Kong, shared my passion for photography, and had an uncle who lived aboard one of these junks! This man had the inside track, obviously; since he already had the trust of at least one my

potential subjects, I knew he would be able to do far more for me in far less time than I would have been able to accomplish alone. And it was all because I had the good fortune to sit across from a man who was connected to me, *and* because I wasn't afraid to strike up a conversation with him. If I hadn't bothered to make the effort to talk to him, I never would have discovered this connection. That's the important thing here—I approached him in some way.

Short of having a connection such as this, there's probably no better way to meet new people than through a referral. In the workplace, this is called networking, and if you're a serious people shooter, the practice of networking should be high on your list of weekly tasks. The old saying "It's not what you know, but who you know that counts" certainly applies to photographing people. You'd be surprised at the number of willing subjects your physician, minister, hairstylist, waitress, gas station attendant, and day-care center staffer can provide. And again, it

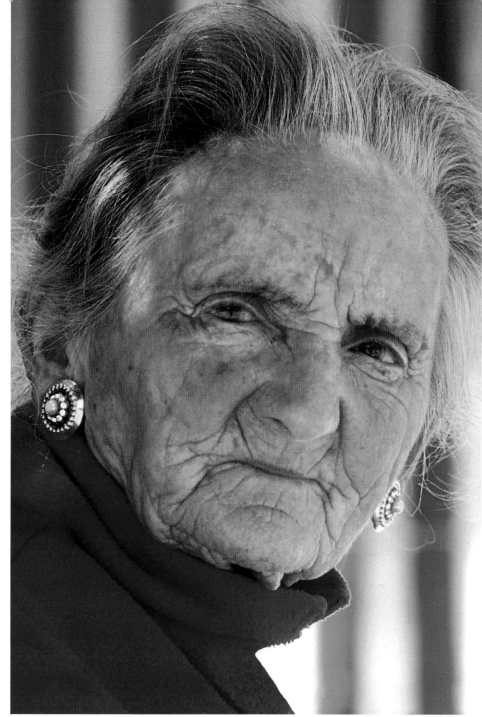

My good friend Peter Hook is from Australia, but he works in Dubai. His wife is Karen Hook, who is the founder of the Gulf Photo Plus show, which is fast becoming the must-see photographic event of the year in the Middle East. If not for my relationship with Peter and Karen, I seriously doubt if I would have ever had the good fortune of photographing this woman. She is one of Peter's coworkers. When I expressed to Peter that I would love to photograph her, he said matter-of-factly, *Well why don't you ask her?* I replied, Because I don't know her at all and you do! *Before the day was over Peter called and told me that she wanted to meet me and ask a few questions. Her primary concern was being photographed* without her face covered, which would not be possible for her. When I explained that I was interested in photographing her just as she was, with her face covered, she agreed.

The following afternoon we did the shoot, and I got much more than I had ever bargained for. Not only did I shoot the image you see here, but she made several quick changes of clothing and I got a number of other portraits, too. And, before the afternoon came to a close, she was posing for me with her face uncovered, walking barefoot along a sandy, windswept road. Even though I'd like to publish those images, she was quick to tell me that as much as she enjoyed the results of our photo shoot, she would only authorize the publication of the photos in which her face was covered. For that reason, she will remain a "mystery" to most of us.

Nikkor 70–200mm lens, f/5.6 for 1/320 sec.

Donatello, a proud, young Italian man *I met while sitting at a café in Rome, was eager to show me the sights of the city. He wanted an excuse to practice his English, and since I spoke no Italian at all, it was an offer I couldn't refuse. But it was not until late in the afternoon that I struck gold—at least in the portrait arena. It was then that I expressed a desire to photograph people with great character, and Donatello suggested I meet his 98-year-old grandmother. Although Donatello's grandmother was at first reluctant, she eventually agreed to be photographed in her small backyard. With my camera on a tripod, I shot her against the backdrop of a nearby awning, figuring the out-of-focus tone and shape of the awning would provide some nice contrast to the woman's face. She was not at all disappointed. She was thrilled in fact.*

Although I wanted his grandmother to smile, Donatello was quick to explain that she was not going to do that, due to the fact that she had no teeth. Fair enough, so with my aperture set to f/5.6 to keep depth of field limited, I simply adjusted the shutter speed until 1/320 sec. indicated a correct exposure and fired off a number of exposures with varied expressions, this being one of my favorites.

Nikon D2X and 70–200mm lens, f/5.6 for 1/320 sec.

HONESTY IS THE BEST POLICY

Whether you know a subject or are approaching a complete stranger, tell your potential subject why you want to photograph them and what it is you have in mind. Be honest about your intentions. I can't overstate the importance of this. Don't walk up to the farmer at the roadside produce stand and tell him you're doing a story for *National Geographic* magazine when you know that's not true. Don't walk up to that woman on the beach and tell her you're doing a story for *Travel and Leisure* magazine when you aren't. Tell the truth!

Explain to the farmer that you aspire to one day shoot for *National Geographic* and that he could be instrumental in your reaching this goal. Confess to the woman at the beach that you aspire to do freelance work for magazines such as *Travel and Leisure*, but before you can live that dream, you need examples that will showcase your creativity in photographing people involved in leisure activities. Most subjects, when told they can help you, are eager to do so, especially when you also inform them that you'll give them a free color print as a way of saying thanks for their efforts. And if you are shooting digitally, you can share the results of your efforts with them right away via the camera's monitor.

does bear repeating, your sincerity and tone have a big impact on exactly how much these valuable contacts will do for you.

When I ask students why they don't take more pictures of people—in particular, of strangers—*fear of rejection* is the answer I hear most often. They assume their request will be rejected, and rejection can sometimes sting. And truth be told, fear of rejection is justifiable. Throughout the world, the people you wish to photograph—friends as well as strangers—have something to say about you taking their picture, whether they express their opinion verbally or with a rude gesture. Even the strongest photographers feel a pang of rejection when someone they feel is a great subject refuses to be photographed. On more than one occasion, my wife, my kids, my mother, and several friends have turned me down at what I felt to be the most inopportune time, as the location, the light, or the time of day was "perfect"—perfect for me, of course, but at that moment not perfect for them.

The reasons people don't want to be photographed are, perhaps, many, but I've concluded that there are primarily two main ones. First, most people say *no* at the moment you ask them simply because they feel that you

couldn't possibly take a good picture of them at that time, at that place, wearing those clothes, and without being able "to freshen up first." Ironically, these reasons for refusing are the very reasons that draw you in in the first place: the time (the light is perfect), the place (the environment complements their personality or character), their clothes (their attire fits or contrasts sharply with the environment), and their appearance (dirty face, messy hair, sweaty brow, or the joy or sexiness they're exuding at that moment).

Second, people also say *no* because they don't believe your intent. Again, nothing plays a more pivotal role in winning people's trust than the level of sincerity you convey to them. This is true even when photographing family members. Trust, like faith and nourishment, is a universal need. Tell them why you want to take their picture. There's a reason, isn't there?

Only twice in my over-thirty-year career as a photographer have I really felt the sting of rejection, and one of those times is still the most memorable—and the "sting" was literal as well as figurative. I was on the fourth day of an assignment for an airline magazine, photographing the vendors at an outdoor market in Malaysia. Up to this point, I had met resistance from no one I had approached. I had become so accustomed to feeling at home in this foreign land that I no longer asked anyone's permission; I simply shot first and asked questions later. An elderly Chinese man selling oranges caught my eye as his stark blue clothes were in perfect contrast to the "wall" of oranges surrounding him; he also had a really great face with one of those long moustaches. As I was busy framing him up with my camera and 200mm lens, he quickly grabbed an orange and threw it right at me, and before I could even think, it smacked me right in the head.

Needless to say, while other nearby vendors laughed, and he was heard ranting, I made a quick exit from the busy marketplace, feeling rather embarrassed and a bit humiliated. I was tempted to let this incident shatter my confidence, but I chose instead to get right back on the horse and within ten minutes found myself shooting once again in, albeit a different part of, the large market.

Taking a shot of anyone who protests doesn't mean you run the risk of getting hit with an orange, of course, and if I had simply asked first, I could have avoided this embarrassing encounter altogether. But, again, some people just don't want their picture taken.

Shooting surreptitiously is seldom the right approach either. You aren't treating your subjects fairly, and getting them to sign a model release will be difficult at best. If you want to use your photographs for commercial purposes

Nothing plays a more pivotal role in winning people's trust than the level of sincerity you convey to them.

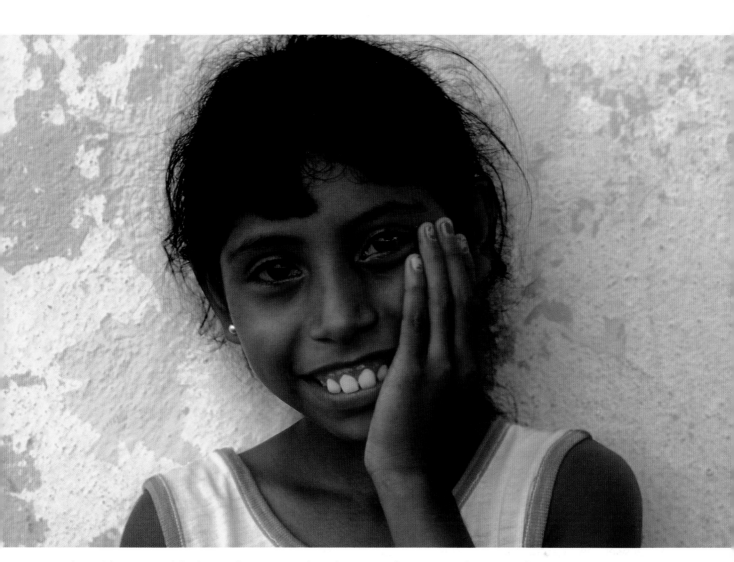

someday, without a model release, they are worth nothing! Although some photographers argue that being "sneaky" is the only way to get "real" people shots, I strongly disagree. I've shot some of my best candids because I made my presence known to the subject. The real joy in photographing people comes when subjects are free to pose willingly and when all parties involved agree that the final image is an accurate portrayal of the subject. And again, for those shooting digitally, you can share that accurate portrayal immediately via the monitor.

Finally, I want to stress just how important it is to listen to your subjects. As mentioned earlier, people do talk back, and oftentimes, what they have to say is worth its weight in gold. You may have everything all figured out in your mind, but don't be surprised if, after winning your subjects' trust, they also have ideas about how they see themselves. One of the most important questions I've asked my wife, my kids, my other family members, as well as total strangers is this: *If you could look any way you want while being photographed, and in the environment of your choice, what would I see and where would you be?* The answers may surprise you!

I don't speak a word of Spanish, but fortunately the Spanish schoolteacher spoke English, and she was on my list of subjects to shoot for an assignment dealing with the impact of a gold mine on its surrounding community. Shooting a portrait of the teacher at her desk against the blackboard, surrounded by schoolbooks was very easy since she woke up that morning knowing full well that a photographer would be taking her picture. When we were done, I thanked her for her time and, before leaving, asked if she could help me with a few more pictures that I felt the client would also like to have, namely a few portraits of the children attending the school. This is a good example of networking. In well under fifteen minutes she had orchestrated what became one of the most productive thirty minutes of my photographic career. As she lined up the more than twenty children outside in the playground, I found three different backdrops against which to photograph them, including the textured side wall of the one-room schoolhouse that you see here. Of the number of children I photographed that morning, Angela was, fittingly enough, like a little angel, and it was only later that I realized that the yellow paint on the wall behind her was akin to the halos often seen in paintings of angels.

Nikkor 105mm lens, f/5.6 for 1/125 sec.

My students and readers of my books often ask me how to get images of complete strangers *and* signed model release forms. Showing people how to do this became the premise of a story I proposed to John Owens, editor at *Popular Photography* magazine in New York, and I'll recreate the process here.

Of course, walking up to a complete stranger has its share of risk, but that risk is often minimized when you have a specific reason in mind when asking permission to take a picture. This isn't the time to simply say, *I don't have anything in mind, other than wanting to take some pictures of you.* Rare is the individual who jumps on a waiting bus without first knowing in which direction the bus is headed. You must at least offer up some reason for wanting to take someone's picture, and of all the "lines" I've used over the years, nothing—and to this day I still mean *nothing*—has worked better for me than the truth, because more often than not, the simple truth works.

So, I just explain the simple truth to people that I'm always looking to add more people images to my portfolio, and I conclude by saying something like *and I'm hoping you can help me in accomplishing that goal by allowing me to take your picture.*

It's also important to add that at no time did I tell anyone I was a working professional, a book author, or a contributing editor with *Popular Photography* magazine. And to keep me on the "straight and narrow," John Owens sent Debbie Grossman, the magazine's associate editor, along to make certain I was playing the role of a photographer who wanted to get some much-needed people pictures for his portfolio.

My first stop was a local café, not only to get some morning fuel but also to strike up a conversation with the locals. The

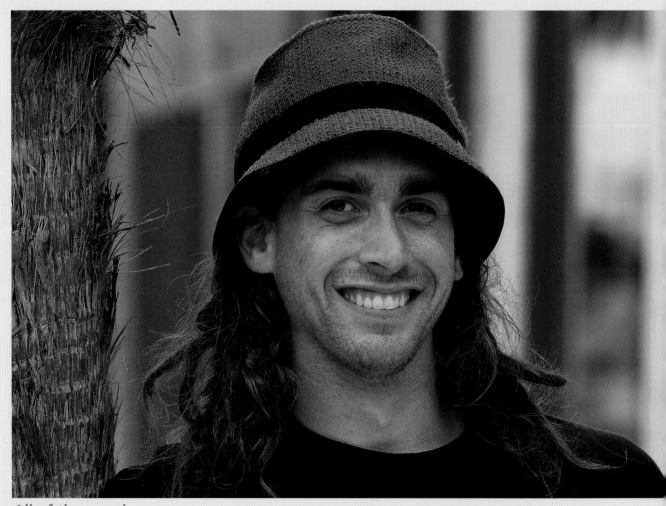

All of the people *in these photographs live in and around Venice Beach, California. When they woke up on the morning of October 17, 2005, none of them had any idea that before their day was over they would be approached and photographed by a someone they had never met before—and each of these individuals would also sign a model releases.*

Above: 70–200mm lens, *f*/4 for 1/320 sec.; opposite, left: 17–55mm lens, *f*/5.6 for 1/60 sec.; opposite, right: 70–200mm lens, *f*/5.6 for 1/250 sec.

first person I spoke to was Kraig (opposite), the young man who took my order. I was quick to comment on his great face and hair, and I inquired if he was by chance trying to break into acting. I was also quick to explain that I was a photographer who needed more pictures for my portfolio, and after making the simple request to photograph him outside near the café during his break, he eagerly agreed.

It was during this time that I went into "networking mode" and asked Kraig who else he thought might also be a willing subject, whether it be a fellow employee at the café or a regular customer. It wasn't long before I had more than a dozen willing subjects, all thanks in large measure to Kraig and to his telling them about myself and my needs. This is networking at its finest.

Later on that day I moved on to the Venice Beach boardwalk and came upon a young mother and her three-year-old child, a fortune-teller, and a waitress who worked at one of the many sidewalk cafés. Again, I told them all the same story I had told Kraig, and all were happy to help.

To get all my subjects to sign a model release, I simply explained that someday I might get lucky enough to have the image published, and if I should get lucky enough, I would do my best to see that they were made aware of it, but that, more importantly, I could never get the pictures I made of them published without their permission, so . . .*Can I get your okay on this release, which could allow both of us to have our fifteen minutes of fame?*

As usual, no one said no. If you're inclined to be far too shy or timid to say just what I've explained, don't despair; chances are really good that you have a friend who can do the talking for you. (Also see the appendix A on page 156 for additional information on model release forms.)

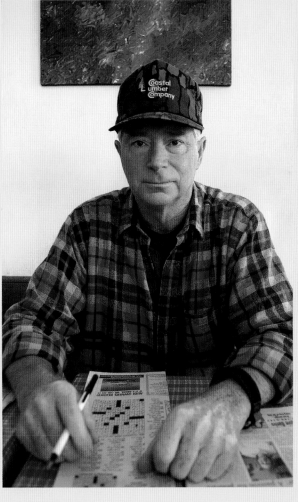

Observing People

People-watching—everyone does it. It's not enough to just go up to anyone; you must watch to find the interesting subjects. And, whether you do it consciously or subconsciously, you make sweeping generalizations about the people you watch. *He looks like a football player*, you remark about the 250-pound teenager with the thick neck at the mall. *She looks like a drug addict*, you think about the woman on the street with stringy unwashed hair, dirty jeans, and no shoes.

The broad generalizations and descriptions you make about people are greatly influenced by a number of factors, not the least of which are how you were brought up and Madison Avenue—i.e., print and television advertising. Beyond these, the three most important criteria that determine your reactions to the people around you are: (1) physical appearance, be it overweight, underweight, potbellied, athletic, blue-eyed, brown-eyed, natural, heavily made up, clean-shaven, bearded, weathered, youthful, long-haired, short-haired, blonde, redhead, and so on; (2) clothes, be they designer fashions, hand-me-downs, summer dresses, winter coats, business attire, formal wear, bathing suits, and so on; and (3) environment, whether it be work, play, in the city, the country, school, church, mountains, desert, beach, a pool, in the USA, or in a foreign land.

As you observe people (whether they are relatives, friends, or strangers), listen to your feelings. Notice what you're drawn to: her walk, his mischievous grin, her long and bouncing hair, his blue eyes, her silly hat, his torn jeans, his wrinkled skin, her sports car, his automotive garage, her florist shop. Are you interested in the dirty faces and unkempt hair of the children from a broken home, or would you focus solely on the 7-year-old boy's worn out sneaker and the dirty toe sticking out of it? Would you photograph the elderly man at the local diner with his coffee cup raised to his mouth as his tired eyes peer directly into the camera, or would you choose to photograph him looking off to the left or right? Perhaps a composition showing only his large, weathered hands grasping the cup and showcased against his bright red flannel shirt would be more representative of what you're feeling.

The way you deal with your feelings determines which people you photograph and how you will eventually choose to photograph them. You might be less likely to photograph a subject that makes you feel nervous or frightened (*He looks mean, and he's big, too*) than a subject that makes you feel warm and welcome (*He looks like my funny uncle, plus he smiled when I looked at him*). Another photographer, however, might find the "mean" subject appealing (*I can see the teddy bear beyond that mean attitude*) and the smiling subject suspicious (*I don't trust that smile*). Understanding what you're drawn to visually is part of the art of understanding and photographing people. Everyone is unique, and it is this difference that makes capturing people so varied, challenging, and rewarding.

The way you deal with your feelings determines which people you photograph and how you will eventually choose to photograph them.

In addition to being surprised by this man, I couldn't help but feel the irony of the situation: I was in a timesless place—a coastline that probably looked the same as it had back in the sixties—yet the calendar clearly said 1997 while the man's appearance still said "sixties." Even his clothing and bandanna reminded me of the sixties. But most of all, it was his face, which conveyed his passive demeanor, that compelled me to frame up this simple portrait.

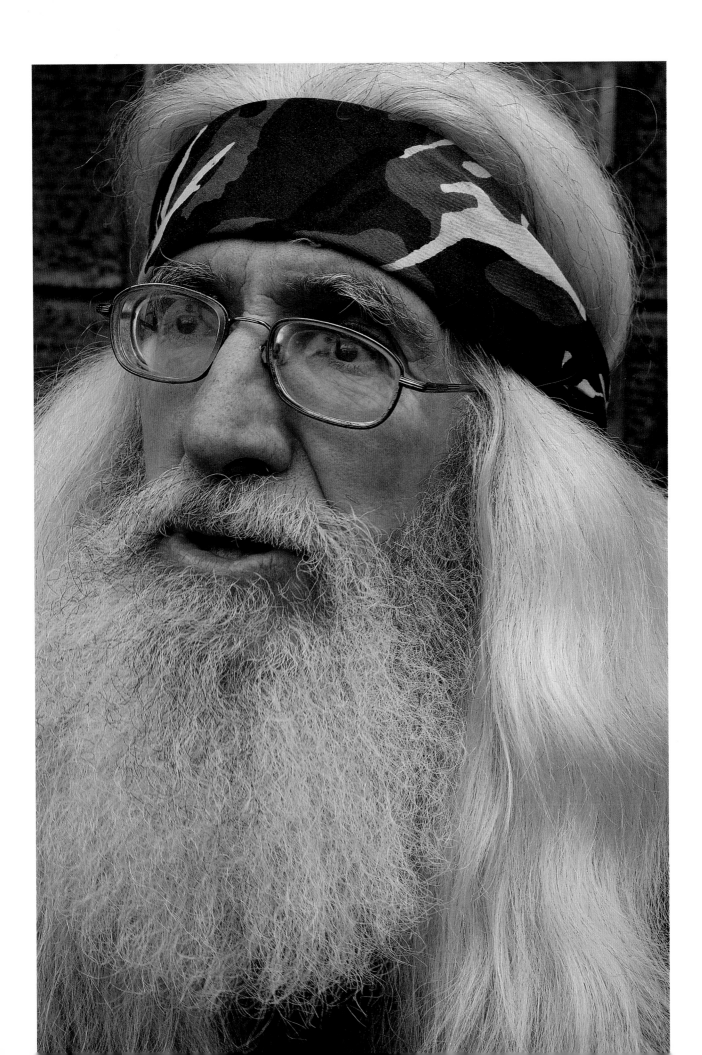

People and Their Environment

Nothing can add to or detract from a subject's appearance more quickly than the surrounding environment. A portrait of a young man wearing a blue denim shirt sitting on a log at the beach can suggest that he is a solitary, introspective individual; however a shot of that same man in the same clothing sitting on a bed in a jail cell might suggest that he's a hardened criminal or a sympathetic figure whose life took a wrong turn.

A tightly composed shot of a 6-year-old girl's smiling face tells you only that she is happy; however if you include the environment around her, you would convey a deeper understanding of her ear-to-ear grin because you'd show the blue ribbon in her hand as well as the Olympic-sized pool where she beat her competition in the background.

When you photograph people, whether at work or at play, the importance of the right environment can't be overstated. For example, if your 7-year-old has a gift for playing the piano, it makes sense to photograph him with the piano. If your boyfriend is a skin diver (and you don't share his passion), then make sure to include the beach and palm trees. And, if your mother or grandmother does, in fact, make the best homemade apple pie, then the kitchen (or an apple orchard) is the perfect backdrop for a picture of her holding her apple pie. Generally speaking, if the environment is going to be part of the composition, it should call attention to—or, at the least, relate to—a person's character, profession, or hobby.

CONTRASTS

Besides obviously complementary environments, you can certainly photograph people in environments that contrast sharply with them. This is perhaps most evident in the work of some fashion photographers. Photographing models in coal mines, junkyards, or even huge bank vaults, for example, is in stark contrast to the "norm." This departure from the typical images of models frolicking on the beach, dining alfresco at a café in Paris, or buying flowers at an outdoor market is meant to surprise viewers. The contrasting environment calls attention to the clothing. The viewer is quick to raise the burning question *Why would she be wearing that beautiful summer dress in a coal mine?*

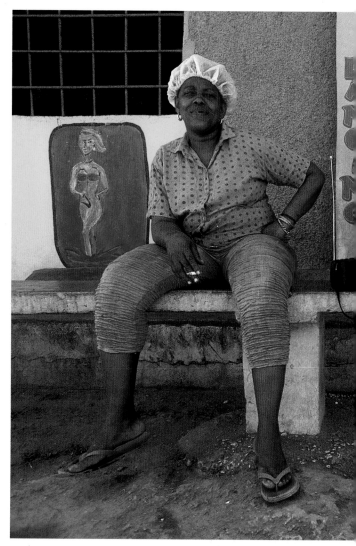

Imagine for a moment the stark contrast of a nude figure lounging on the steps of the New York Stock Exchange; or a well-known CEO sitting in an old, torn-up recliner inside a burned out building; or someone dressed in winter ski clothing walking down the sun-drenched beaches of Hawaii. Let your imagination run wild as you think up odd environmental juxtapositions for your photographs, and you'll soon find yourself with a "shoot list" that will keep you busy making images for months, if not years, to come.

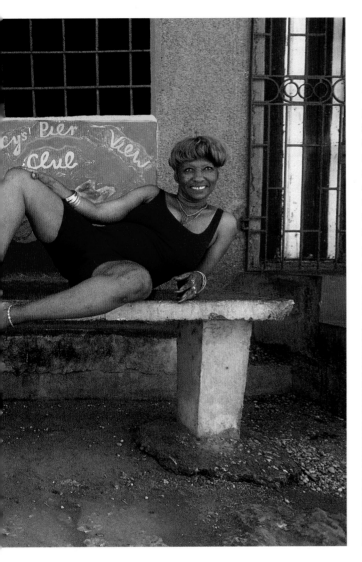

These two images share a common thread: a surrounding environment that is very telling. And with the inclusion of each environment, a sense of place—and a sense that a bigger story is being told—is conveyed. In the image to the left, two proud "ladies of the night" eagerly pose for the camera in Jamaica against the backdrop of their place of business. And the image of the punk rocker and cop in the background (below) is a great story of the troubles that plague many inner cities around the world—and, yes, this image was staged, including the "rent-a-cop."

Left: Nikon F5 and 17–35mm lens at 20mm, *f*/8 for 1/125 sec.
Below: Nikon F5 and 35–70mm lens at 35mm, *f*/5.6 for 1/60 sec.

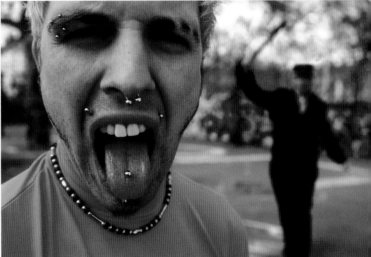

When you photograph people, whether they're at work or at play, the importance of the right environment can't be overstated.

People and Their Clothing

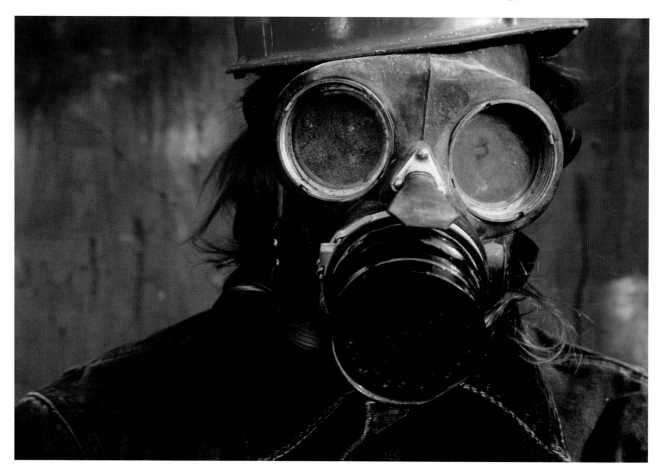

When you walk into a hospital and a person in a white uniform greets you, there's little or no question that that individual is a nurse. If, however, the same person were wearing faded jeans and a gray sweatshirt, you might question that nurse's abilities as a medical professional. Many people consider clothing to be an important barometer, indicating whether someone is rich or poor, liberal or conservative, playful or serious, meek or powerful. Simply put, clothing (or the absence of it) can define and redefine your character and personality. How many police officers look authoritative out of uniform? How many priests or ministers are identifiable as members of the clergy when they take off their collars? Defense lawyers are all too familiar with the power of attire, as once shaggy-haired, raggedly dressed defendants arrive in court with haircut, suit, and tie to enter a plea of *not guilty*.

For most people, clothing is a primary form of identification and provides an immediate answer, albeit based in large part on assumption, to the question *What do you do?* A portrait of a firefighter in uniform or a Native American in full headdress or a coal miner with illuminated helmet leaves no doubt, at least to some degree, as to how these people spend part of their time.

In many cases, clothing immediately identifies people's nationality or culture, as well. For example, if a young boy in lederhosen were to walk down a New York City street, many people might remark, *He must be from Germany or Switzerland.* Similarly, a bald 35-year-old man wearing sandals and a bright orange robe is immediately thought to be a Buddhist monk. Granted, people stand out more when they are "out of place" (i.e., out of their normal environment), but what they also do is spark a vision of "another world"—or a larger world.

Finally, how many of us have toiled side by side with coworkers for months and not paid much attention to them until the company picnic? When you finally take notice of the people you work with on a daily basis, you discover that the usually conservative business attire of the white-collar world and uniforms of the blue-collar world give way to, perhaps, more revealing and flamboyant clothing. Keep this in mind when you're shooting, since the clothing can add or detract from the essence of what you are trying to say about the person you're photographing.

In the examples on these and the following two pages, it's the clothing that tells the story. Whether it's a "story" about a subject's job, a place of residence, a festival, or even the weather, the clothing is, first and foremost, the strongest indicator of these things.

In the first example (left), note how the clothing (and the background, too, to a lesser extent) seems to tell a story of what this man does for a living. You see the hard hat and sandblaster mask, photographed against a backdrop that appears to be an industrial setting. In the second example (right), you see what might be a fisherman, and you imagine his commercial fishing vessel nearby on this day of clearly inclement weather—all as told by the bright yellow rain slicker.

Truth be told, the "sandblaster" is my son, Justin, who is not—and, chances are, will never be—employed as a sandblaster. I picked the mask up at a garage sale, along with the blue hard hat, and simply posed him sitting down in front of a neighbor's dumpster. And the "fisherman" is actually an employee of the US Fish and Game Department who was part of a story I photographed for *Audubon* magazine about the impact of gold mining on our nation's streams and rivers.

Left: Nikon F5 and 35–70mm lens at 70mm, f/8 for 1/125 sec., Kodak E100VS film
Right: Nikon F5 and 105mm lens, f/8 for 1/60 sec., Kodak E100VS film

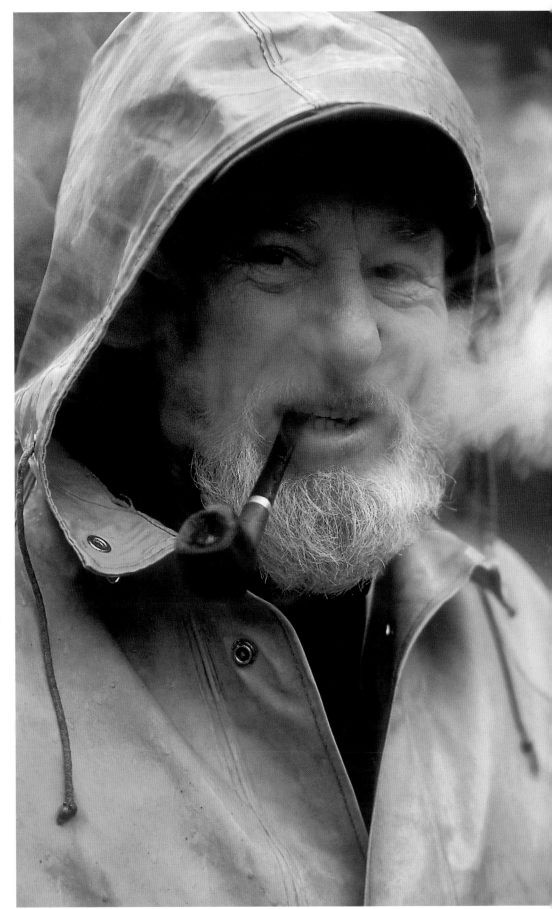

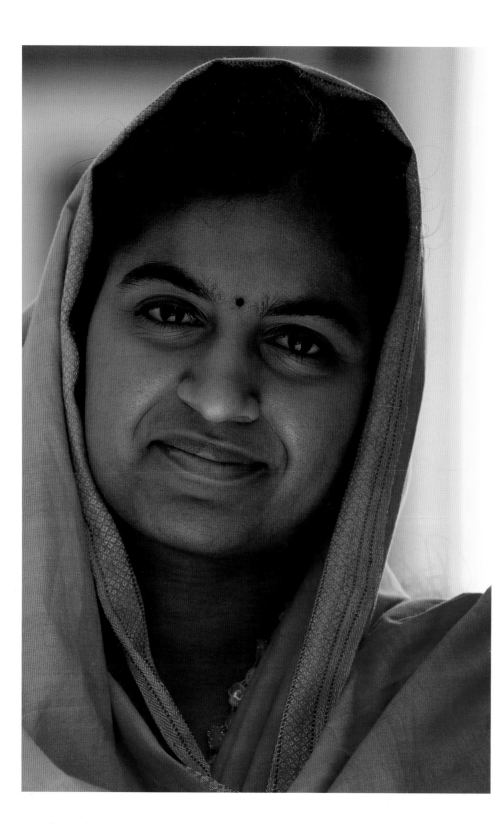

Note how a simple baseball cap is capable of conveying two completely different feelings. Who seems like the winning high school football coach? Obviously, the coach who does not turn his cap backward is going to be seen as the one who's more serious, more determined, and more reliable than the other, who may not be a coach at all, but instead is just a fan. And we draw these conclusions based on one element: clothing.

Actually, this is my brother Greg, who has one of the most extensive collections of baseball caps of anyone I know—and he is definitely your typical and fanatical football fan who knows everything there is to know about football but, of course, has never coached a game in his life. He's a surgical nurse!

Nikon D2X and 70–200mm lens at 200mm, *f*/5.6 for 1/320 sec.

A good guess, judging by the clothing, is that the woman at left is from India. But, she is actually a computer science teacher whose portrait I took while she was on her lunch break in a place called Knowledge Village in Dubai, United Arab Emirates.

Nikon D2X and 70–200mm lens at 100mm, *f*/5.6 for 1/160 sec.

Simply put, clothing (or the absence of it) can define and redefine your character and personality.

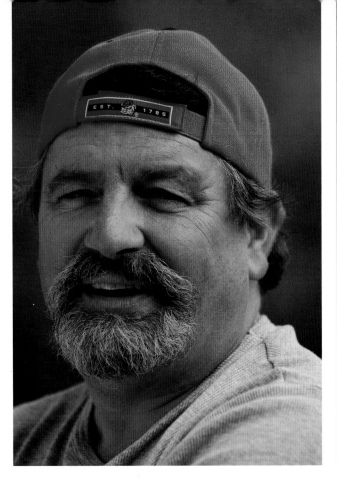
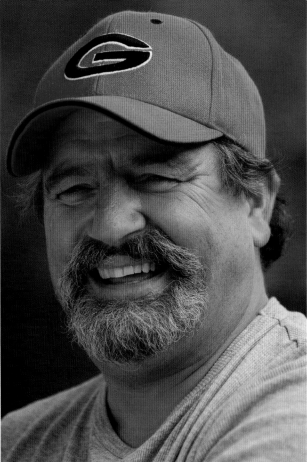

ON THE FACE OF IT

How much information can you gather from the following scenario: You see two people facing each other at some distance from you, and their faces are blocked from view. It's apparent, based on the sometimes subtle and sometimes rapid movements of arms and hands, that a conversation is taking place, but what kind of conversation is it? Jovial? Enthusiastic? Happy? Somber? Frustrating? Romantic? Sad? Any attempt at answering that question would be based, in large measure, on guesswork. Due to your distance, it isn't possible to make an assumption about a conversation that you can't hear without seeing the faces. If, however, you were able to clearly see both of their faces, you would be quick to note that the conversation was at times volatile, at times somber.

Experienced landscape photographers know that if the light or weather isn't quite right at a given moment, they must wait until it is (or come back when it is). Sometimes, the wait will only be minutes, but sometimes it may be hours or even days. In effect, landscape photographers must wait for the right "expression" to fall on the landscape, an expression that conveys the mood and emotion they wish to capture. And like the landscape (with its varying light and weather), the human face is ever changing. Expressions of anger, sadness, frustration, disappointment, doubt, indifference, and joy all might cross the faces of both people engaged in conversation.

Unlike photographing people in their environment, however, shooting close-up portraits of people's faces makes many photographers (and their subjects) uncomfortable. This type of "close encounter" confronts the boundaries of intimacy. Still, there are some photographers who thrive in this intimate environment; and they usually know the value of good conversation. Making your subject's face come alive for your photographs can be a challenge, to be sure. Startling questions, piercing statements, funny stories, and the simple comment *You look great!* can all combine to make your portrait work come alive.

THE FACE AS A CANVAS

If the eyes are the window to the soul, the face is the wall that surrounds this window. And on that wall are a host of "knick-knacks" on display that reveal character. The face suggests struggles as well as triumphs, compassion as well as anger. And that wrinkled brow? Does it speak of wisdom or depression?

Furthermore, the face not only conveys a multitude of expressions, but for many, it is also something to be adorned. In Western cultures, women and men decorate their faces in numerous ways, using anything from simple self-tanning lotions to blush, lipstick, eyeliner, piercings, moustaches, and beards. In India, women mark their foreheads with different-colored dots to indicate their marital status (single, married, or widowed). Tribes in New Guinea place large disks in the lower lip, and tribes in Africa scar the faces of 12-year-old boys with a hot stick as a rite of passage in to manhood. Whether the face is adorned with a simple frown or smile—or with makeup, facial hair, or scars—how the face is decorated says a great deal about the person, as well as the prevailing customs and culture.

Working with People

Choosing the Right People

A chief advantage that location photographers have over studio portrait photographers is the opportunity to photograph people in a seemingly infinite variety of environments all over the world. This freedom to choose not only which environment but also which people you photograph translates into far more opportunities to be truly creative. After all, there are only so many backgrounds one can use in a studio.

Perhaps more important, though, is that location photographers encounter subjects on their own turf, where, understandably, people are more likely to feel at ease, at least when they are first approached. But all of this freedom doesn't guarantee success. In truth, some of my most compelling subjects were at first the most resistant, but because they fit the part I imagined so perfectly, I simply had to be more patient than at other times. Eventually, short of someone being a fugitive or in a witness-protection program, most if not all subjects will give in—if you are willing to invest the time.

The result of the increased subject variety that you get as a *location* people photographer is the increased importance of choosing the *right* people. One of the primary considerations of photographing anybody is making believable results. Whether you're on vacation or on a quest to someday be a commercial photographer, your goal should be to return with some hard evidence that you really did photograph a doctor or a homemaker or a lawyer or that fisherman from Scotland or that computer science major from Singapore or that waitress at the Oktoberfest in Germany.

For example, a picture of a Caucasian woman selling pineapple at a roadside stand in Maui isn't nearly as believable as the Hawaiian man selling pineapples just down the road. Granted the woman might really have been selling those pineapples, but she just is not as believable as the man doing the same thing.

In another example, while shooting an assignment in Paris some time ago about the art of bread-making, four of the first seven bakeries I visited the first day were, much to my chagrin, run by Vietnamese, Chinese, and Russian proprietors. Before you assume that I'm biased, let me assure that I am—but not in the way you might be thinking. If I were in Paris to do a story on the rise in Asian bakers in Paris, I would have gladly photographed them, but my assignment was to feed the fantasy of Americans who travel to France: that all French bakeries are run by the French. So for my needs, it only stood to reason that the bakers must look "very French."

Would you portray a person who is clearly overweight as a tennis pro? Would you portray a child who is dressed in dirty and worn-out clothes as an honor student? Would you portray a very conservative looking 25-year-old woman as the owner of a tattoo shop? Of course not, and it's not because you're prejudiced. It's because you want your subjects to be believable.

The result of the increased subject variety that you get as a location people photographer is the increased importance of choosing the right people.

This man really is a coal miner who I asked to photograph at the end of his shift while I was on assignment for a mining company's annual report. But by looking at him, you can learn what makes this image successful. You can learn what type of props you would need if you were using a model to "play the role" of a coal miner: the illuminated hard hat, the work clothes and gloves, and the soot. Aside from the "accessories," this man looks the part. If you are casting for a coal miner, you need a model who looks like he could really endure tough manual labor.

Nikon F5 and 35–70mm lens at 50mm, *f*/8 for 1/125 sec., Fujichrome 100

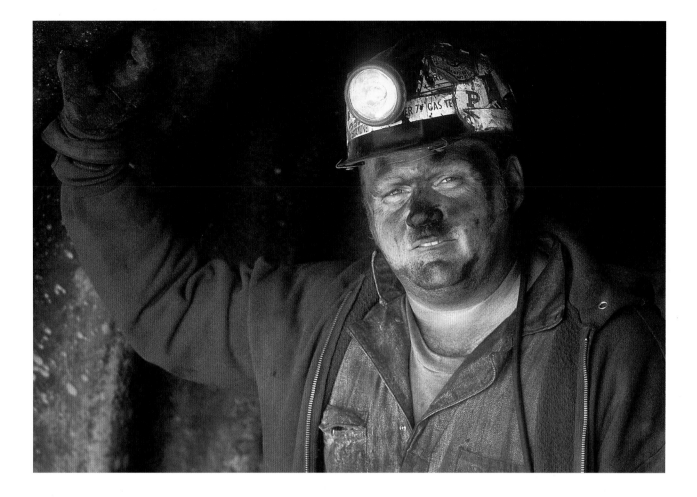

EXERCISE: PRACTICING "CASTING"

All of us have seen movies and, at one time or another, commented that an actor was miscast and not believable in a role. Perhaps you've even gone so far as to say that the actor didn't *look* the part. The same can apply to photography. Whether you're consciously or subconsciously thinking about someone's appearance, you'll find that there's always that one person you see who you feel is perfect for your planned composition. Whether your goal in selecting a subject is to win a photo contest or simply to add a compelling image to your photo gallery, you'll often find yourself playing a "casting director."

Shooting stock photography works the same way, and one of the keys to shooting successful stock imagery is to learn the art of casting. In fact, the following exercise is one of the many lessons I offer in my online course on becoming a successful stock photographer. As many students have remarked, it proves to be the most challenging, as well as the most rewarding, exercise of all. I know of no better way to test your casting skills, reveal what kinds of people you're drawn to, and show how good you are at the "art" of public relations.

To begin, head out the door and find *no less* than eight *new* faces, photographing each person as nothing more than a head shot against a plain colored wall. The challenge here is twofold: (1) It will force you to network and meet eight new subjects, whether they are friends of friends or simply people you introduce yourself to at the store or mall; and (2) It gets you playing casting director with these new faces.

After shooting each head shot, explain to each model that you're working on developing a "people portfolio" in the hopes of someday shooting professionally and that this will be the first of several photo shoots you hope to do with each person (so keep contact information if your models are willing to share it). Then, when you're done, sit down with family members or other friends and together start "casting" each model; list three different "roles" that each person could fill, for example blue-collar worker, teacher, doctor, lawyer, bookkeeper, scientist, stockbroker, maid, gardener, nurse, golfer, tennis pro, homemaker, minister, student, unwed mother, drug addict, writer, banker, and so on.

Once you do that, you can contact your models again to make the arrangements to actually photograph them in those roles; you will need the necessary props (clothing) and the right environment (office, kitchen, garden, lab, and so on) to make everything believable, which is the goal.

Breaking through the Shyness Barrier

One of the greatest challenges photographers face is learning to break through the shyness barrier; for some, that means not only subject shyness but photographer shyness, as well. Assuming you've gotten past the internal obstacle that keeps you from asking others to pose for you, how do you convey your intentions with sincerity, certainty, and confidence?

After talking with subjects for several minutes and getting a sense about them, I often ask a provocative question: *How do you define or see yourself?* Obviously, this question can't be answered with only a simple *yes* or *no*. It invites more conversation, and it's here where the experienced photographer has the edge—and now you will, too. At some point, you follow this question with another: *If you could look anyway you want, wearing what you want, and do anything you want while being photographed, what would I see in the final image?* The purpose of this question is, of course, to draw the person into the photographic decision-making process, thereby opening them up to the idea of being photographed.

In addition, my ratio of success in taking pictures of people over these past two years has increased tenfold due to the use of a digital camera. I used to carry a Polaroid SX-70 with me, which I used to take snapshots of hesitant subjects; the most resistant people were quick to proceed after they saw the Polaroid example of what I had in mind. Now, I no longer need the SX-70 thanks to the immediacy of the digital camera's monitor. Putting people's minds at ease has never been easier now that they can clearly see, before I really proceed, just how great they will look!

A final note about breaking through the shyness barrier: Some photographers insist that they work alone when photographing people, without the aid of an assistant. I, along with scores of other shooters, feel the exact opposite. An assistant can engage the subject in conversation, keep an eye out for unbuttoned shirts or opened zippers, flyaway hair, spinach in teeth, and any other potential problems that you might not notice. An assistant enables the photographer to concentrate on one thing and one thing only: creating great images.

I've shot on a few occasions without an assistant, and given a choice, I'll take an assistant every time. And just because you aren't a working professional certainly doesn't mean that you can't enjoy the freedom that comes from having someone else do the talking (as well as the "looking after") for you. If you know someone who

I've met my share of shy people over the years, and I have two rules. Rule One: If I find myself having photographed people who were unaware of my presence (shy people included), I try my best to track them down, as was the case with this boy in Cuba. He just happened to walk into this scene as I was making the shot and cleary, by the look on his face, was not comfortable being photographed.

Right after taking the shot, I picked up my gear and followed. After I saw him go into a small apartment, I knocked on the door and was greeted by his grandmother. With the aid of my interpreter, I explained that I had just photographed her grandson and wanted to send them a print (and get a model release).

Rule Two: If I'm drawn to someone who's truly shy, I invest the time needed to overcome that shyness and shoot away from crowds. If someone really doesn't want to be photographed, I respect that and move on.

enjoys engaging conversation and likes meeting new people, then you not only have a great assistant, but you also have a great "people gatherer." Put this person to work! You will soon see a very noticeable increase in the amount of your people pictures—whether they be photographs of strangers in a foreign land, coworkers, or even just your family members.

"FLAWS"

If you've established a degree of trust with your subject (whether it's a family member, an acquaintance, or a stranger), most people will share some fairly intimate—and even sometimes startling—details about their lives and preferences. At some point in the conversation, you'll probably learn about a physical "flaw" your subject has

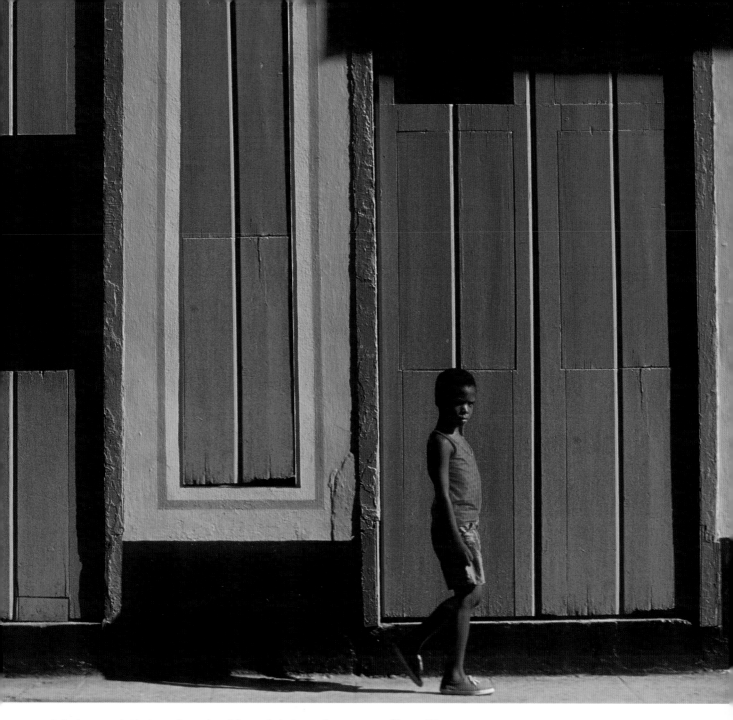

and hates, and that makes the idea of being photographed unappealing. Ironically, it might be that very thing that drew you to this person in the first place. So how do you overcome that? In some cases you don't, but more often than not you might want to point out the positive aspects that you saw in the "flaw," whatever it was.

For example, if a person is self-conscious about wrinkles, feeling that all they do is serve as a reminder of lost youth and vitality, you might explain to your subject that you were drawn to this face of great wisdom, a face on which so many stories have clearly been etched. It's a triumphant face, a face of joy and sadness, a face of love won and love lost. It's a beautiful face that makes you feel safe. You know that you are in the presence of someone much wiser than yourself.

My ratio of success in taking pictures of people over these past two years has increased tenfold due to the use of a digital camera . . . and the immediacy of the digital camera's monitor.

Posed vs. Candid

hotographers all over the world frequently debate whether posed or candid portraits are more pleasing. I think that both types of portraits can be appealing when the photographer's primary goal is to depict the subject as accurately as possible. Everyone has been asked to pose for the camera at one time or another, even if it was for nothing other than a school portrait. For most people, those shooting sessions were very impersonal (and date back to kindergarten, I might add), and they were for *posed portraits*, meaning simply that the subjects were directed by the photographer to move, stand, or sit a certain way; to tilt their head "this way" or "that way"; and then, hardest of all, "look right into the lens and smile."

Candids, on the other hand, are usually pictures of people who were unaware that their picture was being taken, or—and this is where the debate gets really interesting—they are pictures in which the subjects *appear* to be unaware that their picture was being taken. In "true" candids, the subjects are not directed or told what expression to convey; they are just being themselves at that moment in time. Unlike with posed portraits, with candids at no time is the presence of the photographer actually felt.

But what if the photographer is able to convey the idea of a candid moment while the subject is fully aware of the photographer's presence? For years we were led to believe that the famed French photographer Robert Doisneau had really captured a great candid of a couple sharing a kiss as they passed in front of an outdoor café and his waiting camera. The image, *Le Baiser de l'Hotel de Ville, Paris*, was and—as far as I am concerned—still is one of many Doisneau greats. But now we've recently learned that Doisneau staged the scene, instructing his models to cross in front of the café, sharing their kiss and warm embrace repeatedly, until he felt he had the one shot he needed.

In Doisneau's defense, I wouldn't be surprised if he had, in fact, seen another couple in a warm embrace, sharing a kiss as they walked in a somewhat hurried pace past a café he was seated at. I could believe that he might not have gotten shot, but might have made a mental note of it and was soon engaging the help of some friends to re-create that moment. And what's so wrong with that? Back in 1950 when he made this image, the streets of Paris were often festive—the German occupation had recently ended a few years before and love was once again in the air. It was time to be French again, and this, of course, meant that open displays of affection returned to the streets of Paris. So what, if he staged a moment?! The fact is, he should be commended for staging it so well that no one ever questioned that it was an authentic candid for all those years. Staged or not, does

Among the many photos I made on this day, this was not on my list of picture ideas. While I was hunched over a small tidal pool containing a purple starfish, this self-described "hippie from Montana" happened by. We started talking, and as is my nature, I was soon making his portrait.

With my lens at 200mm, I framed up this backlit portrait—but not before moving in even closer with my aperture set to f/5.6, metering off of his face, and adjusting my shutter speed to 1/125 sec. for a correct exposure. I then recomposed the scene you see here, and despite the fact that my light meter now told me my exposure was about 1½ stops overexposed, I ignored it and shot several frames at 1/125 sec., which of course proved to be correct. The light meter indicated an overexposure because when I recomposed after setting my exposure off of his face, the area of brighter backlight behind him influenced the light meter. But since this area was of no concern to me, I simply ignored that meter information.

Nikon F5 and 80–200mm lens at 200mm, f/5.6 for 1/125 sec., Kodak E100VS

it really take away from the "truth" that the image expresses? It was an exciting and liberating time to be on the streets of Paris, a time to celebrate, and the image captured the spirit of that moment for the all the world to *feel* and *share* in.

As I've said in some of my other books, every image is a "lie," and if it succeeds, that lie will be full of truth. The lie I refer to here is, of course, the lie of composition. By the very act of selecting a certain composition, the photographer presents only a small portion of the scene—thus, the start of the lie. The tight crop of a full-frame shot of a child who smiles for the photographer says nothing about the real world of poverty that surrounds her; missing from the photographed scene is her house made of

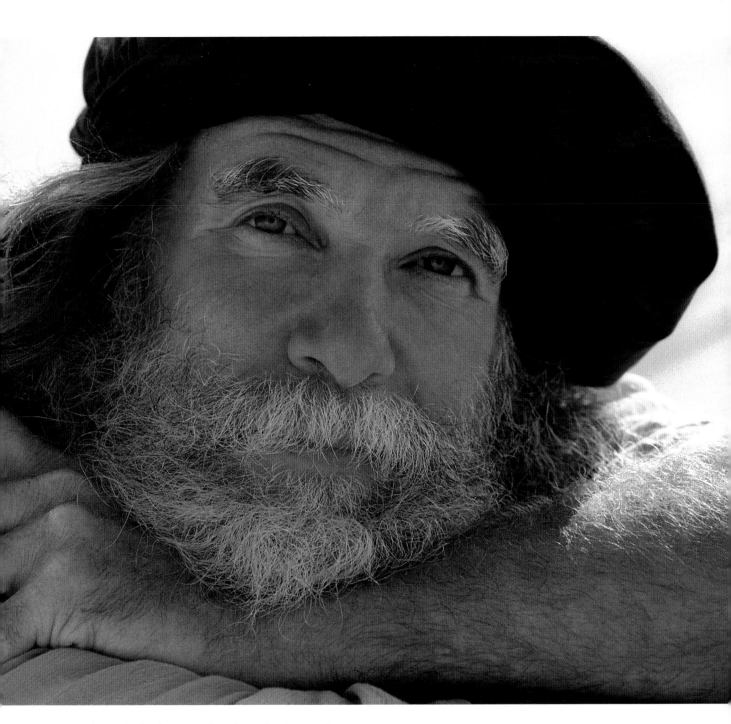

corrugated metal, the four starving dogs sleeping on her porch, and the raw sewage running past her house in the nearby ditch.

Ultimately, my feeling on the debate of real candid photos versus staged candids, or candid portraits versus posed portraits is simply this: If it makes me *angry*, if it makes me *sad*, if it makes me *laugh*, if it makes me *feel*, then it's the truth. If the subject conveys the message that you are trying to get across—regardless of whether you've staged, created, or even re-created the scene—and it *does not* look staged, then as far as I'm concerned, it is the truth! Hollywood has been staging, creating, and re-creating the "truth" for years, so why not photographers? Why not you?

Every image is a "lie," and if it succeeds, that lie will be full of truth.

EYE CONTACT

Do the subjects of all your portraits need to look directly into the camera lens, making eye contact with the viewing audience, to be effective? In my opinion, the answer to this question is, more often than not, *yes*. But it's not always possible to manage this when shooting true candids, since for most candid photography, the subject is not aware of the photographer's presence and, therefore, rarely (if ever) makes direct eye contact with the photographer and camera.

For the viewer, this lack of eye contact sometimes enables a greater study of the overall composition, since the viewer's eye is not as drawn to the direct gaze of the subject. Additionally, viewers can easily laugh at the subject's plight or feel the subject's pain without feeling that they are lacking in sensitivity. On the other hand, when the subject of a photograph looks straight at the camera, regardless of what that subject might be doing, the viewer has a tendency to feel more deeply in response. This direct eye contact is, of course, all about connecting with one of our own. We don't feel the same connection when, for example, we make eye contact with a chicken or a cow. If we did, I doubt if many of us would be eating chickens and cows.

When I notice someone taking an interest in my photography, I have a tendency to invite them over and show them what I'm shooting. In this instance, there were three young girls who seemed fascinated by my interest in shooting close-up abstracts of peeling paint on a nearby old and very weathered door. I suppose if I had not been a photographer, I would also have wondered why on earth anyone would be having what appeared to be an up-close-and-personal relationship with an old door. Once I had showed them the results of my close-up work via the digital monitor on my camera, I was quick to tell them that I really love to photograph people, and although two of the three girls were quite reluctant, one of them was not, so I made quick work of photographing her against a nearby blue house.

As luck would have it, a boy in red came walking through the scene just as I was firing off several exposures. Since I'm known as a photographer who sometimes stages a shot, this is, perhaps, a difficult story to swallow, but the boy in red was truly not planned. Sometimes magic really does happen. Along with my camera and 70–200mm lens on a tripod, and the focal length set to 100mm, I set the aperture to f/5.6 to keep the depth of field limited to the girl, throwing the background (and the serendipitous boy) out of focus.

70–200mm lens at 100mm, f/5.6 for 1/400 sec.

*When the subject of a photo looks straight at the camera . . .
the viewer has a tendency to feel more deeply in response.*

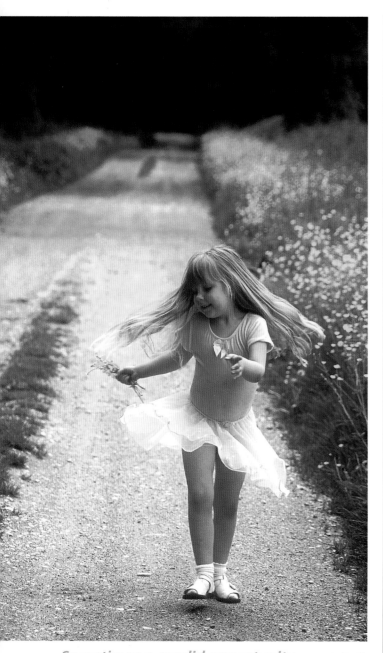

Sometimes a candid opportunity presents itself when the subject that attracts your attention is "lost" in her own world. On a country road in France, I was returning to the trunk of my car to put away my equipment following an afternoon of shooting mustard field landscapes, and I noticed my daughter Chloë off in her own little world, practicing some recent moves she had learned in her dance class. I was quick to raise the camera to my eye and fire off several frames, knowing that she would soon see me and perhaps feel too shy to continue to her "performance." An aperture of f/5.6 kept depth of field limited, and I simply adjusted the shutter speed until 1/250 sec. indicated a correct exposure.

70–200mm lens at 200mm, f/5.6 for 1/250 sec.

PLANNING & PROPS: THE ADVANTAGES OF THE STAGED CANDID

In many of the pictures in this book, my subjects were fully aware of my presence—yet I contend that many of these image qualify as candids. If only because photography is first and foremost a business for me, I rarely have the luxury of shooting true candids. I always try to have my subjects sign model release forms, and many times, I'll get them to sign a release *before* I've even taken the first picture. If I don't have the necessary release, I can't lease or sell the rights to the picture for any commercial use, and chances are good that in today's litigious society I wouldn't be protected either, even if my work were limited to gallery exhibitions. Thus, I have no choice but to announce my presence as well as my intent.

The obvious advantage to working with subjects who are aware of your presence is that you are better able to plan your shots than you would be in a truly candid situation. And many photographers often want to include props in staged candid shots. The reason for this is that props call attention to the subject's "identity" (to interests, talents, or professions). Again, this prop may, in fact, have nothing to do with the subject, but if the casting is done well, it does indeed make the image that much more believable.

A prop can be prominent (such as a pet boa constrictor hanging about the neck of a street magician), or it can be part of a background (the '65 Mustang behind the car buff). Either way, props are useful. Let's say you see a woman wearing jeans, a flannel shirt, a cowboy hat, and cowboy boots, against an out-of-focus background of green tones. Does she live in the country? More than likely. Does she own horses? More than likely. Does she breed horses? More than likely. Does she listen to country music? More than likely. And you gather all this information *not* from the surroundings in this case, but from the props (in this case, the clothing). Is she really a cowgirl? If you believe it, then she is!

Additionally, some props (such as musical instruments, garden tools, artwork, books, fruits and vegetables, a glass of iced tea, a teddy bear, or a cell phone) can solve the problem of what to do with the subject's hands. And subjects are more likely to feel relaxed when holding familiar objects. Obviously, choose props that are appropriate for the subject. For example, don't put a shovel in the hands of a man whose fair skin and overall look screams that he spends all of his time indoors.

WHITE BALANCE & WARMING FILTER

If I could offer up just one tip that's guaranteed to deliver much more pleasing results for the digital amateur photographer it would be this: Set your white balance to Cloudy, and leave it there for *all* your outdoor photography! The reason is simple. Most amateur photographers don't rise at the crack of dawn or stay out late during those long days of summer in order to capture warm *early* morning or *late* afternoon light. Most amateur photographers find *late* morning through *mid* afternoon to be the ideal time for picture taking "because it's now bright enough." The trouble is that the light at this time of day is *not* warm and inviting but rather a bit blue and off-putting.

But when you shoot at these times of day with your white balance set to Cloudy, you will, in fact, impart a degree of warmth to your images that can often make the difference between a good shot and a great one. If you're a film shooter, then you can come really close to accomplishing the same thing by using the 81B filter to warm things up.

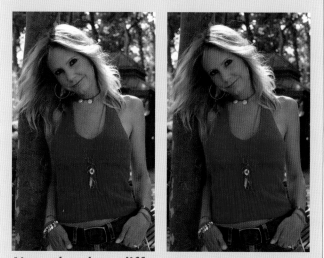

Note the clear difference between these two images of my wife, both taken around 2:00 P.M. on a summer's day. One (left) is clearly a bit cooler than the other, and since warm and inviting portraits are what you're hopefully striving for, using the Cloudy white balance setting makes even more sense. In the much warmer image (right), I set the white balance to Cloudy.

Both photos: Nikon D2X and 17–55mm lens at 55mm, f/5.6 for 1/320 sec.

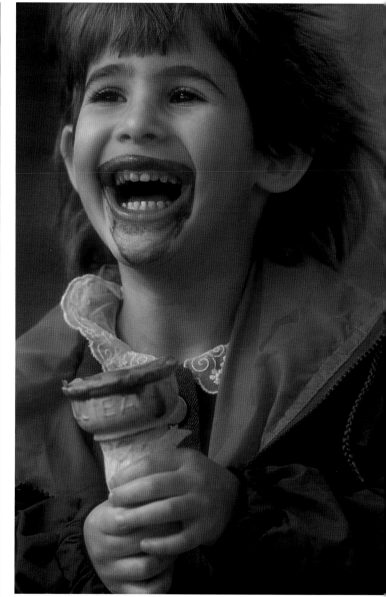

Ice cream and the chatter from a nearby friend can often make for a splendid photographic opportunity. As this little girl was consumed by laughter following the nearby antics of her friend, I fired off a number of exposures with an aperture of f/5.6 and the camera set to Aperture Priority mode. I have no problem using Aperture Priority mode when the light is evenly illuminating my subject, as was the case here. (Aperture Priority mode has the photographer select the aperture and lets the camera choose the shutter speed.)

80–200mm lens, f/5.6

Lack of [subject] eye contact sometimes enables a greater study of the overall composition.

Photographing People in Foreign Lands

Whether you travel across several continents or just across one border, the opportunity to meet new and exciting people is the fuel that drives many photographers. On frequently traveled roads, you'll find many willing subjects who are accustomed to being approached and photographed. This holds true for both the waiter at the café along the Champs-Elysées in Paris and the basket weaver on Singapore's Arab Street.

Since today's airplanes can whisk you to other continents in fewer than eight hours, and at prices that are truly cheap, many people are realizing their dreams of traveling to distant lands. But getting there might actually prove to be the easiest part of the whole trip, unless you've done a good job of preplanning. With the Internet at almost everyone's fingertips, you can pretty much get most of the essentials needed to make certain your photographic journey will be a productive one.

You can visit Web sites that offer up a flavor of the land and the people you hope to photograph. In addition, you can discover the local customs; the necessary attire, if any, for visiting certain locations; and, of course, any holidays or festivals that may interfere with your specific plans.

A NOTE ABOUT CUSTOMS

Prior to leaving the United States, you should first register all of your camera equipment with the local customs office or with the customs officials at the airport. Ask for the Certificate of Registration for Personal Effects Taken Abroad. You simply list each of your items (camera bodies, lenses, flash, laptop, and so on) and their corresponding serial numbers on the form, and then you'll get this form stamped with the customs seal of approval, after you've signed and dated it. Until you add another piece of equipment, you'll never have to fill out a new form again.

This customs form deserves the same respect and care you give your passport. It can save you hours of potential aggravation. If you lose some gear or have some gear stolen while abroad, this form allows you to provide the local police with the necessary serial numbers. But more than that, when you return to the United States, you're protected from the customs agents who may demand proof that you began your trip with that $3,000 camera system, and that you didn't just buy it in Hong Kong and aren't now trying to sneak it back into the United States without paying any duty on it. No problem, as you unfold your customs paper, which clearly shows the equipment having been registered prior to your journey abroad.

WHAT LANGUAGE BARRIER?

Depending on where you plan on going, you may need to brush up on either your French, German, Japanese, Chinese, or Spanish. If you've never spoken the native language of your destination, don't assume you'll always find someone who speaks a little English. This is classic American arrogance, and you'll find a much more receptive audience if you learn at least half a dozen words or phrases. I'm not talking about anything beyond *Please*, *Thank you*, *Good-bye*, *Hello*, *Where is the toilet?*, *Where is the*

train station?, and *Where is a telephone?*—but making an effort with these simple phrases really makes a difference.

I've traveled in more than forty-four countries, logged more than two million air miles, and if there is one thing that I've learned, it is this: When I, as an American, speak even a few words in the language of the country I'm visiting, I get treated like royalty. And yes, it's true that in most large cities all over the world, you will find someone at the hotel who speaks English well enough to help you; but once you're on the streets, who are you going to turn to? Packing one of those pocket-size language computers is a good idea for sure, as well as is buying one of those pocket phrase books and keeping it handy in your back pocket.

Or, for the ultimate experience, why not consider hiring an assistant who's a native of the country you're visiting as a guide and translator? It only takes a simple inquiry at the hotel desk (remember, this is called networking) to see if someone can recommend a coworker, relative, friend, or neighbor who has both the time and interest to take you around and be your "spokesperson." This person will, obviously, know the city or countryside better than you and, of course, will speak the language. The English-speaking people at the hotel can take it from there and get it all arranged; and whether it be for a day, several days, or a whole week, this assistant will not only make getting some great people shots easier, but he or she can also get your model releases (which you had the hotel translate and type up for you for $20) signed.

Granted your guide may not speak English any better than you speak his or her language, but at least a guide will know what you want and where to take you to get it. And you have your phrase book, so if you get in a jam, just point to that phrase you need.

So, what does it cost to hire a local assistant? I've paid anywhere from $15 to $100 for the day, depending on a given country's local economy.

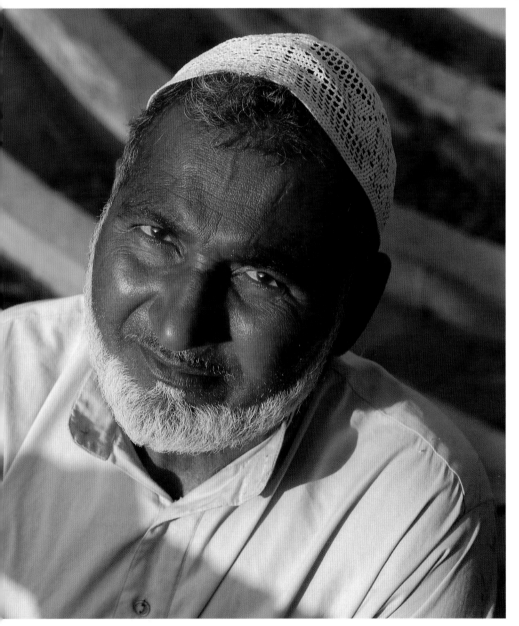

It takes a very special craftsman to build the wooden dhow boats found throughout the Middle East. It's a trade that takes years to learn and perfect. This older gentleman of Pakistani decent had been working in the dhow yards for more than forty years and had finally reached the level of master builder. Taking just a few moments from his busy day, he was happy to pose while I handheld my camera, and with my aperture set to f/4, I adjusted my shutter speed until 1/500 sec. indicated a correct exposure.

Nikon D2X and 17–55mm lens at 30mm, f/4 for 1/500 sec.

People as Themes

Most, if not all, photographers have experienced what I call *photographic depression* at some point in our lives. Whether it lasts for several days, weeks, or even months, no matter how hard we search our storehouse of creativity, we continually find that the shelves are empty. For some photographers, this lull can be downright frightening, especially when it coincides with an important event or assignment. It's an especially serious problem for professional photographers, who are expected to deliver the goods and who seldom have the luxury of taking off for an extended length of time to restock the "shelves of creativity."

When I think about my own dry spells, I find that they usually happen when I'm shooting without a purpose or theme. Although subjects for themes may come relatively easily to nature photographers, people photographers might find it harder to define themes for their work. For example, a nature photographer can easily choose from waterfalls, barns, trees, flowers, butterflies, forests, mountains, deserts, or animals for themes. But when I suggest to students whose primary interest is photo-

graphing people that they consider a theme, they often look confused. Some students respond with ambivalence; they think that a series of simple head shots would hardly be a compelling theme. I might agree that a series of simple head shots is hardly compelling, but what if those same head shots were limited to people who were bald?

The first step, of course, is to select a theme. Suppose you decide to photograph only those individuals who have a deep love of gardening. You might begin by driving around your neighborhood, taking note of the yards that look as if they should be featured in *Better Homes and Gardens*. Stop your car in front of these houses, knock on the door, and introduce yourself to the owners. Compliment the people on their yard, and then briefly explain your current photo project (shooting portraits of gardeners). Since you're proposing to photograph homeowners in an environment that calls attention to a favorite pastime, people will probably agree to pose for you. As you develop this theme over time, you'll discover surprises in your pictures that you might not have even thought of when first planning these shots. For example, you might find that most of the gardeners have weathered complexions and rough hands, wear loose-fitting cotton clothes, and seem rather tranquil in nature.

Obviously, these pictures would be vastly different from a series of shots for which coal miners are the theme. Their world is usually dark, their faces are seldom clean when they work, and their eyes often seem scarred with fear.

Children provide an opportunity to shoot a theme that's often overlooked because it's so obvious. Beginning with

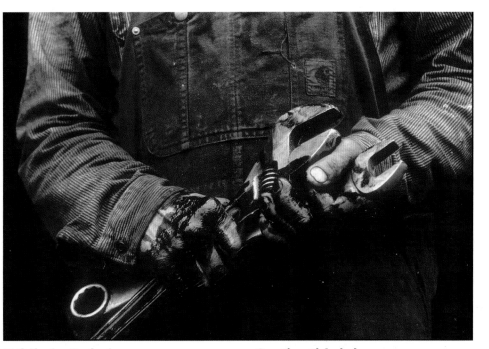

While in Dubai this past year, I visited a small town near the bordering country of Oman where I saw a young woman dressed in her customary black abaya *walking through a weathered, green door. As she opened and closed this door, I noticed that her hand was in sharp contrast to the vivid green paint and made a note of it in my mind. As luck would have it, she soon came back out that same door, and I wasted no time in approaching her. I asked her if she would "hand model" for me, and once I explained what it was I wanted, she was happy to do it. (Fortunately for me, she, like so many others in the Middle East, spoke more than enough English to understand my request.)*

17–55mm lens at 55mm, f/8 for 1/160 sec.

On the third day of a four-day *assignment at a steel mill, a maintenance worker began waving his hands in my direction, excited about a photo opportunity that he wanted to share with me. I had met him earlier in the day, and he had shared with me his passion for picture taking, being quick to point out what he thought would make a good photo on more than one occasion. Now he had just disassembled a large piece of machinery and thought I'd be interested in the abstract potential of these many parts. But it was actually his greasy hands that got my attention. When I suggested that I shoot his hands instead, he was quick to pose.*

(Note: For readers of my previous books Understanding Digital Photography *and* Understanding Exposure, *I chose a classic "Who cares?" aperture of f/8 because depth of field was not an issue.)*

80–200mm lens at 105mm, f/8 for 1/60 sec.

your child's first birthday, have the child sit on a kitchen chair and hold the birthday cake. Repeat this exact composition for the next seventeen years. The resulting images will be fun to look at and cherished for a long time.

Other potential themes: people who wear hats, have blue eyes, have red hair, drive Saabs, wear uniforms, own horses, drink beer, make homemade jam, or work at the country store. Clearly, this list of themes is endless.

HANDS AND FEET

One of my favorite themes has been the study of hands (as seen on the previous two pages), and lately I've begun to look at feet with a discerning eye, as well. I've been working on hands for more than ten years, and I see no reason to think I'm close to the "end." And now that I've begun to look at feet, I can only hope that I will be reincarnated as a photographer, since I have several lifetimes of work ahead of me with just these two subjects alone!

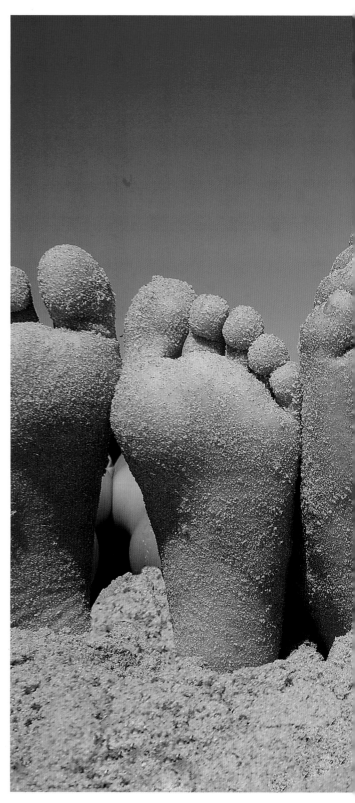

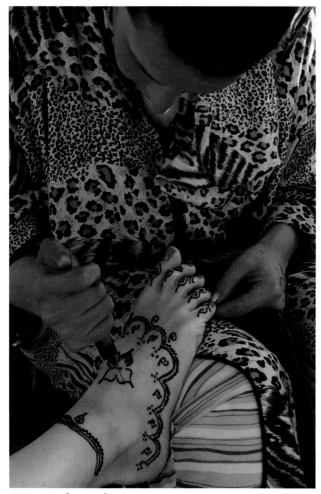

More often than not, the message is in the details, and saying more with less can make for strong images. This simple close-up made in the open market inside the Medina of Marrakech is an image about hands and feet that speaks of the art of henna painting. To get this composition, I handheld my camera, set it to Aperture Priority mode, and moved in close to fill the frame.

17–55mm lens at 55mm, f/11 for 1/250 sec.

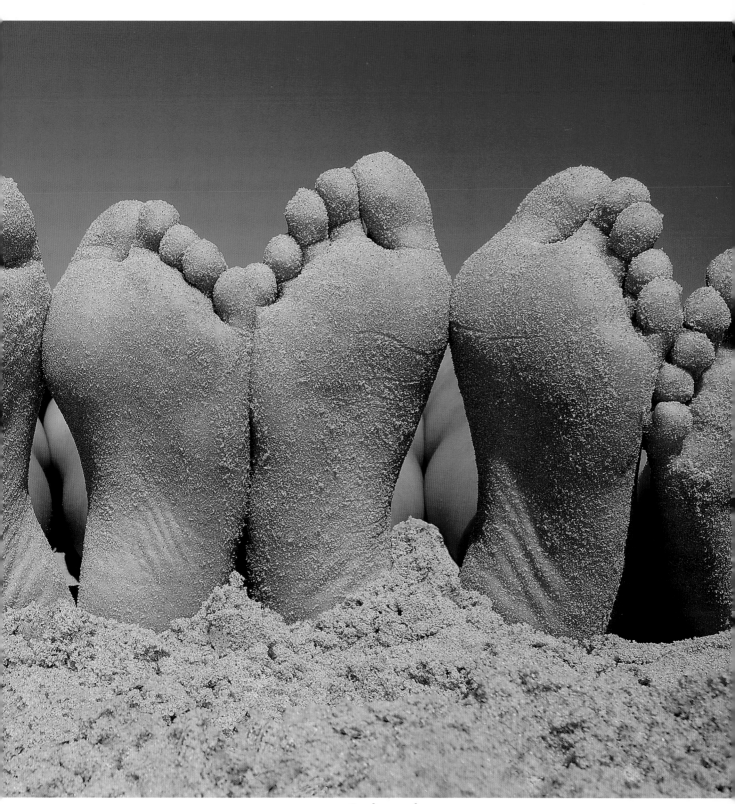

So how do you photograph a group of kids who've spent a day at the beach? You gather them all up, make a simple request that they all lay down side by side, and move in close with your camera and wide-angle lens to fill the frame with happy, fun-in-the-sun feet. With my aperture at f/16 to maximize depth of field, I simply raised the camera up to the blue sky and adjusted my shutter speed until 1/125 sec. indicated a correct exposure.

12–24mm Nikkor lens at 18mm, f/16 for 1/125 sec.

LOVE

It's said that love makes the world go around, and if ever there were a theme that has unlimited potential, this would be it. Displays of affection take a myriad of forms; a simple compliment, a card, a letter, a kiss, holding hands, a look, and, of course, a hug. And from the standpoint of commercial value, the theme of *love* is high on the "want list" of stock photo agencies worldwide. Since love crosses all cultural and ethnic boundaries, it is truly one subject that can be found worldwide.

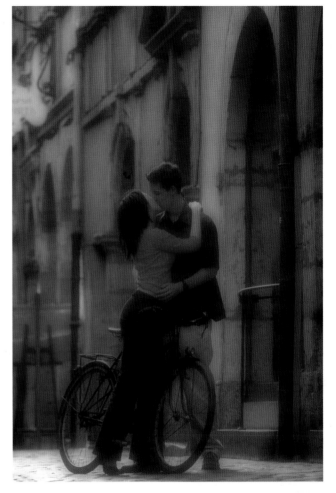

EXERCISE: USING PEOPLE TO EXPRESS A CONCEPT

In addition to using props to make your subjects believable in the roles you assign them (see the exercise on page 33), I want you to also consider using people as "props" to convey ideas. Find the appropriate people to convey the concepts in the list below. Which person you use and that person's relative size in relation to the overall picture frame will go a long way toward the success of your images. Should the subject be a man, a woman, or a child? Should the subject be casually dressed or in formal attire? Should the person be large in the frame or miniscule? The choices are yours, of course, since you are, after all, the casting director as well as the photographer.

- It's not the load, but the way you carry it, that causes the breakdown.

- It's lonely at the top and that explains my desire to achieve nothing.

- A journey of a thousand miles begins with one step.

- Climb the stairway to the stars one step at time.

- Patience is the companion of wisdom.

- No sky is heavy if the heart is light.

- When our memories outweigh our dreams we have grown old.

- Great works are performed not by strength but by perseverance.

To capture this couple on a bench at Coney Island in New York, I simply handheld my camera, set my aperture, aimed, and shot several frames with the camera in Aperture Priority mode.

70–200mm lens at 200mm, f/11 for 1/320 sec.

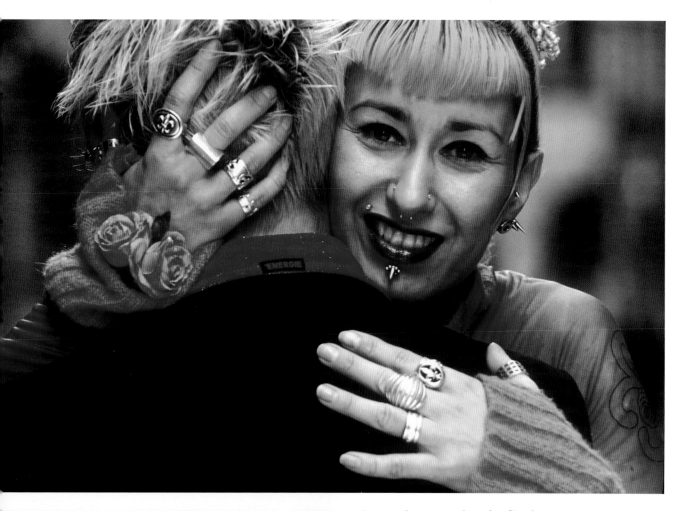

Sometimes, I simply find a street corner and stay put for several hours. I learned long ago that, more often than not, if I stay put, more than enough subjects will cross my path—rather than me constantly being on the go, hoping to find something. That was the case with these two images. In the shot opposite, she saw him coming, stopped her bike, and within seconds they were locked in a warm embrace. With a focal length of 200mm, I was able to isolate the couple from the busy street, waiting patiently until the pedestrians crossing the street in front of them were out of frame. Due to the diffused light on this street, I also chose to shoot in Aperture Priority mode.

On that same street corner, I witnessed so many displays of affection—this was France, after all. In all of my world travels, I've never witnessed more open displays of affection, with or without a camera. Having switched from the 70–200mm lens to my 200–400mm, I was better able to fill the frame with both hugs and kisses, and it certainly didn't hurt that love was in the air in the popular bar directly across the street from me. With my camera on a monopod, I was quick to fill the frame with the young couple engaged in a warm embrace above. Again, with the camera set to Aperture Priority mode, I was able to concentrate more on my composition and not give too much concern to setting the exposure—but, I was only able to do this with confidence because of the relatively even light, thanks in large part the to bright yet overcast skies.

Opposite: 70–200mm lens at 200mm, f/5.6 for 1/320 sec.
Above: 200–400mm lens at 400mm, f/5.6 for 1/640 sec.

People at Work

ost people spend a third of their life at work! Think about that for a moment. Now think about the number of times your friends have made you sit through slide shows of them at work. What slide shows?! Exactly. Most people don't have a visual record of how or where they spend a third of their life. Although your supervisor or boss would eventually fire you if you spent the entire day photographing your coworkers on company time, you can shoot during your lunch hour or coffee breaks. And because you know the other employees, as well as what goes on during the day, you have the chance to shoot both great candids and posed pictures. Thinking of the people you work with as your potential

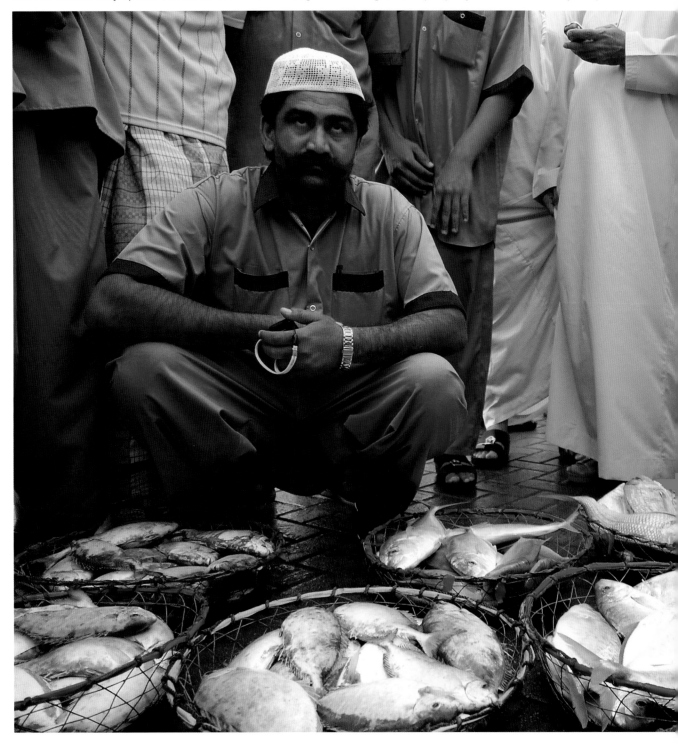

subjects rather than just coworkers you see day in and day out will inspire you as you shoot.

If ever there were fertile ground for photo opportunities, the workplace is it. Consider the wealth of subjects found outside the white-collar world: carpenters, loggers, welders, shipyard workers, farmers, cowboys, firefighters, police officers, taxi drivers, truck drivers, commercial fishermen, steel workers, oil-rig workers, garbage haulers, window washers, commercial painters, railroad workers, landscapers, and power-line workers. The environments in and around which these people work are some of the

most colorful and picturesque. Additionally, you'll find an unlimited supply of props that go hand in hand with the subject right there on location. Blue-collar professionals are an untapped gold mine not only for portraiture but also for stock photography. Furthermore, you might even be asked to shoot a corporate brochure or an annual report for a company whose employees you're shooting for your own personal work.

When you photograph people at work, you meet them on their turf, where they feel comfortable and often freely express their opinions and reveal their emotions. Workplaces can be high-pressure environments, and they're always distracting. As such, most employees are so busy they won't pay much, if any, attention to you and your camera—unless you direct them to. This is why photographers find the work environment to be a breeding ground for great candids. And people on the job are also willing subjects, grateful for the opportunity to be photographed at work so that they can finally show their spouse, friends, and family just what it is they do. After all, most people define themselves, in large measure, by their work.

You might be wondering how to approach people at work. Hang out at a truck stop, and you'll not only find willing subjects, but you'll probably be offered a chance to go on the road. The next time the garbage truck wakes you up with the loud clanking of cans, greet the haulers at the door and tell them what you have in mind. Go to a small sawmill, and ask for the whereabouts of the independent loggers working in the nearby woods. Head down to the local harbor, and make inquiries at the fish-processing plant. Visit a nursery, and ask if you can follow the gardeners to their next job. You should photograph people at work because, if for no other reason, it gives you an opportunity to see, experience, and record how other people live, especially if you don't do a lot of manual labor yourself. In addition, you'll be a bit more versed on the subject of work and why people do what they do.

The bidding is fierce *at the local fish market in Dubai. Almost without fail, when the bidding would end, this lone fish monger would roll his eyes back as if to express disgust at the final bid being paid for each of his lots. To get this shot, I chose Aperture Priority mode, hand-held the camera, set my aperture to f/16, and then let the camera set the exposure for me.*

Nikon D2X and 12–24mm lens at 12mm, f/16 for 1/60 sec.

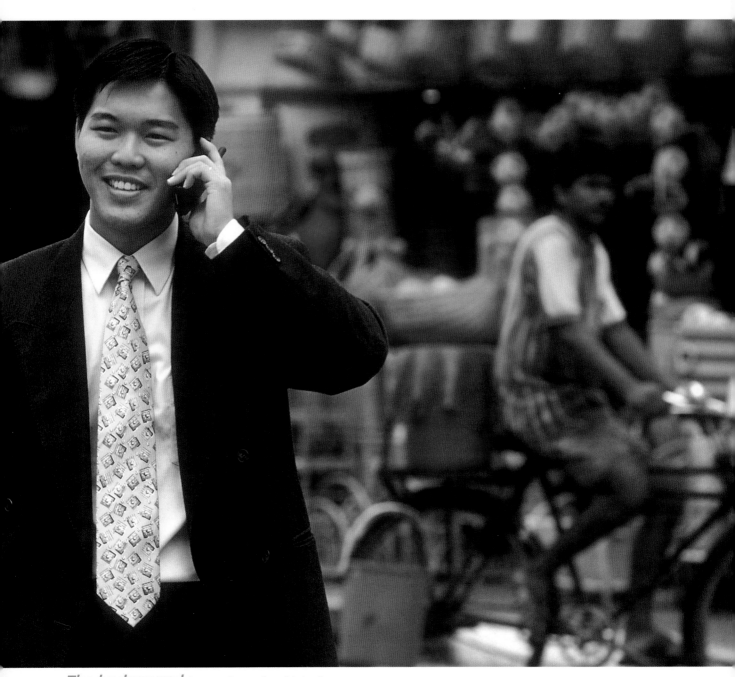

The background *lets you know that this businessman on the go is obviously not in the United States. To get this shot, I set up my camera on a tripod, and as the man walked in my direction, I fired a number of frames while at the same time refocusing the lens as he came closer and closer.*

Nikon F5 and 80–200mm lens, *f*/5.6 for 1/500 sec.

*I*f ever there were
fertile ground for
photo opportunities,
the workplace is it.

Where would the businessperson be without cell
phones and Palm Pilots? Keeping up on the expense report is
a daily task for many businesspeople, whether they're simply
on the road in their home city or halfway around the world.
With the help of my tripod and an assistant holding a reflector
to provide fill light, I shot a number of poses and exposures
of this real businessman I had met earlier in the day.

Nikon D2X and 17–55mm lens at 24mm, f/5.6 for 1/30 sec.

People at Play

What is leisure time? Although this concept usually signifies different things to different people, it always involves pleasurable activities, such as playing in a company softball game, having a backyard barbecue, throwing a Frisbee, searching for seashells, pitching horseshoes, reading a book, fishing on a still lake, listening to music, camping, mountain biking, flying a kite, and going cross-country skiing. These are just a few of the many activities in which people participate, if only to relax and get their minds off work.

Unfortunately, the ability to effectively photograph people at play seems to elude many photographers. How many of you have had the experience of sitting through your neighbor's never-ending slide show of that trip to Maine or listening to coworkers provide running commentary as they show you each 4 x 6-inch print of their family vacations? These situations are a nuisance, because at best, very few of the pictures are compelling. Spare me the photograph of your son holding up his prized seventeen-ounce trout with your distracting jeep in the background; instead, show me a shot in which he's standing in front of the lake so that there's a clear connection between him and the location. You can also be inventive and take a picture of your son's and father's hands as they place a worm on a hook.

Outside Atlanta, Georgia, these three young men were having a great time on this very hot and humid summer day. They had been launching themselves repeatedly from the base of this waterfall into the shallow river beyond. With my camera on a monopod and a "Who cares?" aperture of f/11, I took a number of shots, this one with inner tubes in hand being my favorite. Nothing posed about it, just a pure candid.

80–200mm lens, f/11 for 1/250 sec.

Spare me the shot of you and your friends leaning on your mountain bikes; don't describe the rush you felt coming down a forty-degree incline—show it to me! With a shutter speed of 1/60 sec., pan (see page 107) as your friend zooms by. This electrifying image won't require commentary. Then show me the grandeur of the rugged terrain by photographing your friend from a distance against the large, looming mountains. I'll have no trouble understanding your thrilling adventure.

Show me the intensity on your daughter's face as she pitches a horseshoe. After mounting your telephoto lens on your camera, walk up to her and fill the frame with her face and the perspiration that has formed on her brow. Then focus tightly on the rod that the horseshoes land on; set an action-stopping shutter speed of 1/500 sec. in order to freeze the dirt that will surely fly when the horseshoe makes impact.

And, when you're photographing at the beach, get down low with your wide-angle lens and set the aperture to f/16 to tell the story about your friend in the distance gathering seashells. Then show me the collection she has at the end of her stroll; compose the photograph so that only your friend's hands filled with seashells are visible. These are the kinds of memories everyone wants to capture on film.

Of course, you can argue that this is your leisure time, too, and that the extra effort such shots require is just too much. This is where you're mistaken. It doesn't take any more effort to shoot a compelling image than it does to shoot a merely acceptable one. Although you'll have to think a little bit more, this isn't devising a way to end world hunger. The rewards of your creative thought process will last much longer than the "toll" it takes on your mind and emotions.

A family bidding farewell to another fun day at the beach provides a photo opportunity. If it's your own family, you can simply have everyone get into position while you set up the camera and tripod, and if you use a self-timer, you can join them in the shot. For this composition, I chose to get down low and "push" the family higher up into the sunset sky. I used an aperture of f/22 to maximize the depth of field and adjusted the shutter speed until 1/15 sec. indicated a correct exposure for the backlit sunset sky.

Nikon D2X and 12–24mm lens, f/22 for 1/15 sec.

Children

have yet to meet a photographer who didn't agree that children are the easiest subjects to photograph. They seldom refuse to pose, they aren't likely to stiffen up, and they never ask for payment in the form of pictures.

Children are a source of boundless energy, creativity, and imagination. It wasn't until my children were born that I learned many valuable lessons, not the least of which is that they don't remain children for very long. And what's true for me is true for every parent: Time flies when you have children. So make the extra effort to record, at the very least, the truly big events in your children's lives.

Babies and toddlers are, perhaps, photographed more than any other age group of children. If I could make only one recommendation about photographing children, I would tell you that from the time your child is born, you should have your camera ready at all times. As the months and years go by, you'll record some memorable and touching photographs, and your child will become very used to seeing you with your equipment. As a result, your child won't freeze up when being photographed.

When there is any frustration involved in photographing children, it comes from their inability to take direction. This problem arises more often than not because they are, often, too self-absorbed to listen to you, or they're just plain tired. You'll sometimes need to distract them. Here's one technique: With your telephoto lens on your camera, and the exposure and focus set, cue a friend to lift a pet out of a cardboard box. Your child's expressions will range from surprise to delight to fear to joy as you fill the frame with their expressions. Just keep firing away.

Another idea that has worked well for me is to give the child a toy or doll. Then ask the child to tell you the story behind it. Trust me, most children speak volumes when asked to. If you don't have a prop handy, ask them where fish live or how high they can jump or what shapes they see when they look at the clouds or what their favorite cartoon characters sound like.

When my children were between the ages of 3 and 5, I had numerous conversations with them during which I kept my camera to my eye, shooting their various expressions at will. This routine actually began as a poor man's substitute for a camcorder. These sessions proved to be wonderful experiences. I have a wealth of images that show my children's ever-changing faces and expressions during this time of rapid growth. Children are children for just a very short time, so take the time and make the extra effort to photograph your children not only on special occasions but in ordinary, everyday situations, as well.

When my daughter Chloë was around a year old, she developed such a love affair with her shiny new red rubber boots, she refused to go anywhere without them—rain or shine. She even insisted on wearing them while she took a bath. That probably never would have happened had my wife, Kathy, not been out of town; so, into the bath she went, red boots and all, but not before I fired off several frames of her traipsing up and down the hallways in our home. With a single-head studio-type strobe set up behind me and pointed into the corner where the wall and ceiling met, I was assured that the flash output would evenly illuminate the walls and hallway. Using my flash meter, I got a reading of f/16. With my camera set to the flash sync speed of 1/250 sec., I proceeded to record a number of images on slide film as Chloë walked somewhat impatiently back and forth in the hallway. It is, for me, one of those memorable, cute, and funny images that, more often than not, kids—and only kids—are capable of delivering.

It was only minutes later that I took the single-head strobe into the bathroom and set it up once again in a corner with the head pointed into a corner where the ceiling and wall met. After taking my flash meter reading, I set my flash sync speed to 1/250 sec. and the aperture to f/22. With my 105mm lens, I was able to move in closer and capture this frame-filling image of Chloë's disdain at having her hair washed, again on slide film (opposite page, below).

Left: 24mm lens, f/16 for 1/250 sec., Kodak Lumiere 100
Opposite: Micro Nikkor 105mm lens, f/22 for 1/250 sec., Fujichrome 100

Like so many other babies, Chloë too was fascinated with toilet paper and how it so easily rolled out. On more than one occasion she would unwind an entire roll of paper, and if you've ever tried to roll it all back, you know it's an almost hopeless proposition. Deciding to take advantage of a photo opportunity (the reprimand would have to wait), I set up a single studio strobe head in the bathroom one morning before she awakened, and knowing how predictable this behavior had become, I was ready. Sure enough, shortly after breakfast, she started making her rounds, which included a stop in the bathroom to unwind the toilet paper. I fired off several shots to her obvious delight.

Nikon F5 and 24mm lens, f/16 for 1/250 sec., Kodak Lumiere 100

Hiring "Models"

When amateur and even some professional photographers hear the word *model*, they immediately assume the discussion centers around a gorgeous, tall, slender woman in her late teens or early twenties. Experienced location and studio photographers, however, know that the term *model* refers to anyone—from a baby to a senior citizen—who fits an assigned role and is capable of expressing the desired emotion in front of the camera.

Under the Model Agencies heading in the Yellow Pages of all major cities and many smaller ones, you'll find such a vast array of talent listed that you may begin to wonder why you don't use models all the time. Many photographers are surprised to learn that the cost of hiring models is often quite low. I've never paid a model more than $100 for an all-day stock photography session. And in many cases, hiring a model costs nothing more than a few 8 x 10-inch color prints. (I usually limit the selection to three different shots; if models wants more prints, they must pay $15.00 for each additional 8 x 10.)

Along with the availability of models, and the small expense that hiring them incurs, you might find working with models appealing because both the photographer and the model can gain something from their "marriage." A new approach can make photographers' images look fresh and may even renew photographers' enthusiasm for their work. The model will get new portfolio shots and may even find a photographer who can bring out his or her best in front of the camera.

Suppose that you want to get assignment work from advertising agencies whose clients sell products geared

Some years ago, *I was hired by an advertising agency to shoot a series of ads promoting tourism in Oregon. One of the ads called for a host of models that would be used in a "typical" Oregon street scene showing the bakery, the florist, and the coffee shop side by side. It was on this particular shoot that I first met Lee Selmeyer, who was cast as the Happy "French" Baker to be photographed greeting the many people milling about the street in front of his bakery. Lee has one of those faces (and a personality to match) that makes him both disarming and trusting—and that makes him quite versatile as a model. For that reason, I used him on a number of other jobs, in addition to stock photo shoots. He can play many different roles with that very appealing face and trusting smile. I shot these images over the course of one morning, using a tripod and slide film for all three, and setting all apertures and shutter speeds manually.*

toward healthy lifestyles. These clients might include bicycle and running-gear manufacturers, as well as companies that make breakfast cereals and vitamins. As such, these companies want to show healthy-looking people wearing trendy exercise clothes and enjoying the good life because of the benefits they gain from bicycling, eating nutritious cereal, and taking the right vitamins. Unfortunately, your portfolio shows your expertise in photographing agricultural and travel subjects but includes nothing that demonstrates an ability to photograph health-conscious people having fun. Although you know you can do this, you won't get an opportunity to shoot such an assignment until you *prove* that you can, because art directors and photo editors tend to be very literal when looking for an assignment photographer. What you need is a model willing to do a *test*.

Once you are aware of a hole in your portfolio, go to a modeling agency and explain your dilemma. Chances are good that the agency will come up with a list of models who, like you, want to be hired for advertising jobs but have nothing that shows they can do this type of work. After you choose five or six models who would work, the agency calls the models to find out if they want to do a test, which simply means that they hire out for free in exchange for some usable prints. You might agree on one head shot in return for several hours of posing, or an entire portfolio of shots for several days of modeling. (Needless to say, testing models isn't meant as an opportunity for new photographers to try to hone their skills regarding *f*-stops and shutter speeds, but as a serious shooting session for experienced photographers who have a particular aim in mind.)

Regardless of why you use models, the main benefit is the degree of control that it gives you in your photography. Directing models can be an enjoyable process because these individuals want to be photographed and are usually more than willing to cooperate with you. But you should keep in mind that the extent of their cooperation rests in large measure on the tone and sincerity of your intent.

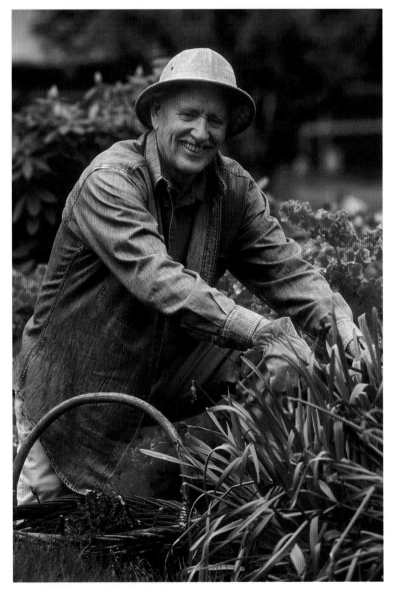

Left: *f*/5.6 for 1/250 sec.
Above: *f*/8 for 1/60 sec.
Opposite: *f*/5.6 for 1/15 sec.
All Nikon F5 and 80–200mm lens,
Fujichrome 100

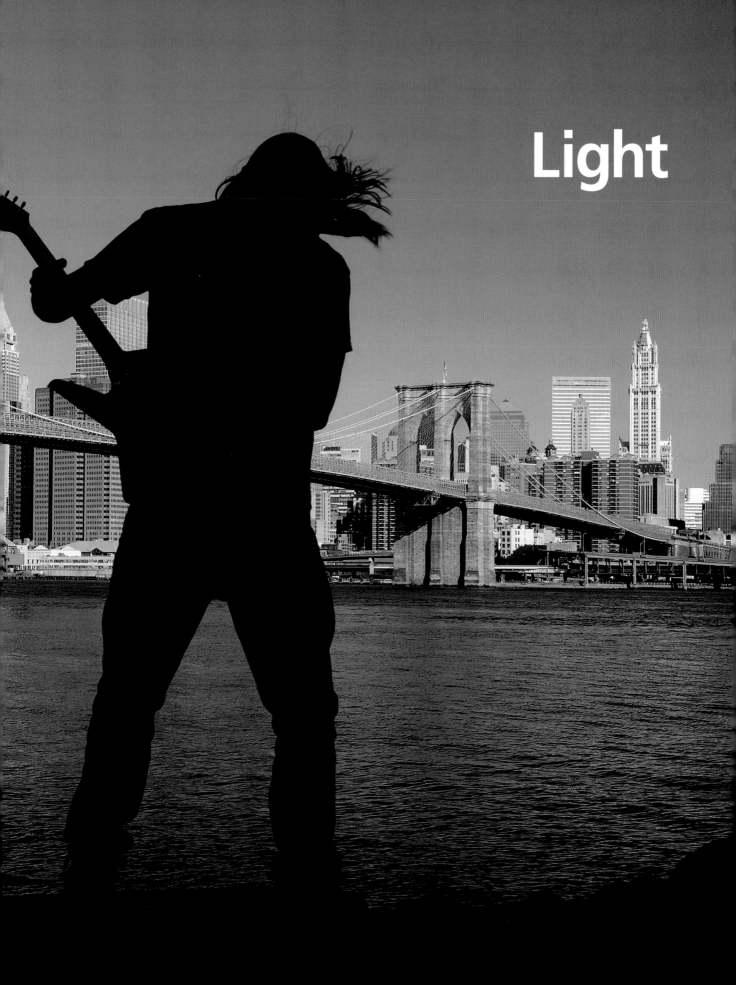

Light

The Importance of Light

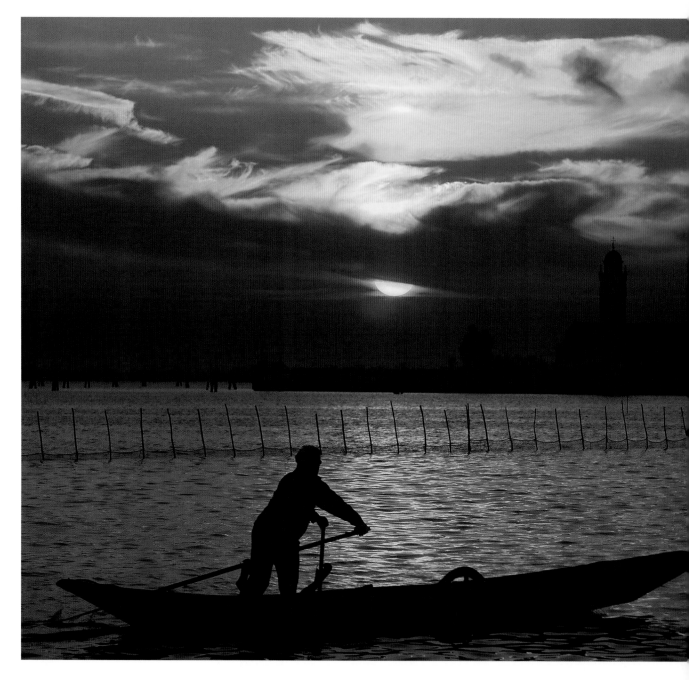

The importance of light (and lighting) can never be overstated, so I want to talk about light in general for a minute before I move on to the specifics of light as it relates to making photographs. Without light, no one would be able to see anything. For all intents and purposes, everyone would be blind.

The first light of morning assures people that a new day has begun. The proverbial light at the end of the tunnel indicates the end of a sorrowful or difficult period. Light also has a direct effect on people's emotions and can dictate their moods. Almost everyone has had the blues. Sometimes this can be related to the seasons; for example, a common type of depression often occurs during the winter months, when light levels are at their lowest.

Whether it is harsh, gentle, glaring, or diffused, lighting plays the greatest role in determining the mood of an image. When you photograph a mean-looking woman under diffused light, you temper her appearance. Similarly, by photographing a meek-looking young man under harsh light, you can make him seem a bit cold and aloof. Both subjects would, of course, say *That isn't me!*

Sunset backlight *silhouetted this woman returning from a day at local oyster beds and also provided a beautiful range of colors.*

Nikon D2X and 70–200mm at 100mm, *f*/16 for 1/250 sec.

In a small village in Belgium a few years back, I was awakened one morning in my hotel room by the sounds of cows outside my window. Looking out to the street below, I saw hundreds of cows milling about. (I later learned that there was an open cow market every first Saturday of the month in the village.) I rushed outside with my camera, monopod, and 300mm lens. This would be a great focal length to capture candid portraits but still keep myself at a safe "psychological" distance from my human subjects and a safe physical distance from the raucous cows—while allowing me to fill the frame.

Among the many candid portraits I shot that morning, this one was one of my favorites due to the direct eye contact and an even, diffused light that softened all shadows. With my aperture set to *f*/5.6, I was assured that the background would remain an out-of-focus tone, thus placing all of the visual weight in this composition on the farmer himself.

300mm Nikkor lens, *f*/5.6 for 1/125 sec.

upon seeing these photographs, and for good reason. The quality of the lighting and the impression it creates in the images is in direct contrast to the way they normally define themselves.

Another important aspect of light is its direction, whether it is hitting the subject straight on, from the side, from behind, from above, or from below. To help you understand this, keep in mind how ugly and frightening people look for the fraction of a second they hold a flashlight under their chin and shine it on their face. This is a result of the light and its angle.

Photography involves three kinds of directional light: *frontlight*, which hits the front of the subject straight on; *sidelight*, which hits the subject from the side; and *backlight*, which hits the subject from behind. And then there's *dappled light*, a modified form of frontlight, and *diffused light*, the only nondirectional light, which simply means that it's evenly distributed in tone throughout the scene. Diffused light is what you get on an overcast day or from a soft box. All five types of light take on different colors and tones depending on the time of day, and the colors and tones greatly affect how your subjects are defined.

Frontlight

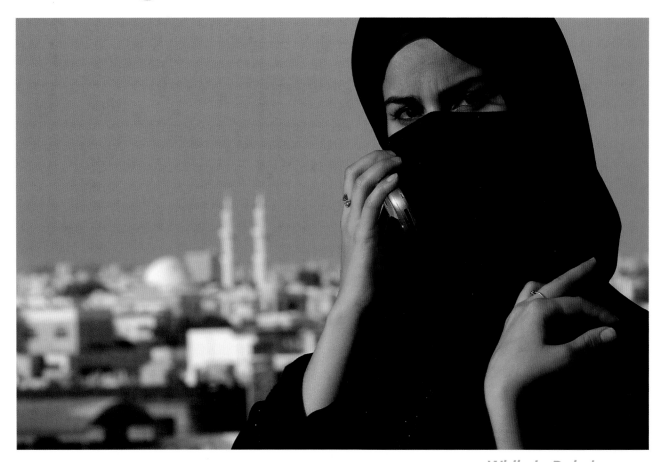

What is *frontlight*? It is light that comes from behind the photographer and illuminates the front of the subject directly, or straight on. For most of your picture-taking efforts, the light source is the sun. Since frontlight, for the most part, evenly illuminates a subject, many experienced photographers consider it to be the easiest kind of light to work with. The term *easiest* here refers to how challenging it is for the camera meter to read the light and make the correct exposure. Since a frontlit subject is uniformly illuminated, with no excessively bright or unusually dark areas, it is relatively easy to meter, and the final photograph will show an even exposure.

With today's sophisticated automatic cameras and their in-camera exposure meters, frontlit subjects, now more than ever, result in foolproof exposures. However, this doesn't mean that frontlight will always flatter subjects, you must exploit its color or intensity to help shape and define the subject's character and personality.

When experienced photographers speak enthusiastically about frontlight, most often it's in reference to its color. The two frontlight conditions that they favor most are the golden hues of early-morning light that linger for an hour after sunrise and the orange/golden tones visible about an hour and a half before sunset. These colors can add a warmth, passion, intensity, and even sentiment to a scene, depending on the age, gender, and clothing of the subject.

While in Dubai, a student of mine accepted my request to pose for some stock photos in and around the downtown area. The image was inspired by the never-ending request my stock agencies make for people all over the world using their mobile phones. From the top level of a six-story parking lot, I was able to compose a frontlit scene that included a Middle Eastern-type background to give it a sense of place and to complement her traditional attire, the abaya. Since the scene was frontlit throughout, both she and the background were a simple exposure. With the camera in Aperture Priority mode, I chose the aperture and let the camera determine the correct shutter speed for me.

Nikon D2X and 70–200mm lens, f/5.6 for 1/500 sec.

An assignment in Mexico afforded me one of my better opportunities to photograph people. I was assigned to shoot portraits not only of the men who worked in an open-pit gold mine, but also of the mine's laboratory workers, the surveyors, the mechanics, the explosives experts, the geologists, the office staff, and even the cooks who ran the huge on-site cafeteria.

Of the many people I photographed, perhaps none was more memorable than Edgar. He was one of the mechanics, and no matter how hard he tried to be "serious" for the camera, he couldn't help but burst into laughter every time I fired the shutter. Since the client was looking for images to convey the seriousness and commitment of the employees, I felt Edgar's chances of getting his fifteen minutes of fame in the company's annual report were going to be extremely slim. But on a personal note, I found his laughter to be a great gift, since more often than not, it's like pulling teeth to get most people to be this spontaneous in front of the camera. This shot is also a good example of the golden, early-morning frontlight that makes getting up early worth the effort. In addition to Edgar's great smile, the warm glow on him and on the large metal container behind him is part of what makes this image so appealing.

As I figured, Edgar did not make it into the company's annual report, but I'm pleased to report that this image has sold very well with one of my stock agencies (and made the cover of this book), giving Edgar his fifteen minutes of fame over and over.

Nikon F5 and 80–200mm lens at 200mm, f/5.6 for 1/400 sec., Kodak E100VS

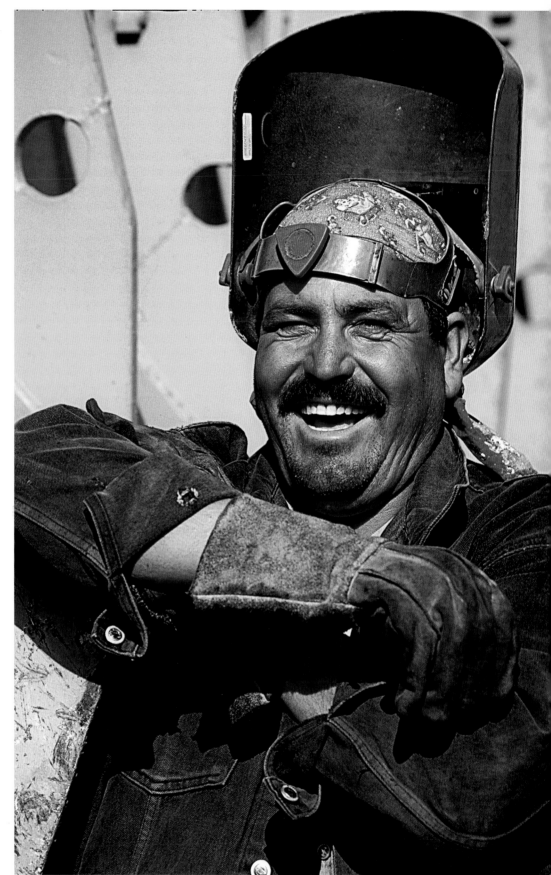

Sidelight

Sidelight hits a subject from the side, illuminating only half of the subject and leaving the other half cloaked in darkness. The combination of light and shadow creates contrast and makes this type of lighting powerful. In fact, sidelight is, by far, the most dramatic type of light. Subjects veiled in sidelight can suggest deception, danger, privacy, intimacy, and intrigue. The interaction of light and shadow reveals and defines form, as one side of a subject's face or body is illuminated while the other side is left in shadow.

When experienced photographers want to render the textures of rough hands or wrinkled faces, for example, they illuminate the subjects from the side. They also know that when they shoot outdoors, sidelighting is most pronounced and effective during the early morning and the late afternoon.

Sidelight offers you a range of exposure options. For example, you might want to overexpose the highlights, thereby showing subtle details in the shadows. Or, you might decide to underexpose the highlights so that you can turn shadow areas into seemingly infinite dark spaces in the final image. And in another case, you might want to arrive at some point in the middle. If so, you need to bracket exposures, a technique that I rarely endorse anymore since almost everyone has gone digital. But if you are shooting film, then to bracket you simply take an initial meter reading of your subject, shoot that indicated exposure, and then shoot two more at the following settings: 1 full stop over the indicated exposure and 1 full stop under. But again, if you're shooting digitally, and if you're shooting in raw format, you can fine-tune the exposure in postprocessing.

Seated next to *a large south-facing window on the main staircase of an apartment building, my daughter's friend Capucine eagerly accepted my request to take this simple yet compelling portrait of her. It owes its impact to the power of sidelight. The tension between light and shadow mirrors the tension between what has been and has yet to be revealed —and perhaps nowhere is this truer than in the face of our youth, who are filled with potential and possibilities.*

I used Aperture Priority mode here, so I set my aperture (to f/8) and simply aimed, composed, and took the shot, allowing the camera to choose the shutter speed for me.

Nikon D2X and 17–55mm lens at 55mm, *f*/8 for 1/30 sec.

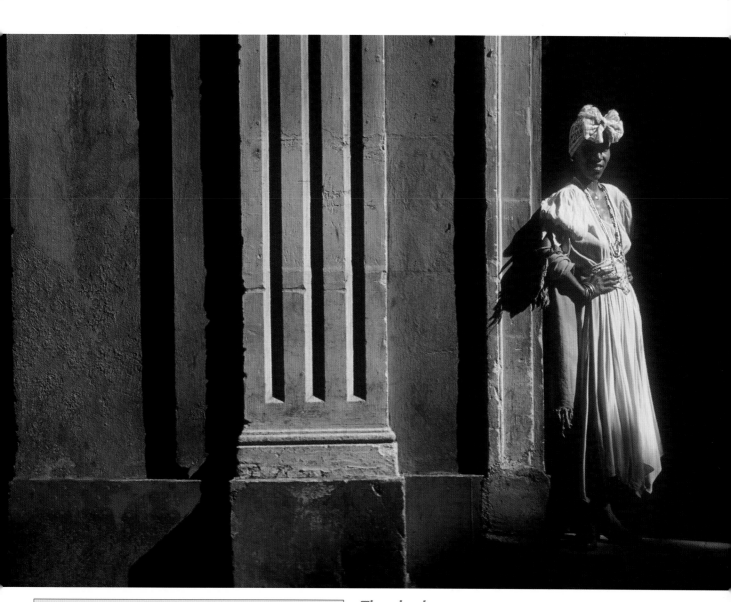

EXERCISE: UNDERSTANDING THE EFFECTS OF SIDELIGHT

This is a brief exercise, but a useful one nonetheless. Take an orange into a dark room, and light it from the side with a flashlight. You'll see an orange that has volume and depth. You'll also see that only one side will be clearly recognizable; the other side won't be visible. If you shine the light directly on the orange from the front, you'll see a complete shape.

Keep the effects of sidelight—the contrast of shadows and highlights, the three-dimensionality—on the orange in mind when you are looking at people so that you can recognize sidelight when you see it and make good use of it.

The shadows that a sidelit scene presents create the illusion of depth as form is revealed. The combination of light and shadow also reveals a drama of what is seen and what is not yet revealed. It's a light that's filled with tension. Here, the early-morning sidelight cast its warm glow across the front of a hotel in Jamaica while one of the door greeters relaxed out front. With my camera on a tripod, I framed up this woman in her hotel dress at an aperture of f/11. I then pointed the camera at the sidelit wall next to her and adjusted my exposure until 1/250 sec. indicated a correct exposure.

80–200mm lens, f/11 for 1/250 sec.

Backlight

If the sun is in your eyes as you are taking a photograph, your subject is in *backlight*. Regardless of what type of camera you use (film or digital), if your subject is backlit, it will, in all likelihood, record as a silhouetted shape—meaning it will be devoid of all details, such as color, texture, and form. If your subject is a person, details like age, skin color, and attire will be lost.

The stripping of a subject's individual characteristics might explain why many experienced photographers prefer not to shoot silhouetted subjects—since silhouettes usually reveal nothing about a person's character. I couldn't disagree more (yet I have to admit that a simple head shot rendered only as a silhouetted profile does little to offer up much detail about how that person really looks). I feel that when you incorporate elements into the composition that relate to the subject, the statement about this person is actually emboldened by the power of the backlighting. Sunsets and sunrises are the most obvious backlighting situations in which this is evident.

Lens choice has the most impact on determining exposure for silhouettes. Today's film and digital cameras do a great job of metering backlight situations, and this is particularly true when composing a backlit scene with your wide-angle lens. Since the size of the sun is reduced via the angle of the lens, you're free to simply aim, focus, and shoot; for those of you who shoot in Program, Aperture Priority, or Shutter Priority modes, this should be music to your ears.

And, yes, there are numerous wide-angle backlit opportunities out there, but most—if not all—of us are hungry for those backlit scenes in which we record that big orange ball as it meets the horizon. It's at these times that you must pay special attention to metering. When you use a telephoto lens with a focal length greater than 80mm, *always* take your meter reading off the bright sky to the left of, the right of, or the sky above the setting or rising sun. (If you meter directly into the sun, you'll record an exposure that's often much too dark.) Assuming you're in manual exposure mode, and assuming you've determined that the composition before you has few depth-of-field concerns (i.e., an f/8 aperture is okay), then all you have to do is point the camera to the left or right of the sun and adjust your shutter speed until the camera's meter indicates a correct exposure. Then recompose and voilà, a perfect backlit exposure. When you take the meter reading before recomposing, make sure the sun is not in your viewfinder.

If you insist on shooting backlit scenes in autoexposure mode, then you would still meter to the left or right of the sun; you would note the exposure so that when you recompose the scene with the sun in it, you can call on the autoexposure overrides to get you back to the exposure you noted when metering without the sun in the scene.

If this sounds like a hassle, it is. And although it works, it takes a few seconds longer than shooting in manual mode—and those few seconds could cost you the shot. Furthermore, you may forget to set the autoexposure override back to *normal*, and before you know it, you've shot a number of other shots that are "off" in their exposure. You'll then find yourself spending time in Photoshop or some other photo-editing software trying to salvage these bad exposures. (If you don't have a grasp on shooting manual exposures, take a look at my book *Understanding Exposure*.)

Backlighting is of course *not* limited to sunsets and sunrises. Any background that's at least 3 stops brighter than the subject in front of it renders the subject as a silhouette. If the sun were hitting a wall made of corrugated metal and a person walked past this bright and shiny wall, that person would be rendered as a silhouette (assuming you took your meter reading from the brighter wall).

I'm always on the lookout for stock photography opportunities, and coming upon this lone farmer who was taking a break from working his wheat field in central Oregon provided a good one. I was quick to introduced myself and explain my intentions since the sun was within fifteen minutes of setting. I asked him to simply bend down as if he were picking wheat and also chewing on a piece of wheat at the same time. Since I wanted to record a big ball of a setting sun, I positioned myself about sixty yards from him and facing into the sun, of course.

With my camera on a tripod, I pointed the lens to the empty but bright backlit sky to the right of both the sun and the farmer (opposite, top). With the camera set in manual exposure mode and the aperture set to f/11, I adjusted the shutter speed until 1/250 sec. indicated a correct exposure. I then recomposed the scene with the farmer and sunset, and shot several frames in rapid succession.

600mm lens, f/11 for 1/250 sec.

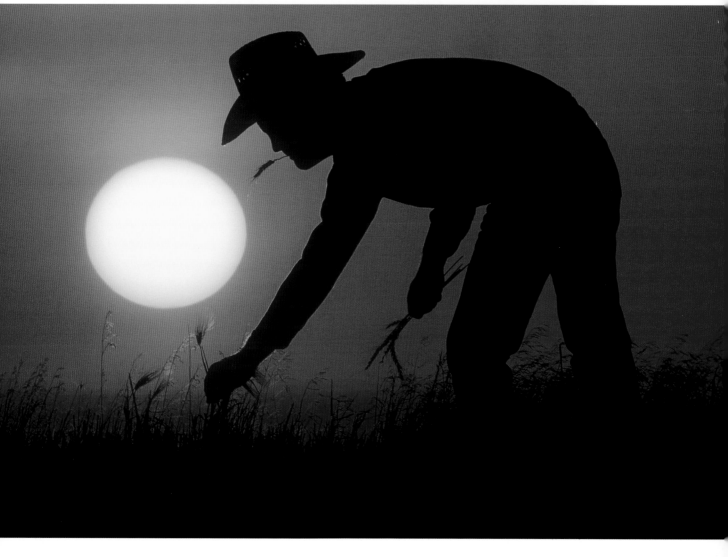

When you use a wide-angle lens to shoot backlit scenes, the sun is often apparent in the shot, but when I'm shooting into the sun using my wide-angle, I favor compositions that block much of the sun, instead only allowing a tiny slice of it to come into play in my overall composition. Compare the two images below. In the first, the sun is far too strong in that none of it is being blocked. The resulting flare is distracting and calls attention to a dirty lens (flares are an indication that there were some fingerprint smudges on the lens or that you may have an inferior lens). Note how much cleaner the composition is in the second shot. This is all due to carefully choosing a point of view that only allows a sliver of the sun's light to peak around the upraised hands.

 Rather than try to get lucky and get the shot while my subjects repeatedly high-fived each other, I asked them instead to hold their hands flush to each other, implying a high five. In that way, I was better able to control exactly where to allow that sliver of sunlight to break through, which resulted in a much bolder and less distracting backlit environmental portrait of two mountain biking friends. In both shots, I metered off the bright sky to the left of the sun and used an FLW filter to impart a deep magenta color to the final images.

Nikon F5 and 20mm lens, FLW filter, f/22 for 1/60 sec.

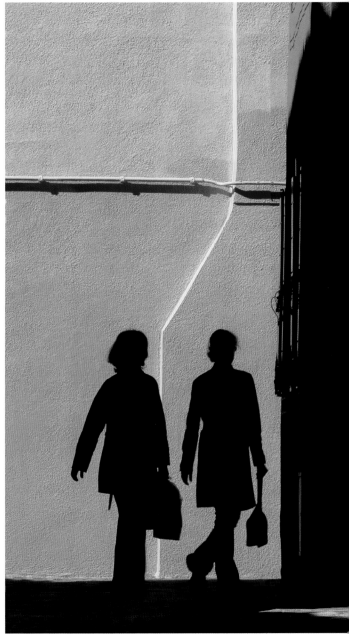

Silhouettes are certainly not limited to sunrises and sunsets. Any situation in which the background is much brighter than the subject in front of it (a 3-stop difference or more is good) will render the subject as a silhouette—assuming, of course, that you're setting your exposure for that much brighter background. One of the lessons I try to drive home in my workshops around the world is the need to see these kinds of lighting situations (and take advantage of them, of course).

While leading a workshop in Venice, Italy, I was presented with just such an opportunity on the colorful island of Burano, which is a forty-minute ferry ride from Venice. As the early-morning or late-afternoon sun lights up the island, the narrow streets and alleyways create what I call shadow pockets. These combinations of light and dark allow for some stunning exposures not only of extreme contrast but also, in Burano, of very vivid color. To make this exposure, I metered off the early-morning front-light that was reflecting off the colorful houses. Since my exposure was set for the subjects that were in sunlight (the woman hanging laundry and the colorful houses), then any subjects in that nearby shadow pocket would be severely underexposed and, therefore, rendered as silhouettes.

70–200mm lens, f/16 for 1/125 sec.

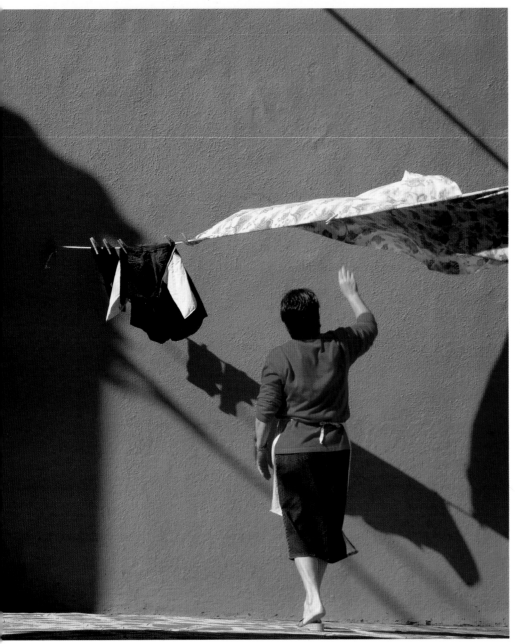

BACKLIT BUT NOT SILHOUETTED

One of the more common questions I get from students deals with the subject of backlit portraits. People want to know how, if the sun is behind the person they want to photography, to avoid recording a silhouette and render the details of that person's face and character. Experienced photographers use a reflector most of the time in these situations. A reflector is nothing more than a white, gold, or silver piece of fabric attached to a pliable ring that allows for a quick and easy setup. A reflector that's ten inches in diameter when stored in its zippered pouch opens up to thirty inches (and weighs almost nothing, by the way).

When you aim this reflector into the sunlight, it acts in many ways like a mirror, bouncing the light right back toward its source; however, it's not the sun you want to reflect light back into but the subject facing you. So, when you use a reflector it's, in effect, like having *two* suns: one that backlights your subject (the actual sun) and one that frontlights your subject (the reflector). Studio photographers have been using this two-light-source approach for years, so why not you?

Once you've reflected the sunlight back onto your subject's face or body using the reflector, it's equally important that you move in close to set an exposure for the light that is now hitting him or her. Even if you're so close that you can't get your subject in focus, don't worry since you're only interested in determining the exposure. So, with the right aperture in place (which you determined based on your depth-of-field concerns), you simply fill the frame with the reflected light and adjust your shutter speed for a correct exposure. Assuming you prefer the ease of manual exposures in these situations, you now simply recompose the scene before you and shoot at this exposure.

There is, of course, one other concern: Who is in charge of holding the reflector? If you don't have four hands, then this is a good time to bring someone along to be your "grip." This person's job is to hold the reflector. If you don't have someone who can come along, there's no reason, especially with head-and-shoulders portraits, that your subject can't hold the reflector for you.

Of all of the reflectors out there, I know of no greater value than the five-in-one reflector made by SP Studio Systems. With its ingenious zippered design, you get a reflector that's twenty-four inches in diameter, in silver or gold, and if you unzip the outer layer, you're left with a twenty-four-inch white diffuser, ideal for those shots you *have to* take at midday (since the diffuser will reduce, if not eliminate, the raccoon shadows under a person's eyes when held directly overhead). When not in use, it folds into its compact pouch of only ten inches in diameter, fitting neatly inside your gadget bag.

HATS & REFLECTORS

You may discover, as I have when out and about, that hats are a popular accessory for many people. When you're photographing anyone wearing a hat, your first thought should be to break out a reflector, as it does a great job of filling in light on the face in places where darkness would otherwise normally prevail due to the natural shade the hat provides.

With the reflector now in place in the image opposite below, the difference in the light on the face is obvious. Clearly the reflector can—and does—make the critical difference between a ho-hum portrait and one that is alive!

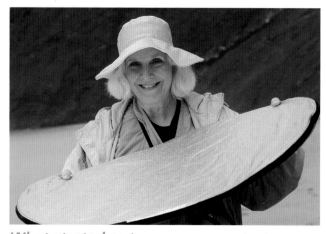

What started out years ago as an occasional accessory has now become all but a full-time tool for me. Yes, I admit, I am a reflector junkie. I can't seem to take a single portrait without using the reflector. In fact, the reflector is right up there on the "must have" accessories list with the polarizing filter, the graduated neutral-density filter, and of course some canned air and a blower brush. If more amateur photographers would use a reflector when shooting portraits, their ratio of success would improve tenfold.

While making this image of one of my students, Kathleen Leicky, I suggested we use a reflector, and she was quick to pull her thirty-six-inch five-in-one reflector from her bag. Since my composition was only a portrait of her face, she was able to hold the reflector for me (above). You can see how much darker her face appears overall when we didn't use the reflector (opposite, top), as compared to the photograph with it (opposite, bottom).

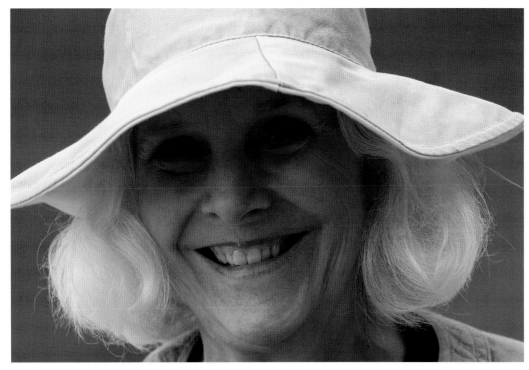

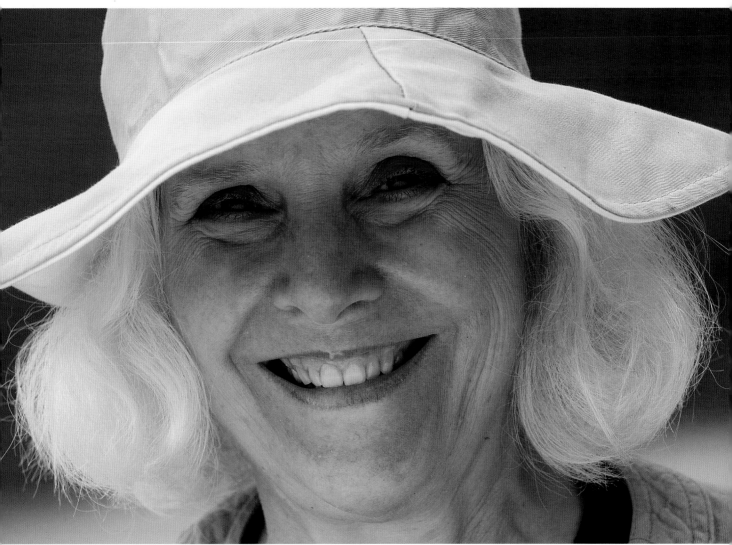

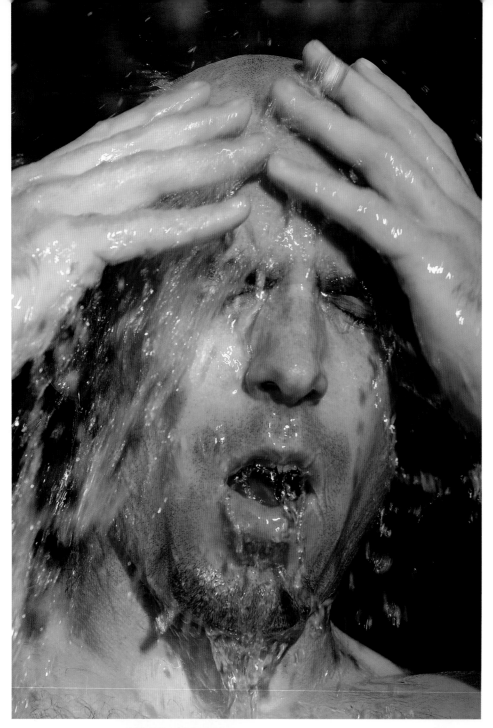

In my classes and my other books I discuss how to create a "rain" effect. Of course, I'm not working in the rain in these cases but on sunny days with the aid of backlight and a lawn sprinkler or a garden hose with a spray nozzle. I often do this with fruits, flowers, and vegetables, but you don't have to limit yourself to those subjects. The concept works equally well for people, and subjects are often open to the added benefit of cooling off on a hot summer's day.

You can get different effects with water. The first image (left) of my niece's husband, Jason, shows him cooling off while late-afternoon frontlight casts its warm glow upon him. You can really feel the texture of the water in this shot, but it doesn't look like rain. In the second example (opposite), Jason is now backlit by the same sun, meaning the sun is now behind him. Since he was backlit, I used a reflector to add fill light into those areas that may otherwise be too dark. With my son, Justin, holding the reflector, and my daughter Chloë, holding the hose, I was able to get my rain shower.

To get the rain effect, I chose the shutter speed first and then adjusted the aperture to get the correct exposure. A speed of 1/60 sec. seems to be the best for making the "rain" look as real as possible. With a slower speed, the rain streaks become too long and lose their luster, and a faster speed results in water that looks like it's from a garden hose or lawn sprinkler.

Top: Nikon D2X and 70–200mm lens at 200mm, 1/500 sec. at f/8
Opposite: Nikon D2X and 70–200mm lens at 200mm, 1/60 sec. at f/11

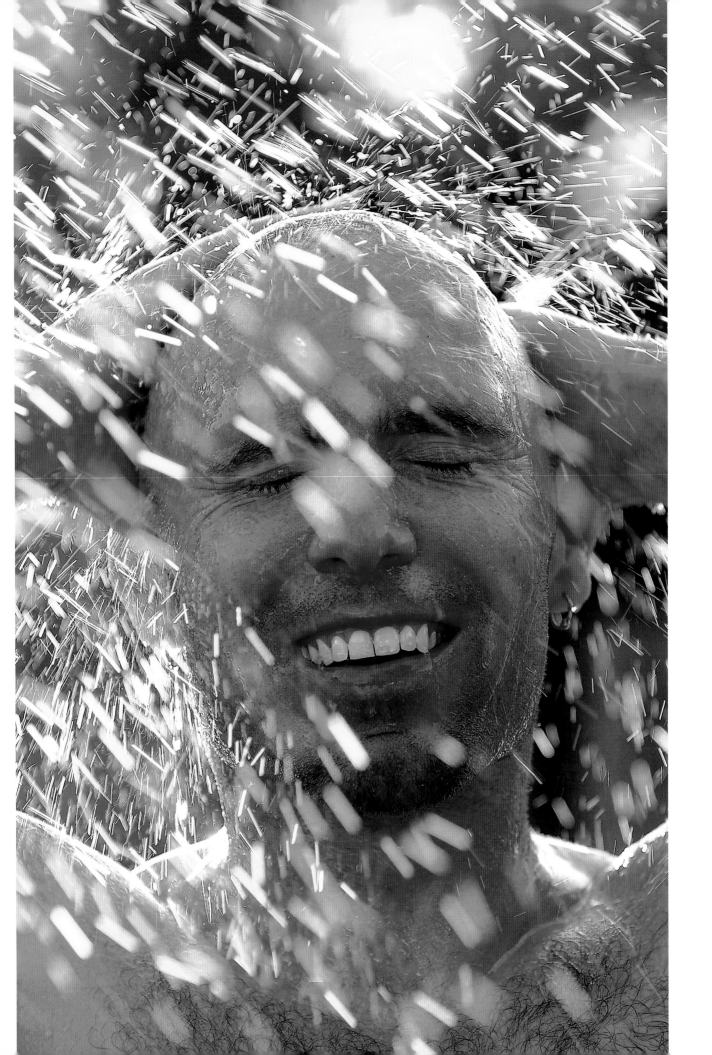

Dappled Light and Diffused Light

Dappled light is a less intense type of frontlight. Although photographers often use it in the studio, they rarely take advantage of it when shooting outside. For example, in the studio, a photographer might position a flat 2 x 3-foot board that resembles Swiss cheese two feet in front of the main light. The shapes and sizes of the cutouts in the board disperse the illumination in varying strengths onto the subject. Although the intensities differ slightly, the photographer can move the board until the brightest part of this dappled light draws attention to the key elements of the subject, such as the eyes, hands, or smile.

When you're working outside, dappled light is just as readily available, but you have to know where to look. You can, for example, find an unlimited supply at most parks. Although the shadows may not be as long as they are several hours after sunrise and before sunset, they're still present. Large maple and oak trees cast shadows across the grass, which is where you'll see a bountiful supply of dappled light. The light passing through the leaves is rendered softer but is still very directional frontlight.

When you think of different types of lighting and each type's relationship to an image's impact, dappled light has, perhaps, the most striking effect. The more the light is directed on a subject, the more important it seems, and because dappled light is a combination of light and dark tones, the lighter areas on your subject will have the greatest visual weight.

Another interesting type of lighting is *diffused light*. It is soft with subtle shadows. It makes faces look kind,

When you think of different types of lighting and each type's relationship to an image's impact, dappled light has, perhaps, the most striking effect.

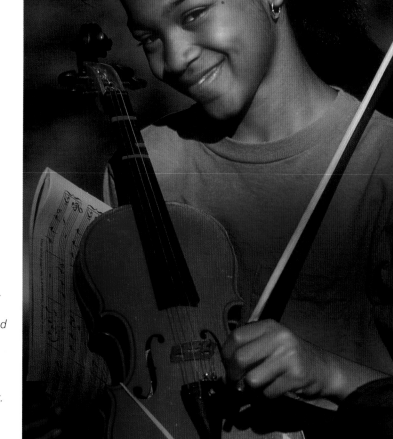

The combination of subtle highlights and shadows produced by dappled light has a kind of angelic effect. To make this image in the local park, I hand-held my camera and metered from the subtle highlights and shadows falling on her blue shirt.

Nikon D2X and 70–200mm lens at 150mm, f/5.6 for 1/320 sec.

enhances the calmness of an image, and noticeably minimizes wrinkles and other skin imperfections. And unlike frontlight or sidelight, both of which can restrict how you pose your subject, diffused light permits both you and the subject to move at will—because it's nondirectional.

Diffused light usually occurs outdoors when a high but thin layer of clouds blocks the sun, creating a sort of giant umbrella. And since it isn't harsh, you don't have to contend with subjects squinting or getting teary-eyed. Plus, nothing is easier than determining exposure when you work in diffused light: Whether you're shooting a study of hands, a face, a whole body, or a subject in a particular environment, every part of the image is uniformly lit. Thus, it's just a simple matter of "compose, aim, and shoot." There are no bright highlights or dark shadows to confuse the light meter.

Diffused light isn't identical to the illumination present when thick rain clouds fill the sky or when bright, sunny days produce areas of shade. If you look up and see the sun, you're shooting under diffused light, even if the sun is almost completely obscured. But if you look up and you have no idea where the sun is, you're shooting under the threat of rain.

Keep in mind that whether you're experiencing very cloudy skies or bright, sunny days with shadows, you must be aware that both are contaminated with a great deal of blue light. I once had a student who was feeling a bit anxious about his first "professional" assignment. He had been hired to shoot a friend's outdoor wedding. When he got the film back, the overall results were pleasing, but he had failed miserably when he shot the family portrait. Since it had been close to noon when he had photographed the group portrait on that sunny day, he had wisely chosen to move the family members to the north side of the large house in order to shoot them in open shade. The final images were far from inviting because everyone was very blue, which of course suggested coldness and distance, not warmth.

During a break from an assignment for UPS in Prague, Czech Republic, I was returning to my rental car following a visit to a local castle. The gentleman you see here was in charge of the parking lot where I had parked the car, and I was able to get a few photos of him, as well. The bright overcast day was ideal for shooting portraits, and as you can clearly see here, the detail in this man's face is rendered clearly and not "marred" by a combination of light and shadow.

I used a monopod and set the aperture to f/5.6 to keep the depth of field limited to the man, thus assuring that the background of green trees would remain out of focus. I then fired off several frames with the camera in Aperture Priority mode, letting the camera set the correct shutter speed for me.

Nikon D2X and 70–200mm lens, f/5.6 for 1/400 sec.

Composing Powerful Portraits

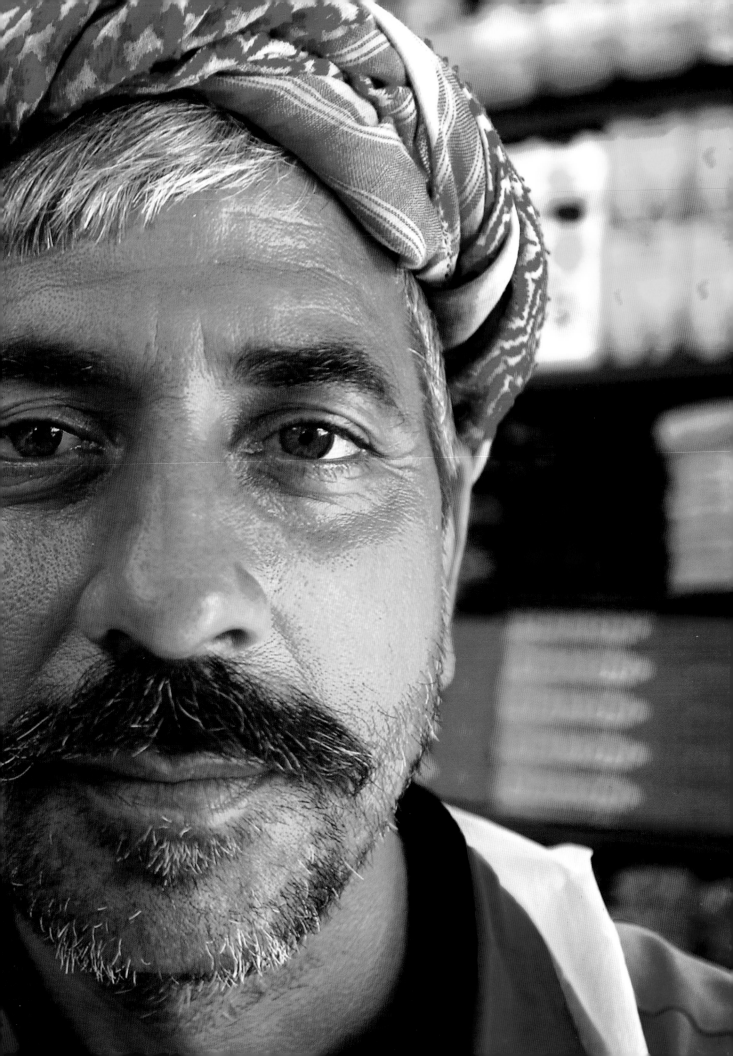

What Is Composition?

Photographic composition is based, in part, on order and structure. Every great image owes much of its success to the way it is composed, which is, in essence, the way its elements are arranged. With any good image, several variables are involved in the process of putting together a compelling composition. You can make the human subject appear small and distant against the drama that might be unfolding in a panoramic landscape. You can also decide to fill the frame, edge to edge and top to bottom, with only the crowd at a football game, cropping out the players on the field below and the sky above. You can include a background that complements the subject or, alternatively, that serves as a shocking contrast to the subject in front of it. You can also choose to emphasize a subject's weathered and worried face by moving in close, or you can step back just a bit to include the hands and face of the obstetrician whose skills have brought so many "subjects" into the world.

In addition to these choices, you can utilize two specific characteristics that dominate every successful composition: tension and balance. Tension, which is the interaction between the picture's elements, affects the viewers emotions. Balance organizes the visual elements and keeps viewers from tripping over the photograph's meaning.

As you compose, you'll discover that finding the best spot for your subject isn't always easy. This is particularly true when you photograph subjects whose environments are supposed to call attention to their characters or professions. Here, you must always be careful not to include extraneous material in the frame that detracts from the subject. For example, your '57 Chevy sitting on blocks in the driveway thirty feet behind your daughter has nothing to do with her splashing in her pool, so make sure that the car isn't visible in the frame.

EXERCISE: THINKING LIKE A VIEWFINDER

Training your eye to see the world through the viewfinder of a 35mm camera is an important step toward cleaning up your compositions. To help my students improve their compositional vision, I have them do the following exercise. You should try it, as well, as I know it will really help you develop a great eye for composition.

First, get a 5 x 7-inch piece of black poster board. With an X-Acto knife or single-edged razor, make a 2 x 3-inch cutout in the middle of the 5 x 7-inch board. Then, with the board raised in front of you, begin walking around your house or

Yep, that's me in the garbage can! I was conducting a workshop in Tampa, and my students were struggling to find something to shoot. I've done some pretty crazy stuff over the years in the name of "getting the shot," but this was the first time I volunteered myself as the subject who finds himself upside down in a trash bin. After explaining to my students what I was about to do, they all set up their cameras and tripods. (I wasn't going to miss the shot either, so I too set up my camera and tripod with the focus locked on the bin and then asked the student whose camera was right next to mine to press my shutter release with her free hand as she pressed her shutter release with the other).

Compositionally speaking, note the use of line in this image and how it creates both tension and balance. The line of the garbage cans leads the eye into the picture. (And their decreasing size emphasizes depth and perspective.) Additionally, the off-center placement of the subject creates added tension, as opposed to having it feel stagnant at dead center.

70–200mm lens, f/5.6 for 1/320 sec.

yard, making certain to look only through the small cutout—this is your viewfinder. The distance between your eyes and the viewfinder board determines which lens the board is simulating. At about one inch away from your eye, the view is similar to that of a 50mm standard lens; at about eighteen inches away from your eye, the view is closest to that of a 300mm telephoto lens.

Suppose you want to make a portrait of your son working at his computer. Looking through the cutout, move around until you see what you feel is your desired composition in the "viewfinder." Now take one more careful look. What do you see behind him, in front of him, and to the left and right of him? Your son's unmade bed, dirty socks, and rock-band poster on the wall behind him are all extraneous and distracting. By moving in a bit closer, shifting to the left or right, or getting down on your knees and looking up at things, you can eliminate parts of the scene that have nothing to do with your son and his computer.

If you do this visual exercise for fifteen minutes a day for the next several weeks, and then once or twice a month for six months after that, you'll find your compositional skills increasing substantially. You'll be training your eye to see the world through a very small window that approximates what you see through your camera's viewfinder.

Fill the Frame

As I've mentioned in one of my previous books, *Understanding Digital Photography*, when you order a cup of coffee, you expect to get a full cup, not so much because that's what you paid for but because the "composition" of the cup just doesn't look right unless it's full. Neither a half-full nor a three-quarter-full cup is enough. In much the same way, effective composition almost always demands that you fill the frame, not half full, not three-quarters full, and not even spilling over the sides, just full.

The biggest challenge many amateur, and even some professional, photographers face is getting close enough to the subject to fill the frame. You can, however, easily solve this problem. You can physically move closer to the subject, switch to a longer lens, or in some cases have the subject walk toward you.

Although it rarely happens, you can get too close to your subject, which is comparable to overfilling a cup with coffee. The most obvious example of this is when you eliminate information in the composition that is paramount to the story you're trying to convey. For example, if I were asked to shoot a portrait of a mechanic and the prized 440 horsepower engine he just overhauled, I would include the man as well as his engine in

My daughter Chloë was happy to "pose" for me as she took a relaxing dip in the hotel pool. Sitting on a nearby lounge chair, and handholding my camera, I framed the first image you see above, choosing to shoot at a "Who cares?" aperture of f/8 with the camera in Aperture Priority mode. Unfortunately, I failed to fill the frame. The eye is quick to figure out that this image is about Chloë, due to her being the only subject in the frame, but the eye is also quick to get restless and "leave"; it knows that if the emphasis is on Chloë, it should see much more of her filling that frame. In effect, the frame is akin to a cup of coffee, and as with a half-filled cup, the distant subject makes tyou feel cheated. The solution is obvious: I needed to get off my duff and simply walk closer to her until the "cup of coffee was filled" (right).

70–200mm lens, f/8 for 1/320 sec.

the photograph. Showing only the mechanic with his arms crossed, holding a socket wrench, would leave out a critical element of the scene: the engine. Similarly, suppose you want to shoot a portrait of a sculptor. Since the artist's hands are what help to define the individual's profession and character, it would be unflattering and completely inappropriate to move in so close that you leave the hands out of the composition.

Filling the frame often means getting closer to the subject, and you can achieve this most easily by simply walking closer. Initially when starting out, make it a point to get in so close that you are cutting off the person's ears and even forehead, and at this point you can begin to think about backing off a just a bit if you feel this would benefit the overall result.

Although it rarely happens, you can get too close to your subject.

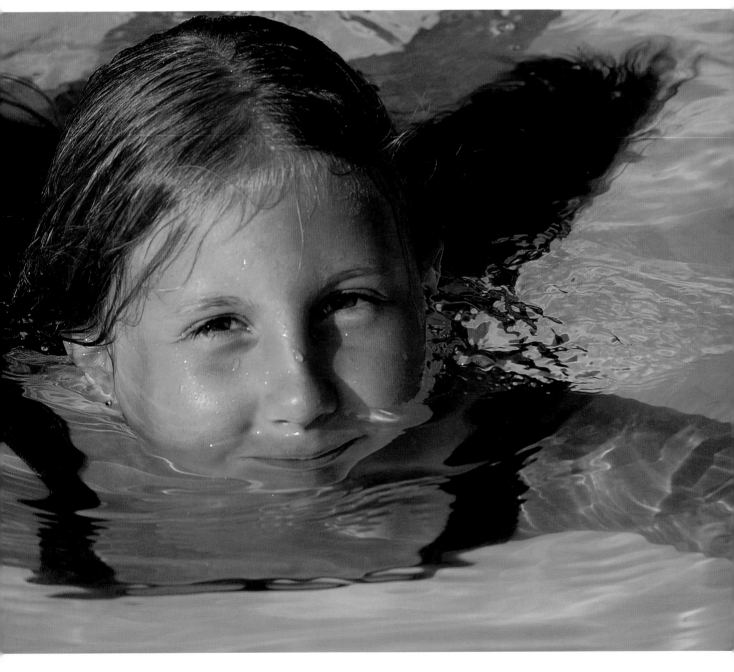

The Vertical Format

Another common compositional mistake amateur photographers often make is forgetting to place naturally vertical subjects inside a vertical frame. In my workshops I see overwhelming evidence that students simply don't consider shooting nearly enough verticals, and more often than not, the horizontal compositions that they do so often shoot are a mere "vertical composition" away from being true prizewinners!

Some students are quick to point out that they can easily crop into the image and "save it" from the cutting room floor. But truth be told, the quality of the overall image will suffer, since the 8 x 10-inch print made by cropping won't be as sharp, and it certainly will never make it in the commercial world as a stock photo—too small. So, the best time to correct this common format mistake—as well as any other common mistakes made by the amateur photographer—is *now* and in-camera while you're there before your subject. It is *not* the job of Photoshop or other photo-editing software programs to come to your rescue in either the exposure or compositional arenas.

Oftentimes, the trouble with placing a natural vertical inside the horizontal frame has everything to do with "extra" stuff that now competes with your subject on both the right and left sides of the composition. Simply turning the camera to a vertical position enables the photographer to clean up the sides by simply *not* including them in the vertical composition. I know of no better and quicker way to crop an image than doing it in-camera.

Once you become more familiar with considering which subjects should be horizontals and which should be verticals, you will soon discover that some subjects can be shot either way—and why not? This discovery can offer up great rewards down the road should your photographic skills take you into the arena of commercial photography. Getting into the habit of taking both horizontals and verticals can eventually pay handsomely, as you're then able to show assignment clients how thorough you can be, and if not with assignment clients, you're sure to be a hit with any number of stock photo agencies.

As I tell my photography students, *When is the best time to shoot a vertical? Right after the horizontal!* Work it, work it, work it. Think of yourself as a sculptor and your subject as a large granite stone. With this kind of mind-set, you will soon be moving all around that "stone," chipping away at it and eventually revealing the many faces that lie therein.

My daughter Chloë
was so elated to discover what turned out to be a basket of huge strawberries at the market that she insisted I take a picture of her with one of them "just to prove how big they were." Shooting both a horizontal and a vertical of most every subject has become a very strong habit of mine—a habit I wish most of my students would get into. The reasons are many, not the least of which is that it often eliminates the need to crop onto the more common horizontal format to make a passable vertical. But there are other reasons, as well: Sometimes, the image just looks better as a vertical. Also, if I'm shooting for clients or for stock, I want the buyers to get their money's worth; offering up both versions enables me both to assure my assignment clients that I've covered all the bases and to make more stock photography sales.

Opposite: 70–200mm lens at 170mm, f/3.5 for 1/200 sec.
Right: 70–200mm lens at 180mm, f/3.5 for 1/200 sec.

The Rule of Thirds

When I took this shot in Holland, I kept the Rule of Thirds in mind. I used a small human presence to lend scale to the vast expanse of landscape before me, and I also strove to keep those people near one of the four sweet spots. All rules are made to broken, of course, but when it comes to the Rule of Thirds, you should be breaking this one the least of all.

I should also just point out that while this is not a typical portrait, it is still, in my mind, a "people picture." Don't feel bound by tradition when focusing on human subjects. Be creative.

Nikon F5 and 80–200mm lens at 200mm, f/16 for 1/125 sec., Kodak E100VS

M uch of the pleasure people have in life is based on the idea of a "sweet spot." Suppose that you get up from the couch and feel a terrible itch in the middle of your back. So you ask your partner to scratch it saying, *Over a little bit. Now down. Just a bit more to the left. Now up. Good.* That's a sweet spot. And if you're familiar with tennis, you probably know that players try to hit the ball at the sweet spot in the center of the racket.

In terms of photographic composition, there are four sweet spots, which are related to the Rule of Thirds. According to this principle, you can imagine a grid of two evenly spaced horizontal and two evenly spaced vertical lines dividing the picture frame into nine equal retangular sections. The four points at which these lines intersect are the *sweet spots*. Carefully composing so that you place your subject on one of these spots is likely to elicit a response similar to the *Aaah!* that follows scratching that itch or the *Wow!* that comes after a tennis player smashes that ace.

Perhaps the easiest and, often, the best examples of the power of the photographic sweet spot are compositions that use people to indicate scale in an awe-inspiring vista. Although a building, ship, forest, or other landscape may dominate the frame, a person placed on one of the points of intersection brings a sense of size and scope to the scene. If the individual didn't appear in the photograph, viewers would see only a massive structure or a vast open space. Thus, the subject's presence is quite important to the success of the image.

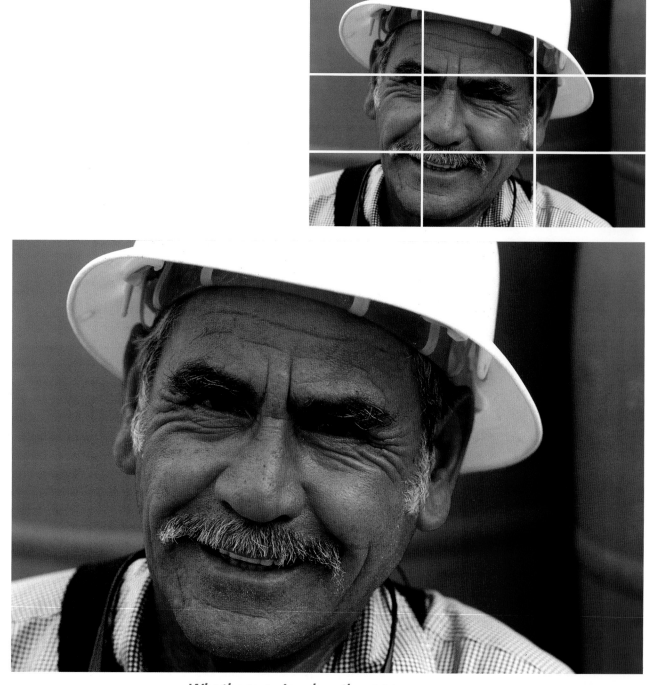

Whether you're shooting full-frame portraits or people in landscapes, you should be striving to follow the Rule of Thirds. And whether you're working in a horizontal or a vertical format, you should be striving to follow the Rule of Thirds. Note how, in both of these portraits, following the Rule of Thirds creates a pleasing balance in terms of subject placement. At least one eye falls on or very near a sweet spot, and both eyes line up on one of the grid guidelines. Both subjects' mouths also line up nicely on or very near another guideline. If you were to position the eyes directly in the center of the frame (not on a sweet spot or a guideline), the image would look more static and there would be less visual interest.

And just a note about backgrounds: For the portrait of the Chinese vendor in Singapore opposite, I used the shawl of one of my students as a backdrop. You don't have to limit yourself to what you see initially. If you don't like a background, you can often improvise to get something you do like.

Above: Nikon F5 and 105mm lens, *f*/4 for 1/160 sec., Kodak E100VS
Opposite: Nikon D2X and 70–200mm lens at 135mm, *f*/5.6 for 1/400 sec.

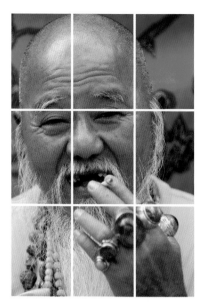

EXERCISE: SEEING THE SWEET SPOT

To train your eye to see and use the sweet spots, make a cardboard frame cutout identical in size to a 35mm film frame. Next, place a small piece of clear, hard plastic over this opening, and use a ruler to draw a Rule of Thirds grid on it. (Draw two evenly spaced horizontal lines that divide the plastic into three equal horizontal sections, and then draw two evenly spaced vertical lines, one a third of the way in from the right and the other a third of the way in from the left.) You should see nine equal rectangular boxes and four intersection points (sweet spots) on the plastic.

Use this grid to view the world for a few weeks, paying close attention to how balance is created when you place subjects on or near a sweet spot. Look at someone's face in the vertical format, and notice the results when the eyes are near the top line and the mouth is near the bottom line. If you do this exercise faithfully over the course of a few months, effective composition will become automatic for you.

Point of View

Most, if not all, beginning photographers tend to shoot everything from their eye level or from the spot where they first caught sight of a willing subject. But shooting from these points of view seldom leads to compelling imagery. For example, the cute picture of your daughter sitting on a swing would have had more impact if you had knelt down to photograph her at *her* eye level. Or, suppose you photographed a man in a brightly colored outfit at a crowded festival in Mexico City? If you had moved in closer, you would have eliminated the other people in the image who are distractions. Are your compositions often predictable, shot at eye level, and lacking any real impact? Then perhaps you need to start searching out fresh points of view.

Walking around to find new shooting positions offers you a wealth of exciting possibilities, while getting close to your subject enables you to better fill the frame (also see page 82). So, climb some stairs in order to shoot looking down on your subject. Lie on your back in order to shoot looking up at your subject. Fall to your knees and greet children at their eye level. Lie down on your stomach and frame cattle-branding through the boots of a cowboy watching the action from fifteen feet away.

Shifting your point of view is an easy way to improve your compositions.

By the same token, if you move close to a picket fence and shoot it at an angle, the repeating lines in the final image will draw the eye to the woman weeding the flower bed by the end of the fence. To eliminate a distracting background, simply move a bit left or right to hide it behind your subject. If you want to make someone look very important, all you have to do is get down low and shoot up as the subject looks straight ahead. If you want to make that same person look authoritative, keep your point of view the same but have the subject look down at the camera with folded arms. To call attention to someone's love of solitude, position the subject in a large open space, such as a park or a dry lake bed, and shoot looking down on them from a tree or rock using a wide-angle lens.

Changing your point of view about sex, politics, or religion leads to a whole new way of looking at the world. This holds true for photography, too. You can breathe new life into tired, worn-out subjects when you view them from a fresh perspective. And while changing your point of view can be scary, it can also keep life exciting and filled with adventure.

Shooting while looking down on a subject is one of my favorites points of view, whether it's from a ten-story hotel or simply from a small stepladder, as was the case with this young gymnast in China. It's fair to say that shooting down from above offers up some fresh and exciting images. Handholding my camera, and with the aperture set to f/8, I simply framed her as she looked up at me, bathed in the strong sidelight of late afternoon that was coming through a nearby window.

35–70mm lens at 35mm, f/8 for 1/250 sec.

If shooting while looking down is a new way of seeing the world around you, then you probably haven't done a whole lot of looking up at the world from below either. When I shot this image, I was quick to use the foreground "lines" of the wall studs to lead the eye to the main subject, the carpenter. The studs created wonderful leading lines, guiding the eye into the composition. I simply handheld my camera, chose Aperture Priority mode (since the scene was pretty much frontlit), set the aperture to f/22 for maximum depth of field, and let the camera determine the shutter speed.

This is one of those images that says a great deal about those periodic construction booms that America experiences; both banks and new homeowners love this image, obviously, since it's all about the American dream.

Nikon D2X and 12–24mm lens at 12mm, f/22 for 1/60 sec.

Working Your Subject

When shooting commercially, whether it be for stock agencies or a client, *working your subject* and delivering fresh points of view will not only get you noticed but will also either generate more sales (in the case of stock photography) or get you more work. And in the digital age, which most of us have chosen to embrace, worries about film costs when working your subject are no longer a concern.

To better understand what I mean by *working your subject*, think of the following string of questions: Is there a better way to shoot your subject closer (by moving nearer or changing lenses)? Is there a way to shoot looking down on it (by climbing stairs, a tree, a ladder, a bed, the roof of your car)? Is there a way to shoot looking up at it (by lying on your back or changing to a wide-angle lens and looking up)? Is there a way to make the subject look more active (by turning your camera to make a diagonal composition)? Is there a way to make the subject stand out from a busy mass that surrounds it (by combining the narrow angle of view of the telephoto lens with a large lens opening)? Is there a way to increase the subject's visual weight (by making sure your background does not fight with your subject)? Is there a way to make the subject smaller to good effect (by changing lenses, moving farther away, or placing the horizon line near the top third of the composition)? Is there a way to make the subject more dignified (by trying the vertical frame)? If everyone invested the time with each subject, really working each subject, I know everyone's photography would improve.

After walking along the beach at Warnemunde
(a resort town near Rostock, Germany, on the Baltic Sea),
I noticed a nearby hotel that was about ten stories tall.
Following several minutes of conversation with the hotel man-
ager, I was given permission to photograph from the hotel's
rooftop. (Note the point of view, looking down from above.)
This presented me with a number of possibilities, not the least
of which was to focus on the overall pattern of the rented
beach huts below me. When you're working with a pattern
such as this, it's easy to shoot lots and lots of exposures,
considering the host of compositional choices available
simply by using different focal lengths.

Left: Nikkor 75–300mm lens at 100mm, f/8 for 1/250 sec.
Below: Nikkor 75-300mm lens at 250mm, f/8 for 1/250 sec.

If everyone invested the time
with each subject—really working
each subject—I know everyone's
photography would improve.

Scale

Think of scale as a thermometer or an IQ test and it becomes apparent just how powerful a compositional tool it is. *Just how cold or hot is it? Just how dumb an I?* The answers that each of these tools provides can have a huge impact not only on one's emotions but, subsequently, on what course of action one will then choose to take. *I better wear long underwear and take a scarf now that I know I'm headed outside and it's 8 degrees! Well, I guess I'm not destined to be a nuclear physicist now that I know my IQ!*

The power of the human form is much like these tools. *Wow, is that ever a big piece of machinery!* you remark as you see the "tiny" figure standing next to it. Or, *That's a huge cliff!* as you notice the two rock climbers scaling the cliff face. Think about making use of the human form to point to the scale of the surrounding elements, whether they be big or small.

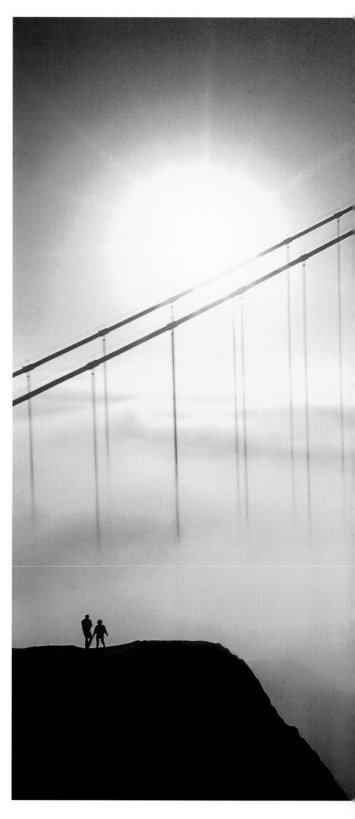

My intention was to shoot the huge rolling bank of fog around the Golden Gate Bridge the morning I made this image, but as luck would have it, a couple showed up and took a stroll out onto one of the lookout points. Without their presence this image would not have been nearly as successful, which is certainly a testament to the power of the human shape, if nothing else. There just isn't anything like it! (Note: I used a tripod and took my meter reading from the bright backlit sky to the left of the rising sun.)

Nikon D2X and 70–200mm lens at 120mm, *f*/11 for 1/60 sec.

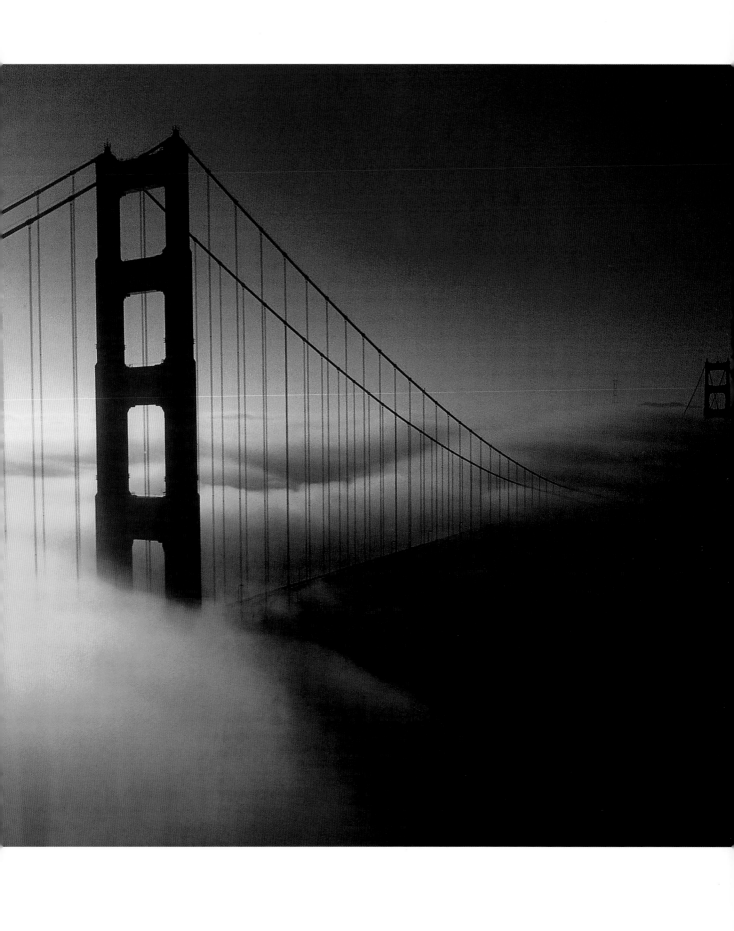

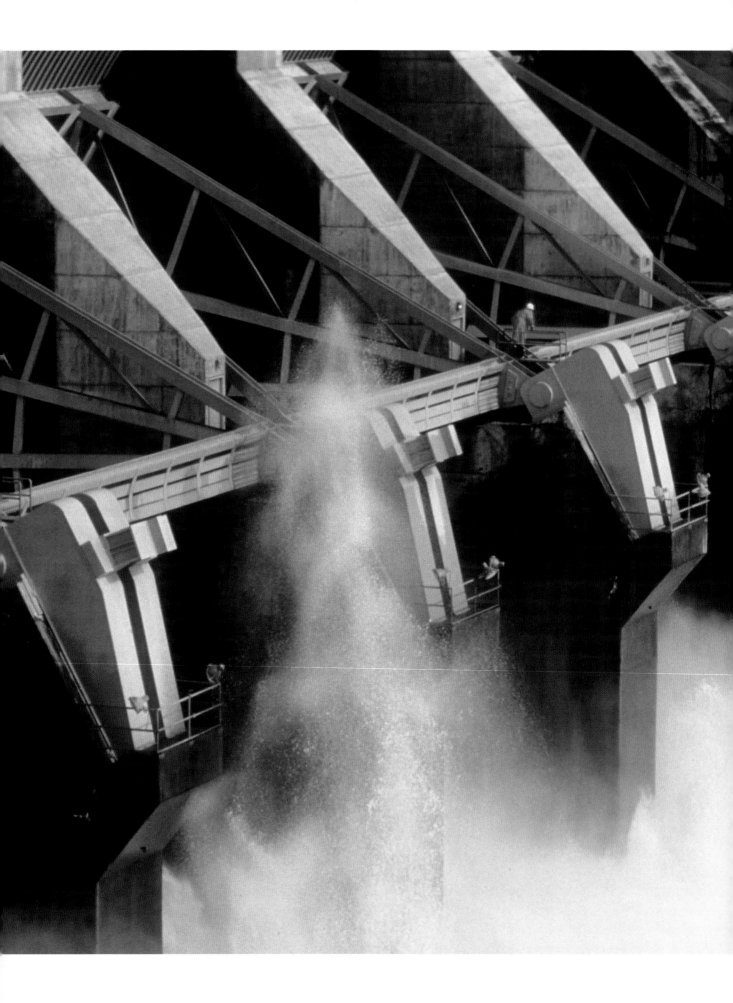

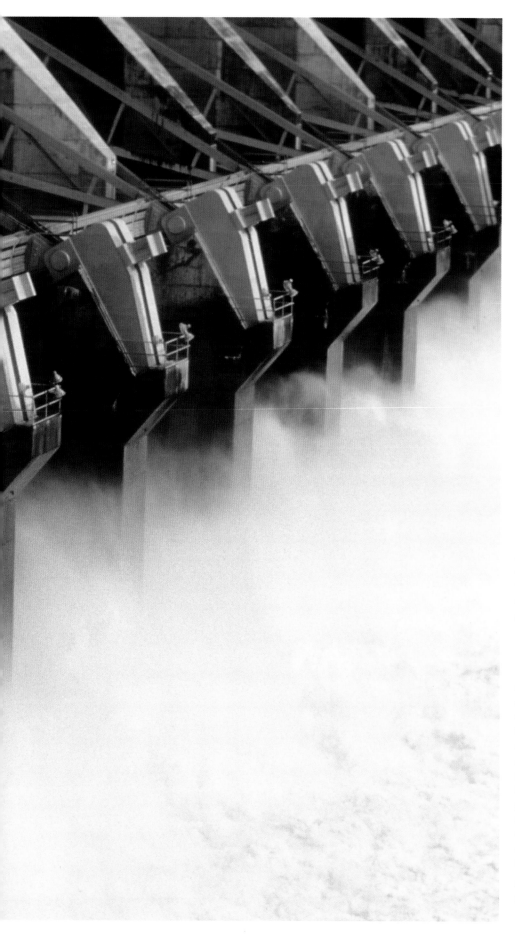

Although I had
spent most of the day photographing a key employee of the Army Corps of Engineers at the this dam along the Columbia River, I still had that gnawing feeling that I hadn't yet "struck gold." Walking along a small road that ran parallel to the dam, I remarked to the man that it would be really incredible if he could stand among the spill gates where a torrent of water was being released. To my surprise, he assured me this was possible and told me to wait where I was. To my utter amazement, he was soon walking along a small catwalk right there among the spill gates and wearing a bright orange-red rain jacket.

With my camera on a tripod, I chose a focal length of 100mm, which reduced the overall composition to a strong and graphic pattern of lines, shapes, and forms by eliminating the distant hills, horizon, and sky that a wide-angle lens would have certainly shown.

I had no idea he would come into the scene wearing this bright jacket, which he later explained was necessary since he would have gotten quite wet without it. When he asked me if the jacket had posed a problem, perhaps taking away from the overall feeling of the shot, I started to laugh. Absolutely not! In fact, he would have gotten lost in the scene without it. But with it, he is easily seen and provides a clear sense of scale, indicating just how massive the dam structure is. Sometimes luck plays a huge role in my work, and this was one such time. Just for fun, place your finger over the man; it's clear that without him, the size, scale, and overall drama of this shot would be far less compelling.

80–200mm lens at 100mm, f/16 for 1/125 sec.

Backgrounds

How critical is the background in terms of creating strong images? In my mind, 99 percent of all compelling people pictures can't survive without an effective one, and more than 50 percent of all images owe their success to the background. The stock photography industry has embraced the importance of backgrounds so enthusiastically that many of the larger agencies' catalogs contain more than two hundred background shots: Vivid blue skies, white cumulus clouds, orange and red sunsets, green grass, autumn leaves, and wildflower meadows are just a few of them. And when you combine such striking backgrounds with people, they become even more important. They can make an ordinary image extraordinary.

Backgrounds don't always have to be recognizable, clearly defined elements; they can also take the form of out-of-focus colors or shapes. A successful background most often relates to the subject or enhances its importance. And on rare occasions, a background can provide a stark contrast to the subject placed in front of it. For example, it makes perfect sense to photograph a turkey farmer from above while he sits in the midst of his two thousand gobbling turkeys. It would make no sense at all to lie down in an empty field and shoot up at the turkey farmer against a blue sky.

In much the same way, it is appropriate to photograph a little girl at her eye level against an out-of-focus background of green foliage as she hunts for Easter eggs at the local park; green is the color of spring, and the blurred background places the emphasis on the child. It would make no sense at all to photograph her with the visibly crowded parking lot as the background. When you consider backgrounds for people pictures, ask yourself, *Where is the connection?* Having a beautiful background but the wrong subject—or the right subject but the wrong background—serves only to magnify this question in viewers' minds.

Lens choice (see page 114) and point of view (see page 90) play very important roles in making the connection between the subject and the background. When you shoot with a wide-angle lens, you backgrounds will, for the most part, be sharply defined. And while objects in the background can be noticeably defined when you use a telephoto lens, the telephoto is more often called upon to reduce backgrounds to out-of-focus shapes or colors. Even the most unflattering of environments can be turned into appealing backgrounds via the telephoto lens. The lens's ability to render muted backgrounds is one reason why it's popular with seasoned professionals. But it's up to you to find the right background that, when turned into an out-of-focus color or shape, connects with the subject.

I once heard an art history professor say that no great painting was ever accomplished without a background. The same can be said of people pictures. I have said it many times in my Internet courses, as well as in my workshops, and it bears repeating here: If you make it a habit to spend more time looking at your background, your success rate with people photography will increase immeasurably. What good does it do to have a really great representation of your human subject if that subject has to compete with a very distracting background?

Sometimes the problem is as simple as the proverbial tree growing out of the subject's head. And we've all seen at least one live newscast with the reporter speaking enthusiastically to the camera while that one person in the background waves his arms, doing a good job of calling attention to himself and away from the main subject. A distracting photographic background is just like that person waving his arms around. It's difficult to concentrate on what the reporter is saying due to this background distraction, and the same will be true in your portrait work, unless you spend the few seconds necessary to really look at your background before pressing that shutter button.

I often look for backgrounds of color that contrast with the subjects in front of them. And if I'm unsuccessful in finding such backgrounds, I can always dip into my bag of "tricks," pull out a large piece of colored fabric, have an assistant hold it at a distance of about ten feet behind the subject, and voilà, the once colorless or busy background has now been transformed into a simple and clean background of out-of-focus tones.

In my mind, 99 percent of all compelling people pictures can't survive without an effective background, and more than 50 percent of all images owe their success to the background.

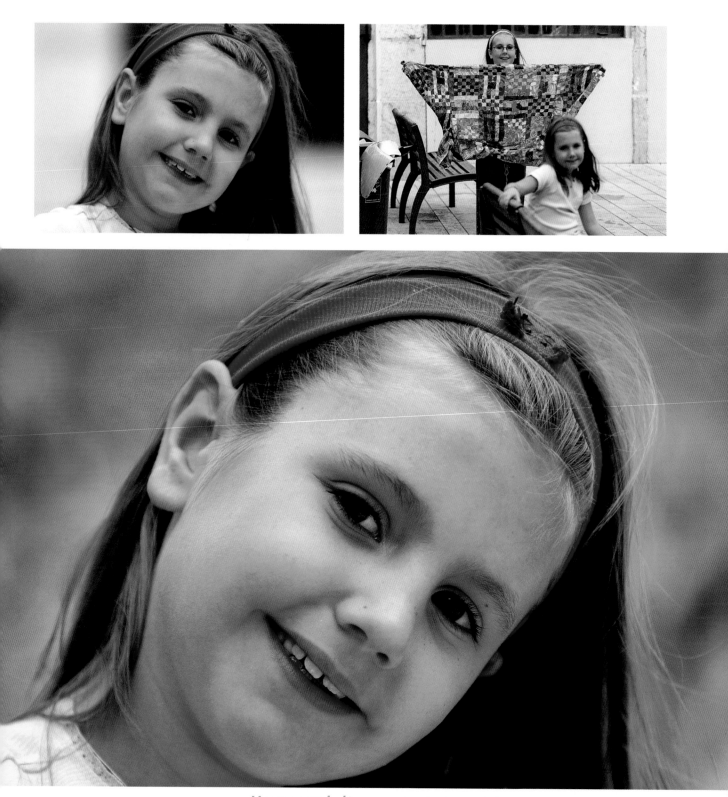

How easy is it to get a clean background? If you carry several large pieces of fabric with you, it's very easy. While my daughter Sophie sat on this park bench, her sister, Chloë, held a piece of brightly colored fabric in the background, thus creating a much better and more vibrantly colored background than the actual background of a wall and window that was in the original scene. With my camera on a monopod and my aperture set to f/5.6, I simply adjusted my shutter speed until 1/160 sec. indicated a correct exposure from the evenly diffused light that was falling on Sophie's face.

70–200mm lens at 200mm, f/5.6 for 1/160 sec.

Throughout much of Havana, the colors of the Caribbean are evident, blue being one of the more dominate ones. There was a large blue wall of several buildings behind this young boy who was engaged in a conversation with a schoolmate while eating a much-prized lollipop. With an aperture of f/5.6, I adjusted my shutter speed until 1/500 sec. indicated a correct exposure from the meter reading I was taking off of the mid-toned blue wall. I then recomposed the scene to include my subject and fired off several frames. Clearly, this background is in marked contrast to the boy and allows the boy to have center stage.

105mm lens, f/5.6 for 1/500 sec.

THE COLOR GREEN

If you are at all familiar with stock photography, you might have noticed that many of the best-selling people photographs have a common link. The majority of the images are made with a telephoto lens (whether the subject is a couple walking in the park, a child riding a bicycle, or a father and daughter sitting on a swing), and they have out-of-focus green tones for backgrounds. Green is the favored background because it appeals to everyone's desire to make a fresh start.

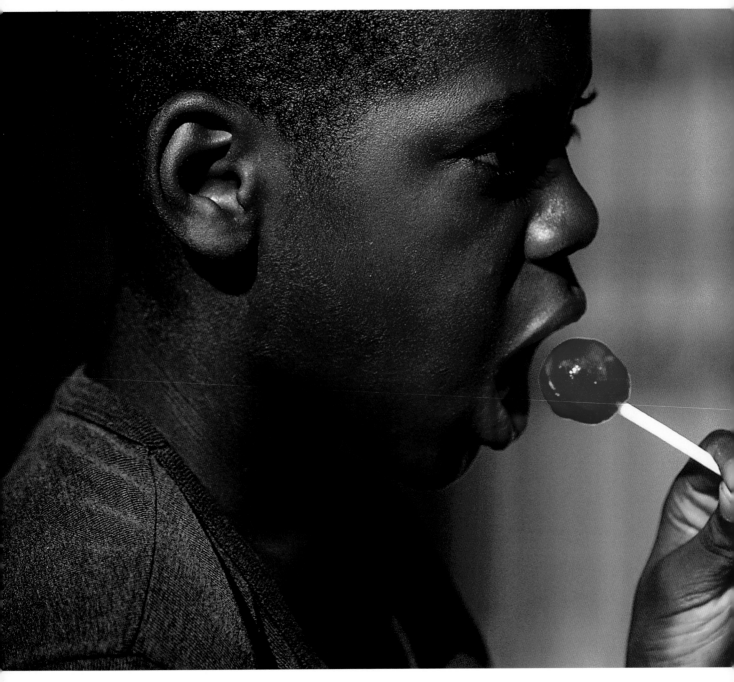

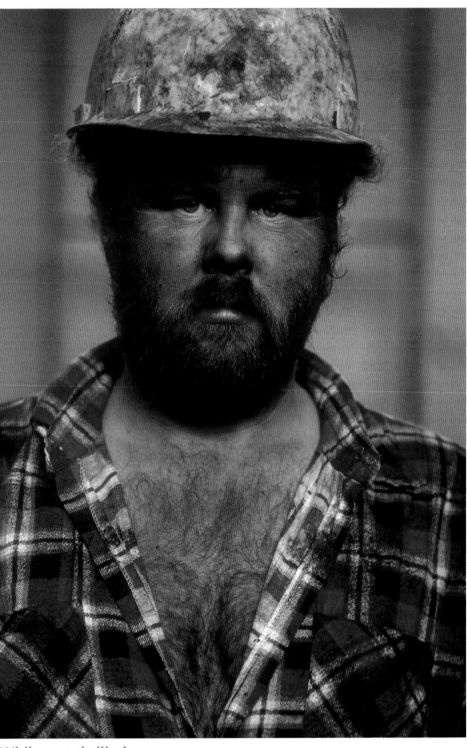

While not thrilled *at the prospect of having his picture taken, this oil rig worker reluctantly posed for me while standing about ten feet in front of a large and brightly painted container. As with the buildings in the photograph to the left, the container proved to be a great background of out-of-focus tone and color against which to contrast him, making it quite clear that he and he alone is my subject. With my camera on a tripod and my aperture set to f/8, I simply adjusted the shutter speed until 1/320 sec. indicated a correct exposure.*

180mm lens, f/8 for 1/320 sec.

Movement and Shutter Speed

There is motion all around us. Most obviously, there's sports. America is a very sports-minded country, and not a weekend goes by that doesn't showcase two or more sporting events. Next to a baby's first few weeks of life and the family vacation, sports-related activities are probably the most-often photographed subjects. And besides shooting sports action, many amateur and professional photographers want to capture the participants' emotions and produce good compositions, as well.

Beyond sports, the hustle and bustle of life produces all sorts of action that is of interest to the photographer. Successfully shooting action-filled subjects requires not only skill and experience but also the right shutter speed. Only a fast shutter speed is capable of rendering such exacting detail and emotion on film. When action—such as a motorcyclist zooming over a hill, for example—is coming toward you, a shutter speed of 1/250 sec. freezes the subject in midair. But if you're shooting parallel to the motorcyclist flying over the hill, a shutter speed of 1/1000 sec. is a must.

When it comes to the creative use of shutter speed, about 99 percent of all professional and amateur photographers still opt for using only the fastest shutter speeds, such as 1/500 sec. and 1/1000 sec. But the opposite end of the shutter speed dial offers a multitude of alternative creative effects that most photographers never discover. Action-filled subjects take on a whole new meaning when you deliberately photograph them at unusually slow shutter speeds.

If you're a purist who still believes in the age-old standard of razor-sharp, everything-in-focus pictures, I don't expect to change your way of thinking. But if you're a photographer who's looking for some fresh approaches to photographing people, I strongly recommend that you consider stretching the limits of your slow shutter speeds to the fullest. Try shooting all of your people pictures handheld at slow shutter speeds of 1/4 sec. or 1/2 sec. for the next week. The compelling imagery that often results will become additional ammunition for your growing arsenal of creative approaches. Much of what you do will be experimental, but as is often the case, new and exciting "discoveries" can only be made in the "laboratory."

Every photographer who is passionate about taking pictures is on a never-ending journey of creative expression and strives to be inventive. Using slow shutter speeds when common sense suggests that this approach probably isn't a good idea has proven to be a successful venture for many photographers. The resulting photographic compositions are filled with tremendous movement and tension. They convey strong moods and emotions, and are anything but boring. You might not be able to identify the sport or activity, but in the midst of the blurred motion, you can recognize the human form. Fast-action shots made with slow shutter speeds are alive. They can resurrect memories of an earlier exciting time or confirm the current excitement in your life. Everyone, by nature, feels invigorated when there's movement in life, and everyone at one time or another has experienced boredom, life without movement.

Beyond sports, the hustle and bustle of life produces all sorts of action that is of interest to the photographer.

As I shot downward from atop a ladder at the edge of a swimming pool, my friend Christopher was more than happy to make several jumps into the pool on this very hot summer day. My interest was, of course, in recording a composition of him in exacting sharpness that would hopefully stop the action of the splash. Holding my camera, I first set the shutter speed to a 1/500 sec. I then adjusted my aperture until f/8 indicated a correct exposure from the blue water of the swimming pool directly below me. At the count of three, Christopher made several cannonball-type jumps into the pool.

Note the incredible tension and sense of movement in this image. The wave that rises around Christopher's body and his diagonal position as he hits the water create a truly compelling photographic interpretation of motion and speed. Granted, it helps immensely to have used a fast shutter speed to capture every detail in crystal clear sharpness; but the very active lines (the wave around the body) and the body position play a large role in making an image of tremendous movement.

17–55mm lens at 55mm, 1/500 sec. at f/8

When I first saw this bright yellow wall, I was quick to photograph it with my Nikon D2X and 17–55mm lens at 55mm. The contrast of colors between the wall and the blue and red signs was enough for me—or so I thought at the time. But once I got home and processed the image, I felt the composition was lacking in some much-needed tension. It was then that I phoned my friend Phillip and asked if he would mind assisting me the following morning at this same location. I simply had him walk at a normal pace in the opposite direction of Paris. With my camera on a tripod and a neutral-density filter on my lens, I was able to shoot a correct exposure at f/22 for 1/4 sec. and assure that Phillip would record as a blurry figure. For me, this lone pedestrian was just the tension this photograph needed.

(Note: A neutral-density filter works in much the same way as a pair of sunglasses in that it reduces the intensity of light. Photographically speaking, this reduction in the light's intensity forces the camera to use a slower-than-normal shutter speed to compensate for the reduction in light. It's a "colorless" filter in that it doesn't change the color of a scene but simply reduces the light levels.)

Nikon D2X and 17–55mm lens at 55mm, f/22 for 1/4 sec.

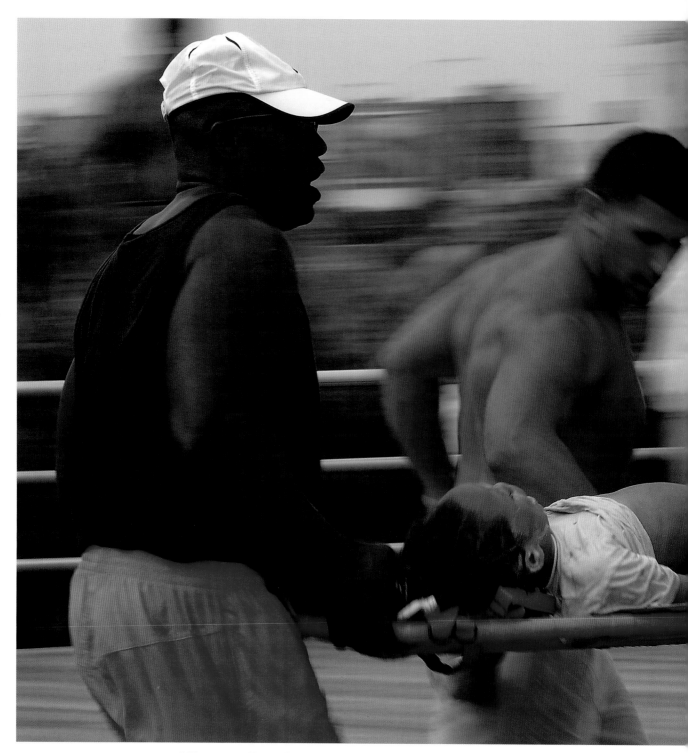

While spending the day at New York's Coney Island, I certainly did not plan on taking a photograph of a little girl being rescued from the ocean by a team of lifeguards. I suppose it was instinct, but as I watched the lifeguards come rushing up from the beach toward the boardwalk with the girls on the stretcher, I immediately set my aperture to the smallest lens opening (f/22), knowing that this would force the slowest possible shutter speed (in this case 1/30 sec.). I then shot the images while following the movement with my camera. A short while later, a photographer from the New York Daily News noticed me shooting generic beach crowd scenes and asked if I had photographed the beach rescue. I showed her my shots via the digital monitor, and she quickly phoned her editor. The next morning, I awoke in my hotel room to see the image in black and white on page 2 of the paper. And fortunately, the little girl made a full recovery.

17–55mm lens at 35mm, f/22 for 1/30 sec.

PANNING

Motion-filled photo ops are present at every action-oriented event, and when you use slow shutter speeds of 1/4 sec. or 1/8 sec. to record them, dramatic effects often result. Handholding your camera at such slow shutter speeds might seem almost ridiculous, but it is indeed necessary if you're going to successfully pan with the action of your subject.

Panning is the action of moving the camera parallel with the action. So if your subject enters the frame from left or right, you move the camera left to right along with the action while depressing the shutter-release button. This ensures that your moving subject remains relatively "stationary" in relation to a particular spot in the frame and records relatively crisp, while all of the actual stationary objects that surround the moving subject record as blurry horizontal streaks. Many shooters embrace panning with zeal since they don't have to use tripods—the last thing you want to do is use a tripod when panning. Panning is all about handholding the camera and moving it in the same direction of your moving subject while you fire off any number of exposures.

You may find that shutter speeds of 1/4 sec. or 1/8 sec. are too slow, rendering the subject, as well as the background, as streaked blurs. If you encounter this, try the following alternative approach: Set your shutter speed to 1/60 sec. and then pan your subject. This often renders the subject very sharp while keeping the background a horizontal blur. You can almost always effectively pan a subject when you use shutter speeds of 1/30 sec. or 1/60 sec. The combination of panning and slow shutter speeds intensifies the sense of motion in the activity in which your subject is involved. And in general, panning brings a sense of urgency to a subject.

When you pan a subject, keep in mind that you must have appropriate backgrounds in order to be successful. Panned backgrounds are rendered as blurred, horizontal streaks of color. If you were to paint colored horizontal streaks onto a canvas, using a single color would result in nothing more than a solid color with no evidence of streaking. But if you were to use several colors, you would be able to distinguish the streaks. In much the same way, panning a jogger against a solid blue wall will show little, if any, evidence of this technique because of a lack of tonal shift or contrast. But a wall covered with posters will provide an electrifying background when panned.

Simply put, the greater the color and contrast in the background, the more exciting the resulting panned image will be. So, rather than concentrating on choosing the right shutter speed when you pan a subject, you should make seeking out an appropriate background a priority. This will greatly improve your panned images.

Throughout the morning, *wheelbarrows filled with fish are rushed from seller to buyer at the Dubai Fish Market. This is clearly an opportunity to do some panning. As the wheelbarrow laden with fish sped past me, I simply moved in the same left-to-right direction while shooting.*

Nikon D2X and 17–55mm lens at 17mm, f/22 for 1/15 sec.

*P*anning brings a
sense of urgency
to a subject.

THE RIGHT SHUTTER SPEEDS
FOR MOTION

Choosing the right shutter speed to capture all the movement of life is, for many shooters, a hit or miss proposition, but it doesn't have to be if you ask yourself the following three questions: Do you want to freeze the action in crystal-clear sharpness? Do you want to convey a heightened sense of speed or urgency? Do you want to capture the ghostlike presence of people against an otherwise sharply focused scene?

Freezing the action of moving subjects is a relatively easy exposure. A shutter speed of 1/500 sec. or 1/1000 sec. will freeze most of the activities we all pursue with precision, sharpness, and clarity. Panning most subjects is easily accomplished with 1/30 sec., and if you want ghostlike figures in your scene, then a shutter speed of 1/4 sec. will often do the trick. There is no *one* shutter speed that is called upon for panning, but with practice and experience, you'll find yourself calling most often on shutter speeds of 1/60 sec., 1/30 sec., or 1/15 sec., depending on the speed of your subject.

Choosing the Right Aperture

You may be wondering why I've used *f*/5.6 for some images, *f*/8 for others, and *f*/16 for still others. After all, as many of my beginning students say, *An aperture is an aperture, and apertures are simply there to help you make the exposure*. This is true—up to a point. If all you're concerned about is getting the right exposure, then you can use any aperture you want, but getting successful images will always be a hit-and-miss proposition.

Apertures have many functions. The most obvious role they play is to control the volume of light that passes through the lens and onto the film or digital sensor.

An aperture is merely a hole in your lens where light enters. When you release the shutter, light comes down this hole and is exposed to the digital sensor or onto the waiting film, thus forming an image. Turning the aperture ring on your lens or wheel on your camera body changes the size of the aperture. Conventional thought suggests that you make the aperture hole smaller when shooting subjects in bright light (snow and sandy beaches) and larger when shooting subjects in low light levels (church interiors).

But truth be told, the aperture plays a far more important role than just determining how much or how little

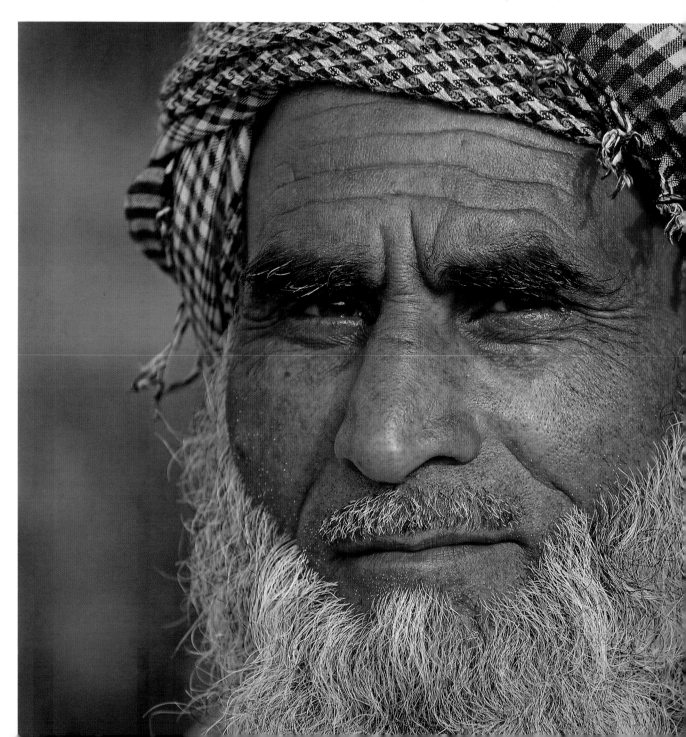

light travels down the lens an onto the awaiting film or digital sensor. It is *your* choice of aperture that determines just how much more of the scene behind and in front of your point of focus appears sharp. (This area of focus from back to front in an image is called depth of field; if only a shallow area is in focus, that's smaller depth of field and if a deeper area is in focus, that's greater depth of field.) So, simply put, the wrong aperture can spoil a picture just as quickly as the right aperture can be responsible for a composition's success. Obviously, then, you should make choosing the right aperture a priority.

What do I mean by the *right aperture*? To understand this concept, simply think about the creative use of aperture in one of three ways: The right aperture can (1) tell a story, (2) isolate a subject, or (3) fall into the what I call the "Who cares?" category. All photographs in which you choose to

isolate a particular subject are also called *singular-theme* compositions.

Of these three aperture options, only the storytelling and isolation apertures really have any noticeable impact on your images. Storytelling apertures (*f/16*, *f/22*, and on some cameras *f/32*) render an area of sharpness well beyond the subject you focus on, and using a wide-angle lens at these settings is ideal for environmental compositions. For example, storytelling apertures allow you to record detail and sharpness in the background when your main subject is in the foreground. The reverse is also true. When the main subject is in the background, a storytelling aperture lets you render both the distant subject and the foreground sharp on film. Thus, storytelling apertures provide extensive depth of field, telling the whole story.

But when you want only the main subject to appear sharp on film and your working distance is between ten and thirty feet, you should choose an isolation or singular-theme aperture (*f/2.8*, *f/4*, or *f/5.6*). When you use these apertures with telephoto lens focal lengths of from 100 to 400mm, they always render any background or foreground colors or objects as out-of-focus tones and shapes.

Telephoto lenses, by their very design, limit the angle of view. And when they're used at singular-theme settings (again, *f/4*, *f/5.6*), they reduce depth of field. As such, these out-of-focus backgrounds give the in-focus subjects in front of them even more visual weight, more importance. Simply put, when you look at a photograph, you quickly scan the image and assume that whatever is in focus is the most important element. Clearly, you should use an isolation aperture in combination with a telephoto lens when you want to focus all of the attention on the subject, not on the surroundings.

The third aperture option comes into play when the aperture choice isn't critical to an image's success, and it

There is perhaps no better combination for shooting a portrait than the telephoto lens and a large lens opening (a small aperture number). When we think of aperture's importance and its ability to render either a great deal of sharpness beyond what we focus on or no added sharpness beyond what we focus on, it of course becomes paramount that we choose the right aperture each and every time. When a large lens opening is combined with a moderate telephoto focal length, such as 100–200mm, depth of field is extremely shallow, as in this portrait. I framed this nursery worker from a distance of about ten feet against a backdrop of plants and blue pots. Note that the area of sharpness is limited to him, and therefore, his level of importance (as the visual weight of the composition) is clear; he is the subject, since the eye assumes that what is in focus is what's important.

To make the exposure, with my camera on a tripod, I set the aperture to f/5.6 and adjusted my shutter speed until 1/400 sec. indicated a correct exposure from the warm late-afternoon frontlight illuminating him.

Nikon D2X and 70–200mm lens at 200mm, f/5.6 for 1/400 sec.

is for this reason that I have, for years, been referring to this as a "Who cares?" aperture. For example, when you photograph your subject against a brick wall, does it really matter what aperture you use? No. The same principle holds true when you shoot your subject from a low point of view against a background of blue sky, as well as when you shoot straight down on your subject from above. In all these situations, and countless others, the aperture doesn't play a very important role since there are no real depth-of-field concerns. Although you can certainly select any aperture you want in such shooting situations, your best aperture choices are f/8 and f/11, because they often render the most sharpness and optical clarity possible in your photos. (Technically speaking, f/8 and f/11 aperture openings are called critical apertures; if a lens isn't critically sharp at these settings, it won't be tack sharp at any of the others either.)

Ultimately, the right aperture will go a long way toward creating the perfect composition, and aperture choice is always yours to make. It's the right aperture that has the powerful ability to determine the visual weight of your composition, and more often than not, the visual weight of your composition will account for its ultimate success or failure.

A NOTE ABOUT HANDHOLDING

For the image below, I handheld the camera and shot in Aperture Priority mode due to the balanced light levels of an overcast day. With my aperture set to f/8, I allowed the camera to set the correct shutter speed for me. Since I was using Kodak Max ISO 400 film, recording exposures beyond 1/500 sec., I was assured that I was in no danger of recording a soft image due to handholding at too slow of a shutter speed. Normally, as a general rule of thumb, you should never handhold your camera at a shutter speed that's slower than the longest focal length of your lens. However, with today's vibration reduction (VR) and image stabilization (IS) lenses, it is now possible to break this "rule" and handhold at shutter speeds that are 2 to 3 stops slower than the old rule of thumb would normally allow.

In all of my world travels, I have never seen a cemetery as big or vast as Calvary in Queens, New York. It's an odd place for a number of reasons, not the least of which is its proximity to the Manhattan skyline. On the simplest level, the views offer a gripping contrast between life and death. The solitude and quiet of this particular day were broken by the sound of a distant car, and it was then that I noticed a lone figure, wearing a red T-shirt, scampering up a small hillside. Grabbing my camera set to Aperture Priority mode, I chose f/22 in order to capture as much depth of field as possible, from the foreground headstones to the distant skyline. Of the six shots I managed to fire off, this one was the most compositionally compelling. The lone figure, that unmistakable shape of the human form, brings a sense of vastness and size to the world it walks upon.

70–200mm lens at 200mm, f/22

When most everything in the scene before you is the same distance to the lens, does it matter what aperture you use? Yes and no. Let me explain. There's no "depth" to this subject, meaning there's nothing in front of or behind him; it's just him and a colorful wall. I could just as easily use f/4, f/11, or f/22, and the resulting depth of field would not show any noticeable difference since the area of sharpness is limited to a given distance. It's a perfect "Who cares?" situation, since honestly, who cares what aperture I use here?

But actually, I do care, and here's why: Every lens has a critical aperture, referring to the aperture that renders both maximum sharpness and contrast; and critical aperture does have everything to do with the design of a lens. Without getting too technical, basically on most every lens for 35mm SLRs or DSLRs, the critical aperture is most often found around f/8 to f/11. So, when depth of field isn't a concern, your only concern should be using the critical aperture, since that will yield the greatest sharpness and contrast.

Nikon F5 and 35–70mm lens at 35mm, f/8, Kodak Max 400

Lens Choice

Just as aperture choice affects composition and the final success of an image, so does lens choice. Experienced photographers use, primarily, two lenses when photographing people: the telephoto lens (the more obvious choice) and the wide-angle lens. The telephoto lens is popular for several reasons. Most important, it frees photographers from having to work with camera-to-subject distances that might make them uncomfortable. This benefits their subjects as well, because everyone, to greater or lesser degrees, has a psychological boundary. Although this isn't clearly marked the way a parking space is, it does exist. You can quickly find out where a subject's boundary is by attempting to shoot an extreme close-up of the person's eyes with a macro lens. Chances are you won't get very far, especially if the individual is a complete stranger.

The telephoto lens is also popular because it renders subjects in correct proportions. When you use either a 50mm standard lens or a 35mm wide-angle lens and want to fill the same area in the frame that a telephoto lens does, you usually end up distorting the subject. For example, if you shoot a head-and-shoulders composition with a 35mm or 50mm lens, the subject's nose or chin might appear larger than it actually is. Shooting the same composition with a telephoto lens, on the other hand, would create the illusion that the eyes, ears, chin, nose, and shoulders are all the same distance from the camera.

Although there's no set rule about which telephoto lens is best, many seasoned professionals swear by the 100–200mm focal lengths. The popularity and quality of the tele-zooms (for example, 70/80–200mm, 70/80–400mm) mean that most, if not all, of these popular focal lengths are available to even the amateur photographer. Tele-zoom lenses are able to zoom in and out, so cropping in-camera is relatively simple. And in some situations, these zoom lenses free you from having to walk closer to, or move back from, the subject.

I'm quite fond of my latest zoom, the Nikkor 70–200mm F2.8 tele-zoom lens. In addition to the limited depth of field it offers, when used at or very near full aperture, it allows me the perfect working distance from my subject, more so than shorter telephoto lenses do. The resulting out-of-focus backgrounds increase the visual weight of my in-focus subjects. Granted, the size and weight of this lens make handholding the camera and lens difficult at times, but for the few occasions I'm not using a tripod, I will opt for my monopod and my mobility is no less than that of a photographer handholding a camera and tele-zoom.

Additionally, all telephoto lenses have a much narrower angle of view than their wide-angle counterparts. For example, a 24mm wide-angle lens has an angle of view of 84 degrees, while the 100mm focal length lens has an angle of view of approximately 27 degrees and the 300mm lens has an angle of view of only 11 degrees. When using my 70–200mm F2.8 lens, I'm not restricted to photographing faces. At a country fair, for example, I can zero in on hands exchanging money, as well as a child's hands hanging on tight to that candy apple.

When photographing a group portrait, on the other hand, I often use a wide-angle lens. I would never use a wide-angle lens for a frame-filling portrait because it would distort the subject's face, but if I back off just a bit, I can shoot a portrait of the subject that, due to the angle of view of the wide-angle lens, also incorporates the surrounding environment. In fact, my *other* favorite lens is the Nikkor 17–55mm F2.8. This is what I often call my "street lens," meaning that if I want to travel light, I simply head out the door with my camera and this one lens and see what I can find as I walk the streets of the world. It's both a wide-angle and a short telephoto lens, so I can shoot "environmental portraits" as well as frame-filling head shots with just this one lens.

To shoot both a portrait and some of the environment that surrounds your subject, I often call on the moderate wide-angle focal lengths of 30–45mm. With my Nikon F5 and my 35–70mm zoom set to 35mm, I moved in close on this young boy from Bavaria and was still able to get a bit of his surroundings, which meant the inclusion of his very own pride and joy: the cow in the background. Since I did want to keep the emphasis on him, however, I chose an aperture of f/5.6, thus rendering him in exacting sharpness, but not his cow. Handholding my camera and lens, I simply adjusted the shutter speed until 1/250 sec. indicated a correct exposure for the ISO 50 film I was using.

Nikon F5 and 35–70mm at 35mm, f/5.6 for 1/250 sec.

One of the telltale signs of the telephoto lens is a background of out-of-focus tones. Here, the swimming pool behind the subject was reduced to nothing but blurry shapes of color. With my camera on a monopod, I decided to shoot in Aperture Priority mode due to the low-angled late-afternoon front-light, choosing the aperture myself and then letting the camera set the correct exposure for me.

Nikon D2X and 70–200mm lens, f/5.6

THE PERSONAL SIDE OF LENS CHOICE

If you haven't noticed, I've used, for the most part, two lenses for all of my work in this book. Although this might imply that these are the focal lengths that you should also embrace, I want instead to encourage you to try other focal lengths, as well, from the full-frame fish-eye to the 800mm lens. Understanding the "vision" of all lenses will go a long way not only toward flushing out what works and what doesn't in your photographic compositions, but also toward developing a personal style. I have several students who use nothing more than their 50mm F1.4 lenses for all their people work!

Photography is one of the arts, and there are no hard-and-fast rules in art. A lens, just like a painter's brush, is a tool. You can use the brush to make strokes up, down, or from side to side. You can squish the brush against the canvas to reduce it to a single hair and paint ultrafine lines. You can also throw the brush out and use a palette knife, your fingers, your nose, or even your cheeks to spread the paint around.

I believe that you can—and should—experiment with lenses in much the same way. Don't reserve wide-angle lenses for group portraits. These lenses have a much greater angle of view than telephoto lenses do, so they're a natural choice for environmental portraits. They gather up those elements that call attention to the subject's character. And when shooting indoors in a small, confined area, you'll have to use at least a wide-angle lens to show the subject from head to toe.

I've had a great deal of success shooting storytelling portraits of people all over the world with my 17–55mm zoom lens. These powerful compositions include the person's head and shoulders in the immediate foreground, as well as information in the background that helps define the subject. Nevertheless, many photographers hesitate to use the wide-angle lens because of the image distortion that can occur. The distortion is often related to the photographer's distance from the subject. If the photographer is too close to the subject, the person's nose will be exaggerated, the ears will appear too far back, and the face will look too round. Tilting the camera up or down also contributes to distortion, because you're tilting the camera and lens at an angle to the subject rather than keeping them parallel to the subject's face and body. To eliminate this type of distortion, simply make sure that you hold the camera straight when you shoot.

You can, however, use the distortion produced by wide-angle lenses to your advantage. Imagine a picture of a little boy begging for food with an outstretched hand that appears larger than the rest of his body. Here, the distortion would emphasize his plight. Don't be afraid to choose a wide-angle lens when you photograph individuals whose professions often call for them to use their hands in special ways, such as boxers, surgeons, pianists, and even ministers. A wide-angle portrait of a person's hands can convey a strong sense of the subject's character.

Whatever lenses you end up preferring will be the right lens choices. There are no wrong lenses.

EXTREMELY WIDE

It's not at all uncommon for photojournalists to use wide-angle focal lengths that offer up anywhere from 75- to 92-degree angle of views. For film shooters, these focal lengths are the 20–28mm range, and for digital shooters these focal lengths are the 14–18mm range. Subject distortion is the norm when using these extreme wide-angle lenses, and in the hands of a gifted photojournalist, this distortion can be used to emphasize the joy or plight of a given subject.

As evidenced by the many images in this book, it's not my style to use these wide-angle photo lengths all that much but, rather, to do so very selectively. On one such occasion, I met a greengrocer who was indeed proud of his fruits and vegetables, so it only seemed natural to place the emphasis on the pride he felt as he held a single pear. Handholding my camera and 12–24mm lens with the focal length set to 12mm (a 92-degree angle of view), I moved in as close as possible to the pear and his outstretched arm. Due to the extreme angle of view, I was able to get all of him plus a portion of his storefront. With my aperture set to f/4, I was able to keep the overall sharpness limited to his hand and the pear, thus further emphasizing the importance of his connection to his business and profession. Due to the overcast lighting, I made the exposure in Aperture Priority mode, letting the camera set the shutter speed for me.

Nikon D2X and 12–24mm lens at 12mm, f/4 for 1/125 sec.

Even rarer than my use of the extreme wide-angle focal length with people is my reaching for my full-frame fish-eye lens when shooting portraits—but when I do, it has everything to do with the idea of creating a feeling of great scope and reach. Over the course of several hours, I watched this Hindu priest at a temple in Singapore receive numerous prayer requests from the local Hindus who visited the temple that morning. He was a busy man as he went from one Hindu god to another, laying down both a sacrifice and chanting a prayer on behalf of each individual who made such a request. During a brief break, I asked him if I could take a photograph of him that would also include the silver plate holding many of the offerings, and he gladly obliged.

The choice of the fish-eye lens was deliberate in that it allowed me to convey the "all-encompassing power" of both the Hindu priest and the temple where prayers were answered. With my camera and fish-eye lens on a tripod, I set the aperture and simply adjusted the shutter speed until 1/100 sec. indicated a correct exposure from the bright yet overcast light filling the scene.

Nikon D2X and fish-eye lens, f/8 for 1/100 sec.

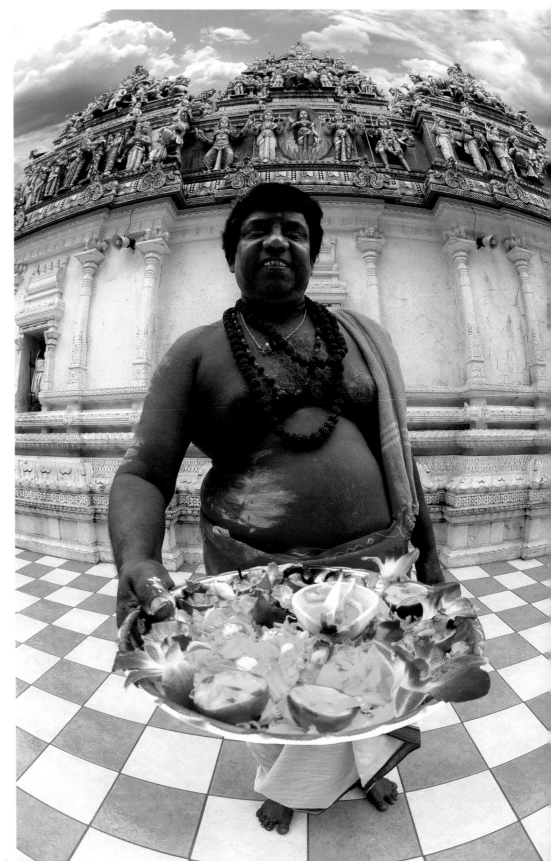

Photo-Editing Techniques

No One's Perfect

Rare is the individual who is 100 percent satisfied with his or her personal appearance. I have yet to meet any people who haven't expressed a desire to make at least one change; perhaps it's their hair's style, color, or length; or perhaps it's the shape of their eyes or their eye color. Women, in particular, seem to desire fuller lips, higher cheekbones, the "perfect nose," the "perfect breasts," and fewer wrinkles.

Unlike women, men are inclined to reveal little about their personal insecurities, but truth be told, most men have shared with me (in confidence) their desire to have washboard abs, bigger biceps, and also fewer wrinkles, a different eye color, and the "perfect nose." And for both men and women, the desire to have that Hollywood smile with perfectly straight, white teeth is also huge.

As further evidence of our obsession with our physical appearance, one need look no further than to the current reality shows, such as *Extreme Makeover* and the hit cable show *Nip/Tuck*. Week in and week out, millions of television viewers sit down to watch the ugly duckling be transformed. And not surprisingly, most plastic surgeons and dentists are quick to report that business is booming.

Of course, the majority of us can't afford the high cost of these extreme makeovers, but that doesn't mean we can't at least live the fantasy of an extreme makeover with the aid of Photoshop and other photo-editing software. Combining "plastic surgery" precision with any digital file can produce handsome princes and beautiful swans. Unlike doctors who must go to medical school for upward of six years before they can begin practicing plastic surgery, Photoshop users can do many extreme makeovers in as little as five to ten minutes. It's really that easy.

When Photoshop first came out, each new version was indicated by a new number replacing the old, such as Photoshop 4 then 5 and 6 and 7, and then all of the sudden we were introduced to Photoshop CS, which has now been replaced by CS2. Although I doubt it was a conscious decision on the part of the great folks who write the software for Photoshop, I can't help but wonder if the CS is simply an acronym for *cosmetic surgery*? Considering the host of tools available to do a makeover, it sure makes me think. And now, with the addition of CS2, it's even easier to do any kind of makeover; for example, the Spot Healing Brush and the Patch Tool, make really quick work out of most makeovers.

I'm not suggesting that you put every subject you shoot be "under the knife"; in fact, I feel that you should allow *most* subjects to simply be themselves. Oftentimes, the very elements that draw me to a given subject are a wrinkled brow or ruddy face or large nose or some crooked teeth. It's these very imperfections that often define the uniqueness of each and every one of my subjects. So why would I want to remove or change them?

On the other hand, there are those times where removing crows feet, changing eye color, reducing a waistline, or whitening teeth does do justice to the subject—and more often than not, it's the subject who makes this request. The most common thing I hear is, *Sure you can take my picture, but only if you take out my wrinkles, or Can you whiten my teeth?* Whether it's removing wrinkles around, or bags under, the eyes; making the whites of the eyes whiter or the blues or browns of the iris more vivid; or making the nose shapelier, the teeth whiter, the chin more pronounced, the hips and thighs narrower, the waistline smaller, it's all here in this section. So let's get the operating room ready, load up the patient, put on some lounge music, and start "cuttin'."

And one more note before we get started: One of the things that I really strive for in my teaching, as well as in my books, is to illustrate my points in the simplest of ways. The last thing I want to do is teach "theory" or talk "tech-speak." So, simply follow my very easy steps. Don't worry about *how* the program does what it does, but rather, simply *enjoy* what it does.

IMAGES AREN'T ALWAYS PERFECT EITHER

Digital technology isn't for human imperfection alone. Sometimes, when an image isn't grabbing you, it's not because of "flaws" in the subject. Sometimes it's the composition or the background, for example. Sometimes a different background will help the subject pop more, thereby gaining more visual weight in the image. Sometimes you forget to move in close enough and the subject lacks impact. These things can also be fixed by photo-editing in the computer.

When I loaded the image opposite into my computer, I realized that my beautiful subject did not stand out from the background due to the similarity between the color of her clothes and the wall behind her. To get more separation between the two elements, I brought in the green door in the image on page 44 to use as the background. The green complements the red clothing better, and the result is that my subject really pops out from the background. We'll cover techniques like this, and more, on the next few pages.

70–200mm lens at 110mm, f/5 for 1/500 sec.

What Wrinkles?

Before we begin, I should mention that the following techniques in the rest of this chapter describe functions in Photoshop, but other photo-editing software programs may have similar features, for which the general concepts will be similar.

The first Photoshop tool I want to mention is the Spot Healing Brush Tool (available in Photoshop CS2 only). I don't know of any other single tool that can as quickly remove wrinkles, fine lines, unsightly moles, pimples, scratches, or razor cuts. When you want to remove a spot on your image, you simply "paint" over it, and presto, it's removed and the skin is now "healed." (If only things worked that fast in the dermatologist's office!)

Whenever I use the Spot Healing Brush Tool, I follow a simple formula: I keep my brush size about 10 percent larger than the spot itself, and I almost always use a "soft" brush setting. Using a hard-edge brush setting oftentimes will leave a mark around the very spot you just removed, which, not surprisingly, calls attention to that same spot in much same way a scar on a person calls attention to an earlier accident.

THE HEALING BRUSH AND THE PATCH TOOL

Like the Spot Healing Brush Tool, the Healing Brush Tool (available in Photoshop CS) can also remove wrinkles, fine lines, pimples, and so on; but unlike with the Spot Healing Brush, with the Healing Brush Tool (in the Tools window) you must define a source point first, before applying the "healing." In other words, you need to click on an area of "good" skin first (to select it) and then you can apply the Healing Brush to the "bad" skin. (The tool will paint over the "bad" area with the "good" area selected.) Again, I keep my brush size about 10 percent larger than the line or wrinkle I want to cover, and almost without fail, I use a soft brush setting.

The Patch Tool (in the Tools window) works in much the same way as the Healing Brush and Spot Healing Brush, except that it allows you do a larger area of "healing" with one fell swoop. This is my tool of choice for removing bags under the eyes. The trick to using the Patch Tool, of course, is to find an area of skin that matches up in color and tone to the area you want to "patch"; in the case of bags under the eyes, I simply make a "skin graft" from an area around the upper cheeks. The Patch Tool duplicates the good skin, leaving no indications that the original, "good" area was ever tampered with.

To use, click on the Patch Tool, and now draw a line around the area you want to replace; once you've finished, click inside the area of "marching ants" and simply move it over an area of "good" skin that has a similar tone and color, and voilà, the bags under the eyes vanish—and with them twenty years of aging!

WORK IN 16-BIT

Whether you are shooting with a digital camera or scanning slides into digital format via a slide scanner, it's so much better if you do your Photoshop work in 16-bit color. Chances are really good if you're shooting in raw format that your camera's output is in 16-bit, and not until you're ready to save the image should you then convert to 8-bit. For those of you scanning with a high-end slide scanner, set the depth mode to 16-bit so that you, too, can have the benefit of 16-bit color.

Why 16-bit color versus the normal 8-bit? In 8-bit color, you have roughly 256 colors/tones to work with. In 16-bit, you have more than 64,000 colors/tones to work with—enough said!

When I arrived early one morning at the dentist's office for a checkup, I found myself sharing the waiting room with George Rourke, who had one of the most tired, weathered, worn-out yet wisdom-filled faces of anyone I had ever seen. I didn't know him before that morning but was quick to start a conversation with him, and over the course of the next fifteen minutes I learned he had spent most of the last two years taking care of his wife who had suffered a severe stroke. He was worn out and tired. I asked George if he could come by the studio where I would love to take his picture.

Since I wanted to take an "honest" portrait of George, showcasing him in all his tired glory, I chose to use a single-studio strobe light mounted inside a soft box and to place the light at a 45-degree angle to George's left; this sidelight effect would emphasize even further the texture of George's face and the stories of a life that could no doubt fill a three hundred page book. But after discussing George's earlier years, I began to imagine how George might have looked before the daily grind of life took its toll on his body. So with George's blessing and the aid of the Healing Brush and Patch tools, I was soon able to reveal a wrinkle-free George. For the comparison, I've done just one side of his face so that you can see the vast difference between today's George and the George of yesteryear.

80–200mm lens, f/11 for 1/250 sec.

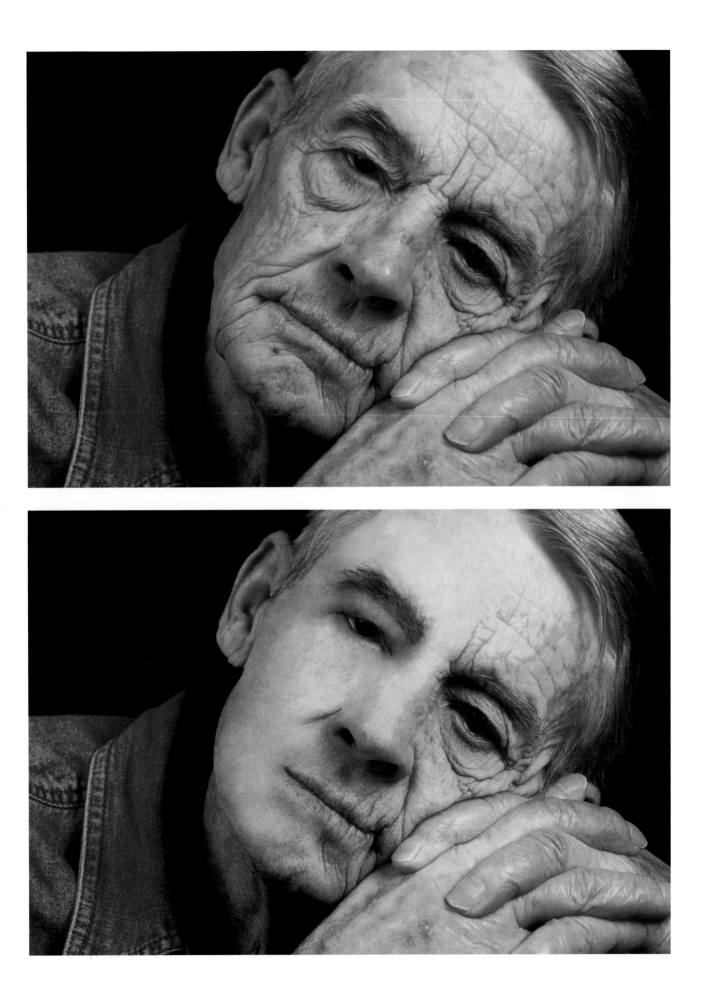

Tweaking Color

With the Hue/Saturation and Color Balance controls under Adjustments on the Image pull-down menu, you can adjust overall color in an image, improving skin tones and correcting unappealing color casts in your images. You can also boost or altogether change eye color and whiten teeth using these controls in combination with the Lasso Tool. In addition, Brightness/Contrast (also under Adjustments on the Image pull-down menu) can add that extra spark to eyes.

Accessing Color Balance from Adjustments in the Image pull-down menu after selecting the eyes using the Lasso Tool.

Original image.

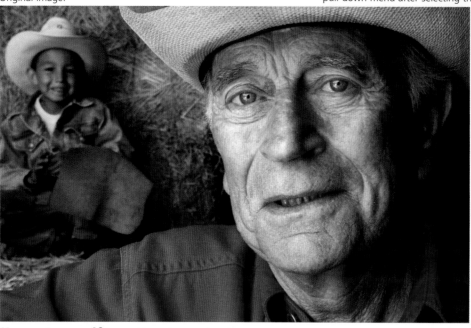

I'm not sure if it was his real name, but he insisted that everyone call him Curly. Curly was part of an assignment I did for Kodak a few years back, and along with his grandson, we made a number of images in and around the horse stables where he worked. The original image (above) is on Kodak Gold ISO 100 color negative film, but after scanning the negative into my computer with the Nikon CoolScan 4000, I had a digital file to work on. I countered the slight yellow cast of Curly's skin by using the Hue/Saturation control. Basically, I chose Yellows from the Edit pull-down menu in the Hue/Saturation dialog box, and moved the Hue slider to the left until much of the yellow cast on his skin was gone. I then used the Lasso Tool (from the Tools window) around his teeth to select them and clean up what little yellow remained there, again by moving the Yellows Hue slider in the Hue/Saturation control to the left.

To make Curly's "baby blues" even more vivid, I selected both eyes using the Lasso Tool. (When you are using the Lasso Tool and you finish with one selection, you can hold down the Shift key and start another selection without losing your first selection.) I then simply went to Color Balance under Adjustments in the Image pull-down menu and added nothing but Blue by moving the Yellow/Blue slider to the right.

I also added a touch of brightness to the eyes using the Brightness/Contrast at about +5 for both. The last thing I did while the eyes were still highlighted was use Feather (from the Select pull-down menu) with a radius of 3 to soften the edges of the eyes a little. As I do most often at this point, I converted the image format to Lab Color (under Mode in the Image pull-down menu), added my sharpness, and finally chose Save As (from the File pull-down menu) to save this altered version as a separate file from my original version, thus preserving my original.

Boosting the blue of the eyes with the Yellow/Blue Color Balance slider.

Selecting the Feather Radius to soften the edges of the eye area.

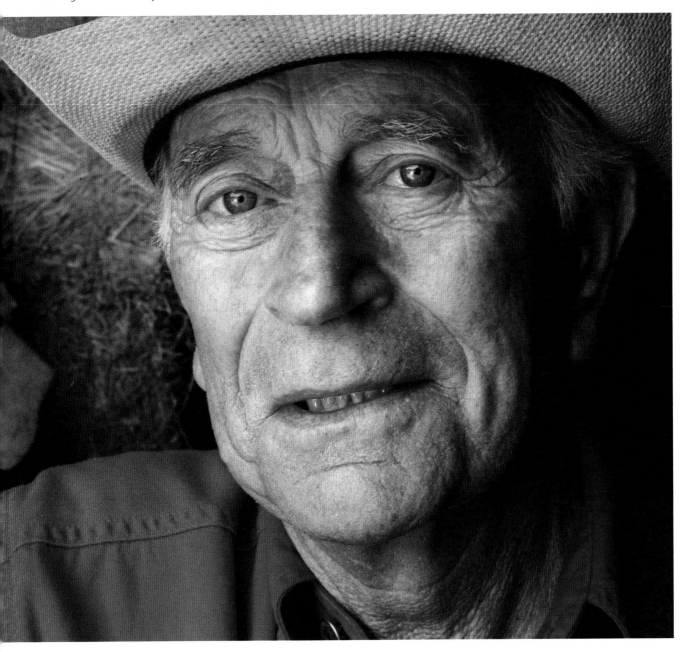

Major Color Changes

In addition to using photo-editing programs like Photoshop to make overall tonal shifts or to boost colors slightly in your photographs, you can also use these programs to make more obvious color changes, both on small and large areas.

Here's an image with two problems; one is really obvious and the other, perhaps, not at all since it's purely a matter of personal taste. The first is the hair: Take note of the pilot's hair color in the first photo (left). His normally white hair has been severely contaminated by his close proximity to the yellow plane; plus all of that frontlight that's hitting the plane is, of course, reflecting back onto him. If you've ever shot that beautiful bride on the shady side of the church and ended up with a woman wearing a blue dress, then you know how easy it is for white to become contaminated. And you can use the same steps I'm about to show you here to also getting back the white in a bride's dress.

With the Lasso Tool, I simply circled the hair, and with the "marching ants" in place, I went to Hue/Saturation (under Adjustments in the Image pull-down menu) and chose Yellows (from the Edit pull-down menu in the Hue/Saturation dialog box). I slid the Saturation slider to the left until the yellow was gone, and just like that, his white hair returned!

The second change was not really necessary, but I personally didn't care for his green jacket; I wanted it blue. So from the Tools window, I chose the Magic Wand Tool, and while holding down the Shift key with my left hand, I made multiple mouse clicks with my right inside his jacket until the entire jacket was outlined. I then went to Hue/Saturation and moved the Hue slider around. (Moving it left or right affects an immediate color change.) When I saw the blue color I was seeking, I stopped moving the Hue slider and went to the Saturation slider to adjust the intensity of that color blue. As with Curly's eyes on the previous pages, I also used Feather to soften the edges of the new jacket color, again with a Feather Radius of 3.

Original image.

Adjusting the Yellows in the selected hair using Hue/Saturation.

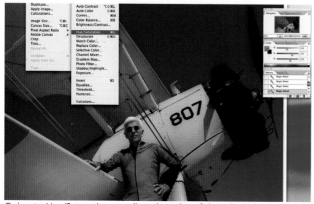
Going to Hue/Saturation to adjust the color of the selected jacket area.

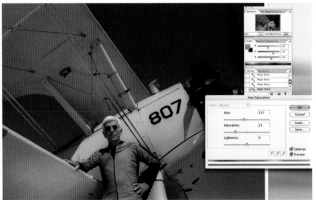

Adjusting Hue to change the jacket color from green to blue.

Adjusting Saturation to intensify the new blue color.

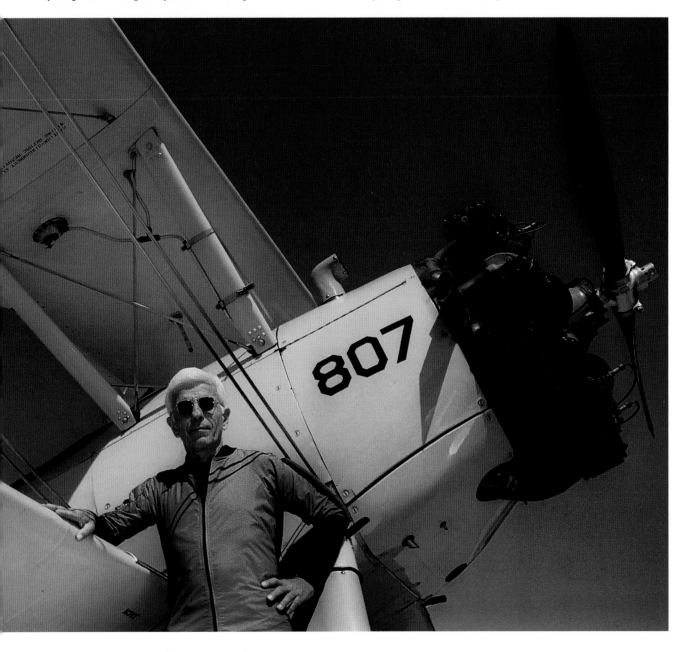

Mixing Color with Black and White

Have you seen the movie *Pleasantville*? If so, then you will really appreciate this next little gem of a tool found in the Photoshop Tool window. Combining both color and black and white into a single image is just one of the many things the History Brush Tool can do. How does it perform such magic? Take a look.

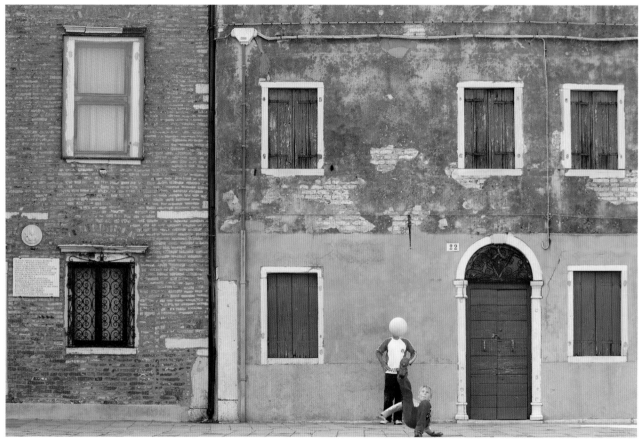

Original image.

First, I started out *with a color image opened on my computer. My choice: two boys kicking a soccer ball in a small town in Italy. I chose Hue/Saturation from Adjustments in the Image pull-down menu to boost the color up a notch. Then I opened Channel Mixer (also under Adjustments in the Image pull-down menu) and clicked on that box in the lower left corner of the dialog box that reads Monochrome. Like that, the entire image was converted to black and white.*

Then, before proceeding, I made sure my History window was open. (To open the History window, go to the Window pull-down menu and scroll down to the word History.) By default, this window keeps a running tab of a total of twenty steps performed while working on a single image. In this case, I had only performed three steps at this point (Open, Hue/Saturation, and Channels), and all of these steps were shown in the History window.

Next, I chose the History Brush from the Tool window, returned to the History window, and clicked inside the small box right next to the Hue/Saturation step listing. That reactivated Hue/Saturation so that I could change any part of the black-and-white image back into color by simply "painting" on the area with the History Brush Tool. Pretty darn amazing!

Since I wanted everything except the boys and their ball to be black and white, I used the Zoom Tool to increase the size of the image 200 percent to make "painting" easier, and I made sure to choose a brush size that was appropriate for the area.

Calling up Channel Mixer from Adjustments in the Image pull-down menu.

The Channel Mixer dialog box with the Monochrome box checked.

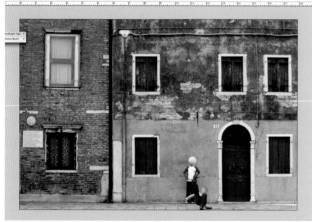

The resulting black-and-white image.

The opened History window, which is accessed from the Window pull-down menu.

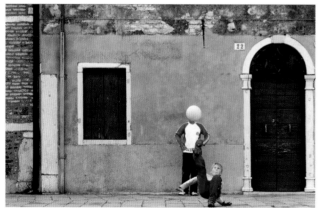

The boys "painted" in color.

If you've seen the movie Pleasantville, you will really appreciate this gem of a Photoshop tool.

"Painting" Different Colors

Of all the tools and discoveries I've made with Photoshop, I know of nothing more valuable than the New Adjustment Layer feature, and I have yet to meet a student who didn't feel the same way. New Adjustment Layer lets you make so many changes to an image with such ease that if you ever wished you could play God, this function will surely give you that chance.

Adjusting Reds in the Hue/Saturation function in New Adjustment Layers.

Original image.

With my image opened *on the desktop, I went to New Adjustment Layer in the Layer pull-down menu, and selected Hue/Saturation. After assigning a name in the New Layer dialog box, the Hue/Saturation dialog box popped up, and by simply moving the Hue slider I altered the colors of this image. Even though I did alter every hue in this image, I was particularly interested in the color of the leaves and flower petals.*

So how the heck did I make these changes without changing anything else? I could have used the Lasso Tool to draw a line of "marching ants" around the leaves and petals, and then apply the Hue/Saturation tool effect only in this area, but that would have required a bit more detailed care than necessary. Instead, I made use of the color palette in the lower portion of the Tools window, one black and the other white. First, I made sure that the front color was black and the background color was white. Next I pressed the Option and Delete keys at the same time to remove previous actions and return the image to the original state. Then I clicked on the white square to make it the front color (and the black color the background one). I selected the Brush Tool from the Tools window and begin painting over the area where I wanted to apply those changes made with the Hue/Saturation command. I was able to have full control over only those areas where I wanted to apply the change by simply painting them with a "white paintbrush." When I was done, I flattened the image.

If you should accidentally make a mistake and paint over an area that you don't want to change, you simply switch the boxes so that the black one is now in front and paint over the

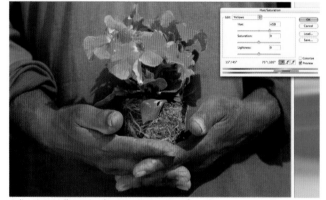

Adjusting Yellows in the Hue/Saturation function in New Adjustment Layer.

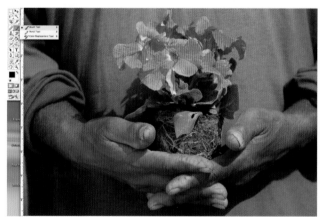

Selecting the Brush Tool from the Tools window.

area you mistakenly painted with white to return the area to the original state. You can paint in this fashion for all of the options (Levels, Curves, Color Balance, Hue/Saturation, and so on) that are available when making a New Adjustment Layer. Even though the entire image changes when you apply any of these tools, you simply hit Option and Delete at the same time, returning the image to its original state, and then select the white box to begin painting only those changes you want back into the scene. The possibilities are truly endless.

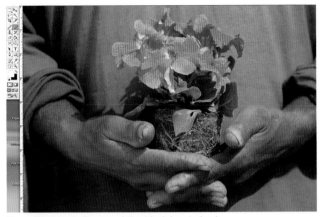

The white box in front and the black box in back on the bottom of the Tools window.

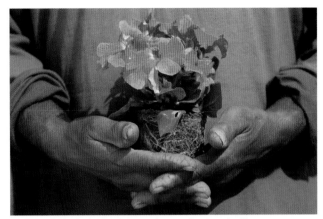

"Painting" the unwanted shirt color out, leaving the flowers.

Adding Drama

I n addition to "painting" selected areas with the New Adjustment Layer feature as discussed in the last technique, you can use the Levels function of New Adjustment Layer to alter hues to intensify the overall color of your photograph.

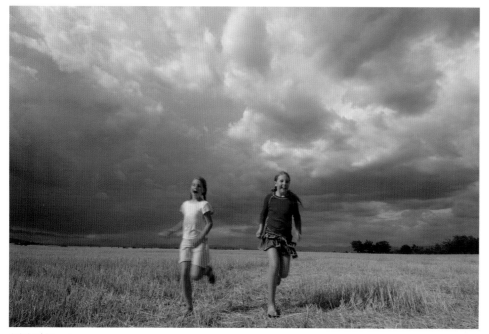

Original image.

This image provides another example. I made this photo this past summer as my daughters and I were enjoying another symphony of thunder and lightning atop the Valensole Plain in Provence, France. One thunder clap was loud and strong enough that it seemed to even shake the earth, and it caused my girls to run for cover. As they did, I managed to fire off several frames before they ducked under the cover of an old farmhouse that was behind me.

As you can see, the original image does show some hint of a summer storm, but it wasn't until I did a Levels adjustment (under New Adjustment Layer) that those angry storm clouds became really apparent. And once again, when I applied this change, the whole image became darker—even my two daughters—but with the aid of my "white paintbrush" (and after pressing Option+Delete to return the image to the original state), I simply painted back the darker sky. Then, after flattening the image, I kicked up the overall contrast by using the Brightness/Contrast control under New Adjustment Layer in the Image pull-down menu. Clearly the second image is far more dramatic than the original.

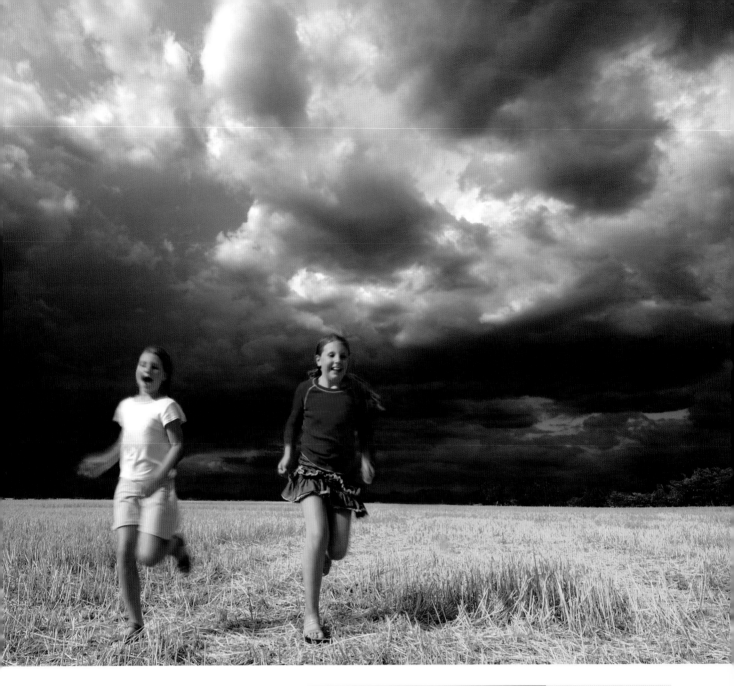

Accessing Levels under New Adjustment Layer in the Layer pull-down menu.

Adjusting Levels.

High-Tech Cutting and Pasting

*B*eam me up, Scotty are words that any Trekkie would recognize. Perhaps the day will come when all of us, with only a simple request, can really be transported to another place, but for the time being, we'll have to be happy with the Extract Tool in Photoshop. This is a really fun tool to get to know—and for lots of reasons, both good and "sinister" I might add. Most of us are familiar with those postcards that show the normal-size fisherman holding that giant fish. That fisherman can now be you with the aid of the Extract Tool.

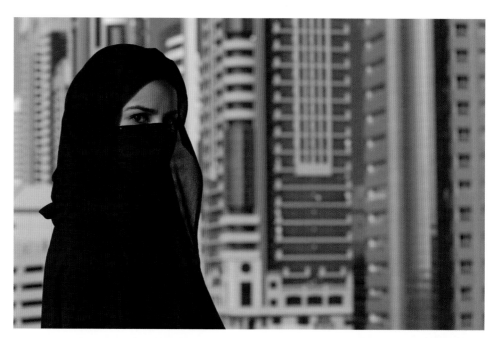

Original Dubai image.

Original Provence image.

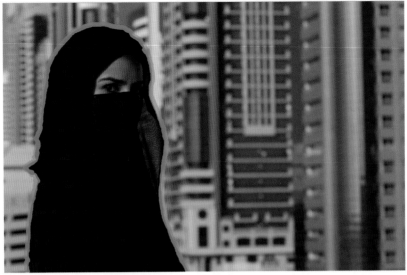

Highlighting/outlining the figure in the Extract window.

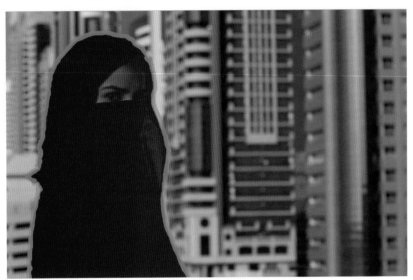

Filling in the highlighted area using the Fill Tool.

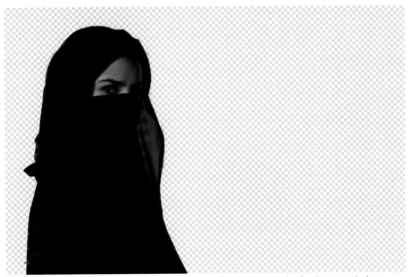

The extracted figure moved to its own window after hitting OK in the Extract window.

In one of my workshops at Gulf Photo Plus in Dubai last year, I met a young woman from Iran. She was well traveled; had lived in the United States, France, and Spain; and was now going to school in Dubai. Typical of a well-traveled person from the Middle East, she spoke fluent English, French, Spanish, and of course Arabic. And, she gladly accepted my request to pose.

When she told me that of all the places she had not visited but still hoped to, the lavender fields of Provence were high on her list. That's about a seven-hour plane ride from Dubai. But with the Extract Tool could take her there in less than two minutes—and without any signs of jet lag.

I first opened the original image of her in Dubai. I went to Extract on the Filter pull-down, selected the Edge Highlighter Tool (the top left-most icon) in the Extract window that opens, and drew a line around her. I then selected the Fill Tool (the paint bucket icon just below the Edge Highlighter icon) and clicked the mouse inside my outline, filling it with "paint." Then I simply clicked OK, and within a matter of seconds, she was all alone against a white/gray checkerboard pattern in a new window.

I then opened my lavender field image that I wanted to move her into. Since the lavender field was a sharply focused scene, I opted to blur it slightly (before placing the woman into) so that it would look as if I had selectively focused while framing her against a lavender field, resulting in a more believable image. To make the blur, I used the Gaussian Blur tool (found under Blur in the Filter pull-down menu).

Selecting the Move Tool (upper left corner) with both the background image and the extracted figure open on the screen.

Dragging the figure into the lavender field image.

Photoshop drags a copy of the extracted piece into the background, so you will also still see the extracted figure in its window.

To move the cut-out figure into the blurred lavender field, I used the Move Tool in the upper right corner of the Tools window. I clicked on this, moved the cursor over the figure, held down the mouse, and simply dragged her from the checkered window into the window showing the lavender field picture. Once I had it in position, I went to Flatten Image in the Layer pull-menu. At this point, you would then be able to make whatever other changes you wanted, whether they involve the Healing Brush Tool, the Clone Stamp Tool, Brightness/ Contrast controls, or something even grander with New Adjustment Layer. Are we having fun or what?!

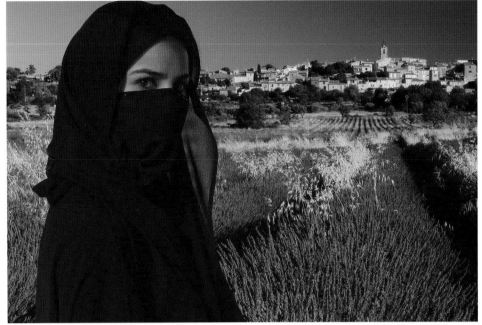

For comparison, I've included the combined images with the unsharpened version of the background. You can see that the final version below, with the blurred background, looks a bit more believable.

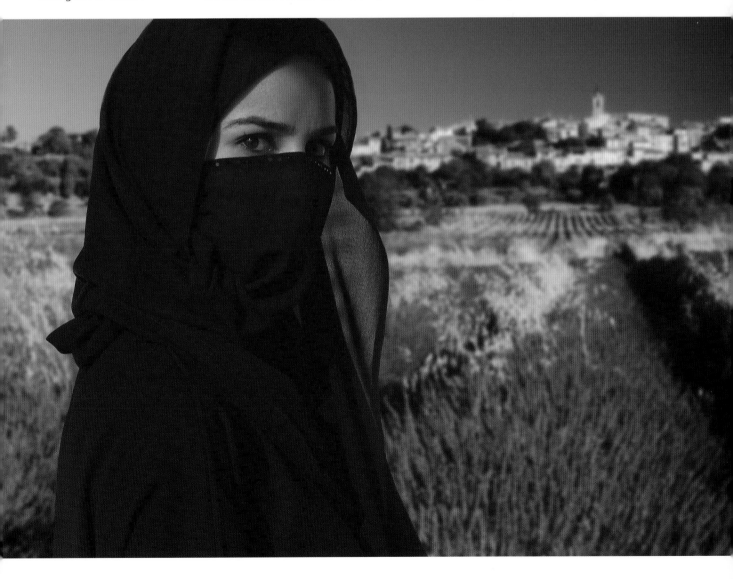

Sandwiching Images

I f you're feeling a real hunger for some photo-editing fun, then you'll love this next feature on the Photoshop menu: something I call the *digital sandwich*. Just like the name implies, you start out with two "slices of bread" (two images) but you end up combining and flattening them so that they ultimately look like one photograph. The simplicity of this "recipe" will have you hooked on making digital sandwiches for months, if not years, to come. Pick any number of your shots for this simple technique, and you'll be amazed at how this simple technique can transform ho-hum images into truly "wow" stunners!

Original steelworker image.

Original sunset sky image.

I'm not a big fan of midday light, but when it comes to potential images for making digital sandwiches, those with midday light can't be beat—if you know how to expose for it with a digital sandwich in mind. That's what I did here. This image of steelworkers set against strong midday backlight in Dubai caught my eye, and I was quick to pull over to the side of the road to mount my camera on a tripod.

Upon returning to my office, I loaded the image onto my computer and began looking through my sunset sky images. I found the perfect one taken in Holland a few months prior.

Then, to begin the sandwich, I went to Levels, under Adjustments in the Image pull-down menu. In the Levels dialog box, I chose the rightmost Eyedropper button in the lower right corner and then clicked in the gray sky of my image, which turned the sky to white. Next, I chose the leftmost Eyedropper button in the Levels dialog box and clicked on the darker areas in the shot to make extreme black-and-white contrast between the sky and workers.

Next, I opened the susnset image and made sure it was the same size and resolution as the steelworkers image (if your images are not the same size and resolution, they won't line up). With both images open on the desktop, I clicked on the sunset image and pressed Command + A to select it and get the "marching ants" around it. I selected Copy from the Edit pull-down menu, clicked on the steelworkers image, and selected Paste from the Edit pull-down menu, which covered the steelworkers shot with the sunset shot. I then went to Blending Options under Layer Style in the Layer pull-down menu. In the Blend Mode pop-up menu I chose Multiply to make my sandwich. To finish, I went to Flatten Image in the Layer pull-down menu to officially make the two images into one. At this point, I was free to make whatever Brightness/Contrast adjustments (in the Image pull-down menu) I needed.

Selecting the rightmost Eyedropper from the
lower right corner of the Levels dialog box.

Clicking on the background area of the image
to change the background from gray to white.

Selecting the entire image (so that it is surrounded
by "marching ants") and copying it.

Pasting one image into the other.

Choosing Multiply from the Blend Mode
pop-up menu in the Layer Style dialog box.

The two images flattened together.

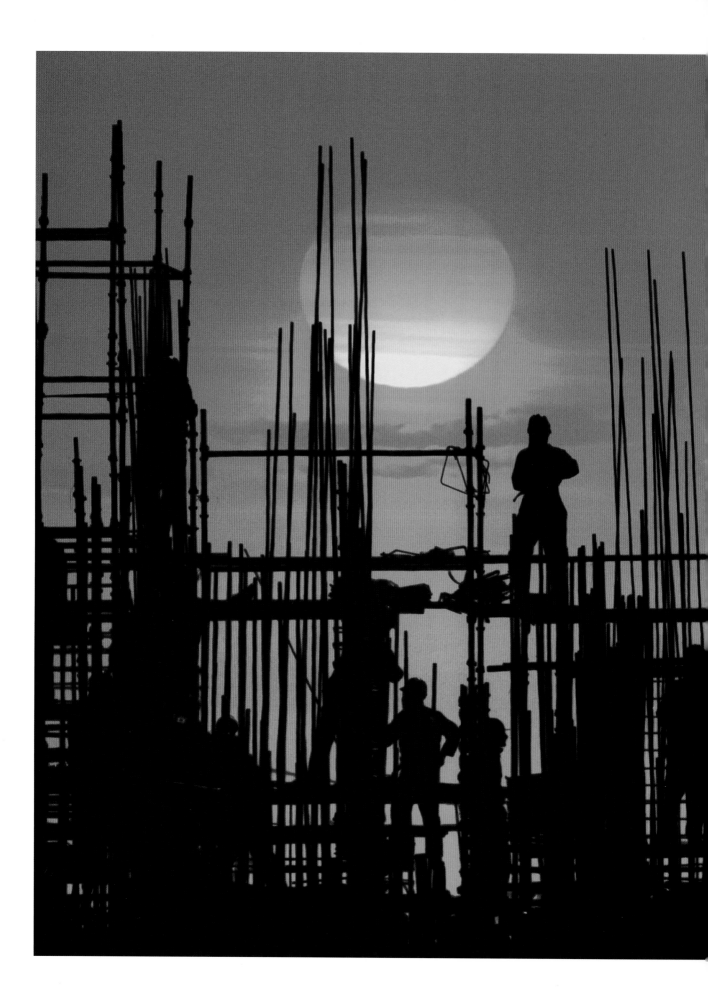

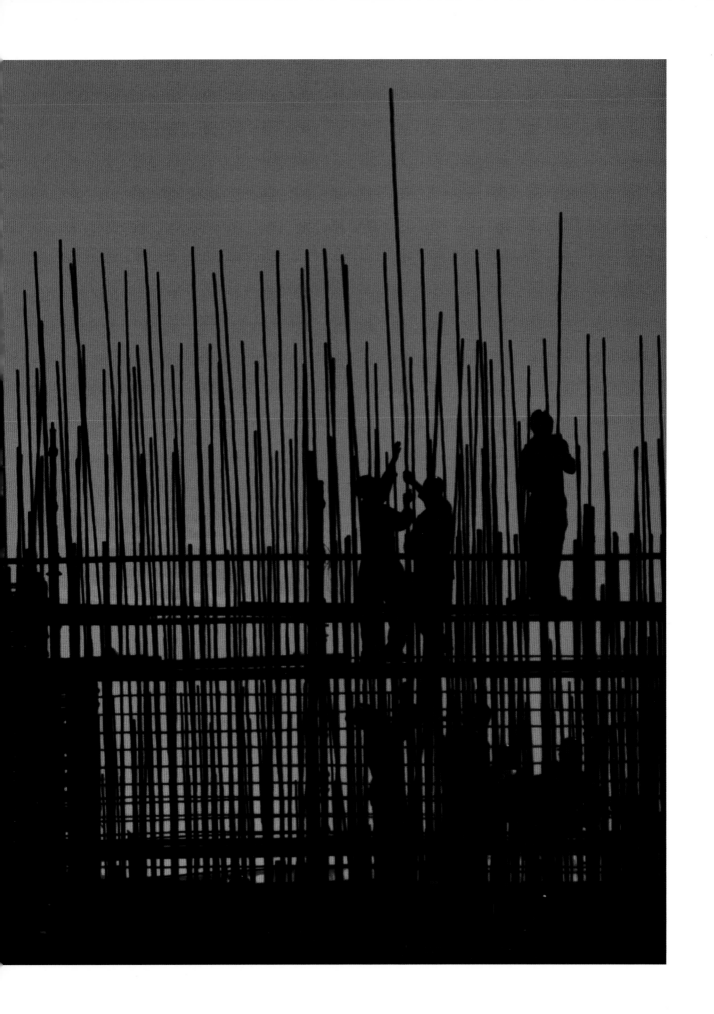

Adding Atmosphere

You don't have to stick to making straight digital sandwiches with two images. You can use the sandwiching concept with one image and other effects to create a dreamlike atmosphere in your images.

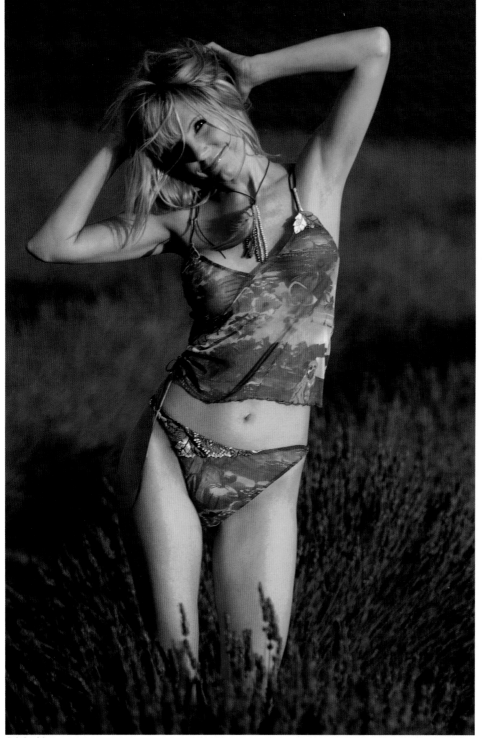

Original image.

The first thing I did *after opening up the original image of my wife, Kathy, in Photoshop was choose Duplicate from the Image pull-down menu. Just like that, I had two identical images side by side. I then selected the Rectangular Marquee Tool from the Tools window and used the mouse to highlight the duplicate image. (When you do this, the "marching ants will appear around the entire perimeter of the second image.) Next I went to Gaussian Blur (under Blur in the Filter pull-down menu) and applied a blur of 50 pixels by moving the slider from left to right. Then I went to the Edit pull-down menu and clicked on Copy. I then clicked on the original image (making it active), returned to the Edit pull-down menu, and clicked Paste. The blurry image was now covering up the original, in-focus version.*

I then went to Blending Options under Layer Style in the Layer pull-down menu. In the Blend Mode pull-down menu in the Layer Style dialog box, I chose Multiply and, presto, I had my sandwich. When I was done, I went to the Layer pull-down menu again, and scrolled all the way down to Flatten Image to officially make these two images one. At this point, I am free to make whatever Brightness/Contrast adjustments I feel I may need.

The original image (left) and the duplicate image with the "marching ants" indicating that it has been selected with the Rectangular Move Tool (right).

The Gaussian Blur dialog box. A preview of the blur effect appears in the window in the dialog box.

Copying the blurry duplicate image into the original version results in two blurry versions.

Selecting Blending Options from the Layer Style function in the Layer pull-down menu (while the window showing the original now-blurry image is active).

Choosing Multiply from the Blend Mode pull-down menu in the Layer Style dialog box that comes up after accessing Blending Options.

The result of the Multiply selection in the left-hand window.

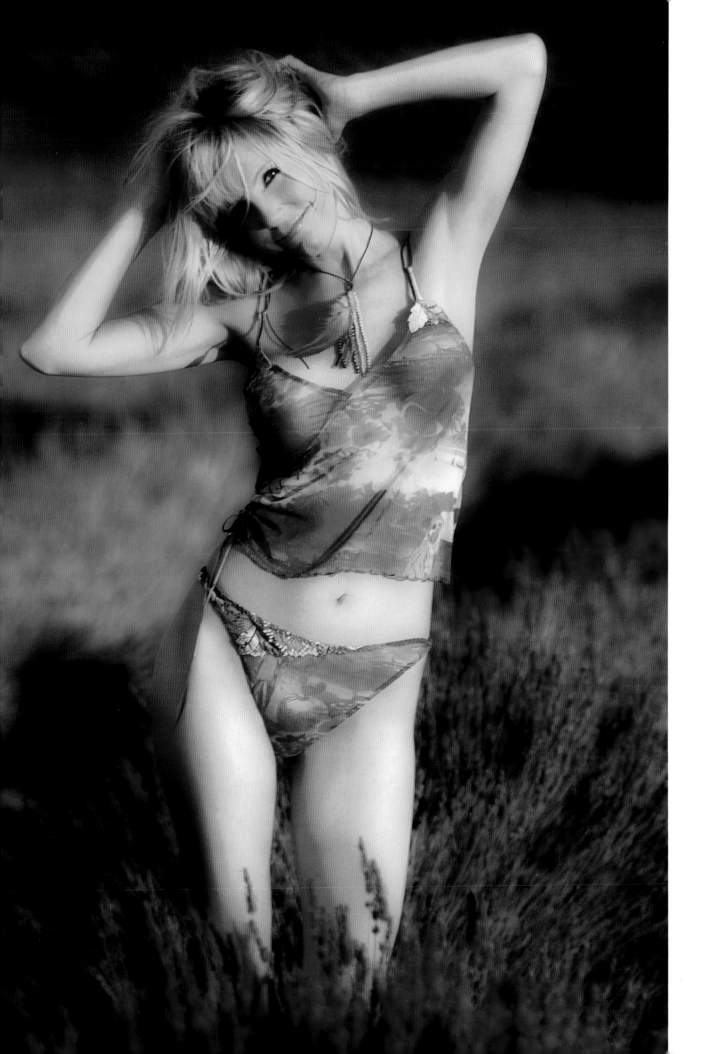

Selective Atmosphere

Where is it written that, when you are using the Gaussian Blur filter feature you have to blur the entire photograph? It isn't written anywhere, of course! Using the Lasso Tool, you can select only a portion of the image to blur.

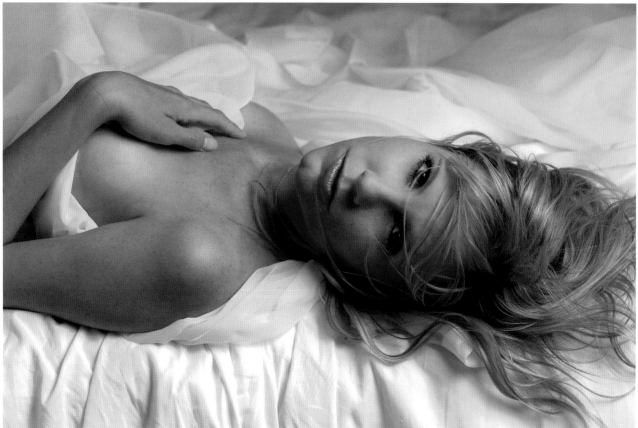

Original image.

I wanted to apply Gaussian Blur to everything in this image of my wife, Kathy, except her eyes, so I used the Lasso Tool from the Tool window to select only her eyes. After doing that, I chose Inverse from the Select pull-down menu. This caused the "marching ants" to appear around everything but her eyes. I then clicked on Gaussian Blur under Blur in the Filter pull-down menu and everything except *her eyes was blurred*. When sandwiched together with the original, unblurred image, the effect is quite stunning.

Duplicating the original image for sandwiching later. (The Duplicate function is in the Image pull-down menu.)

The duplicate image side by side with the original.

Going to Inverse after selecting only Kathy's eyes ("marching ants" appear around the eyes).

The result of applying Inverse: the "marching ants" appear around the edges of the image and the eyes to indicate that everything *but* Kathy's eyes is now selected.

Adjusting the blur in the Gaussian Blur dialog box and applying it to the selected area (everything but the eyes).

Copying and pasting the blurred image into the original.

Selecting Multiply from the Layer Style dialog box accessed from Blending Options in the Layer pull-down menu.

Choosing Flatten Image from the Layer pull-down menu to flatten the layered, blended images.

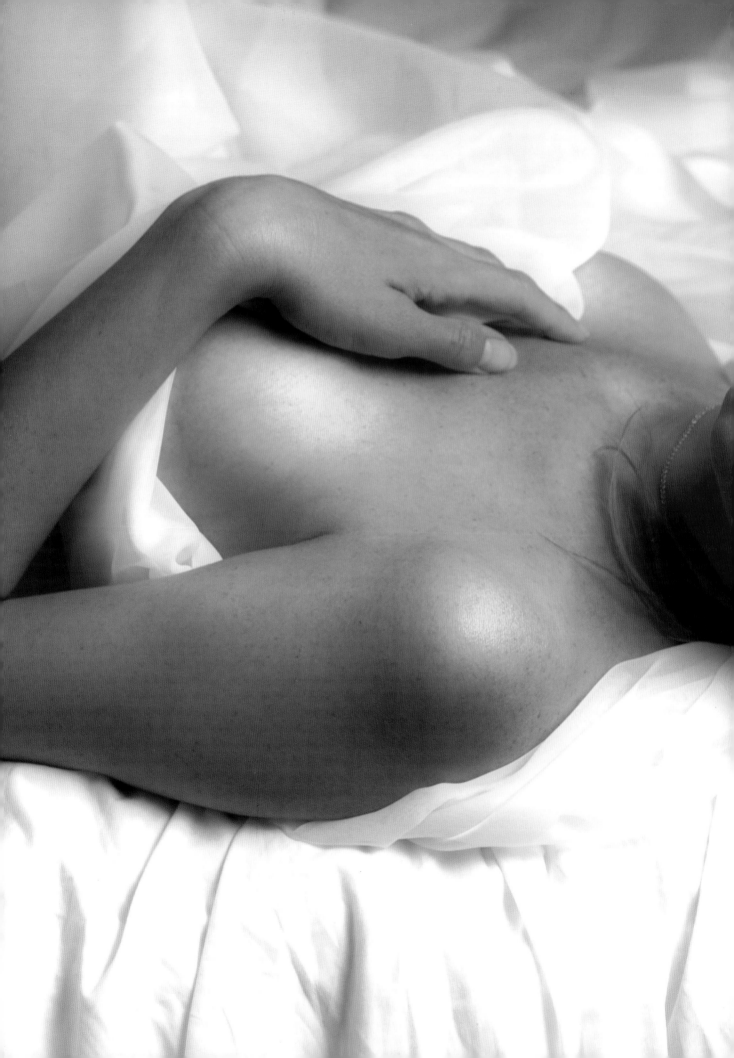

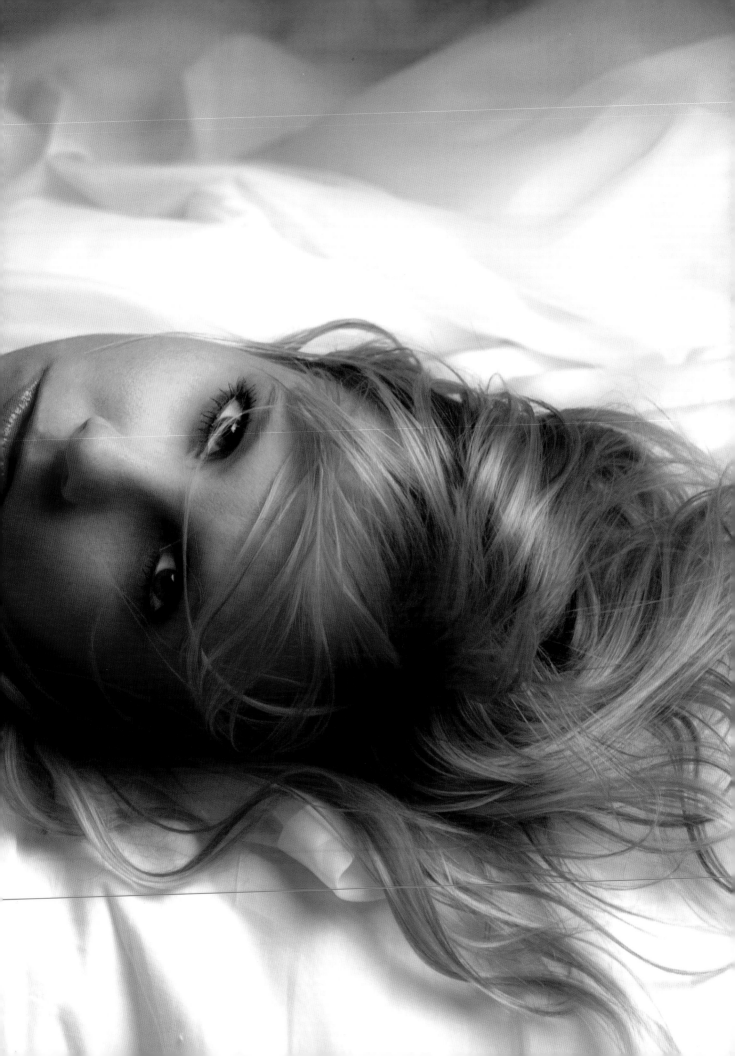

Cropping and Resizing

There's nothing more frustrating than, after putting a great deal of thought and technical know-how into an image, discovering that you still didn't get close enough and fill the frame or that you didn't see the obvious vertical shot or that you didn't notice that the horizon line was, in fact, crooked. Not a problem, because as you'll discover, cropping is easy with any number of photo-imaging programs, Photoshop included. Simply call on the Crop Tool in the Tools window, and just like that, you've cut out distracting stuff on the left and right or you've cropped in really tight and now have that vertical composition you wanted or you've managed to straighten the horizon line.

Okay, so the digital industry has forced me to calm down my rhetoric about doing any cropping via the computer. As many of my readers know, I'm a staunch advocate of cropping in camera, but now with the onslaught of larger and larger megapixel DSLRs, it's fair to say that you can get away with cropping up to 30 percent of a given photo and still end up with a really nice 8 x 10-inch print. Granted, it might be a push to make it much larger without seeing the "loss" in quality, but how many of you make 16 x 20-inch prints on a regular basis? So, I have to concede that cropping via the computer (within reason, of course) will not harm your images. But I still have to have the last word here: Whenever possible, try to get it right *in camera*. More often than not, the problem is not that photographers don't have the right lenses, but that they are too lazy to simply move in closer.

In fact, this ease of cropping with software programs is, no doubt, in part behind many photographers' lackadaisical attitude toward being attentive to effective composition *in the camera*. They reason, *What the heck, I will just crop it later on the computer.* Eventually, more noise (a more pronounced graininess to the image) and loss of sharpness will result. As I mentioned above, you'll probably be able to live with it, but just by way of explanation, let's assume that you produced the original photo with a 6 megapixel camera. The output size of that file (whether it be in raw, TIFF, or JPEG FINE format) will be around 3000 ppi x 2048 ppi or, in more familiar terms, a print size of about 10.2 x 6.8 inches. When you crop 10 to 20 percent

of the image, you are, in effect, casting aside 10 to 20 percent of the pixels. So assuming you still want to produce a print, you're using 10 to 20 percent fewer pixels to produce the same 10.2 x 6.8-inch print. Print quality will be affected. Both grain (noise) and loss of sharpness will be evident—and rather than having the eye respond favorably to the image, it may actually be drawn to those now obvious flaws.

There are a number of software programs available for combating these kinds of problems, one of the most popular being Genuine Fractals. In the simplest of terms, think of Genuine Fractals as giving steroids to the remaining pixels. In effect, the remaining 4,800,000 pixels can now pull the same weight as the original 6,000,000, with only a minimal loss in print quality. But, this additional software costs money, and then there is the time it takes to do the crop on the computer and so on. Just another great reason to strive to make *all* of your compositional arrangements a success *in camera*!

GETTING IMAGES WEB-READY

When it comes to preparing images for the World Wide Web, there is one standard and it is this: Most everything on the Web is in JPEG format. If you have been shooting everything in raw format (as I recommend you do), you may be wondering how to get a JPEG copy of the raw images you want to send to friends, post to a family Web site, or load onto your own "professional photography" Web site.

It's a very easy proposition, made even easier when you set up an Action in Photoshop. If you only want to create a single JPEG image, you would simply open up the file, go to Image Size in the Image pull-down menu, set the Resolution to 72, and then in the Pixel Dimensions box type 700 inside the horizontal header if you're working on a horizontal composition or type 700 inside the vertical header if you're working on a vertical composition. Make sure you have the Resample Image box checked, as well as Scale Styles and Constrain Proportions. Then go the File pull-down menu, scroll down to Save As, and locate the Format pull-down menu in the Save As dialog box that appears. Click on this and you'll see a host of choices. Choose JPEG, and when the JPEG Options dialog box appears all you need to do is set the slider to Maximum and click OK. The image is now ready for the Web.

If you have a whole batch of images that you want to convert to JPEGs, you would do the same thing as mentioned above, but if you assign all these choices to an Action, you only have to manually convert the first image in the batch and all the others that follow will be done automatically. The first thing to do is open *all* the images you want to convert to Web-ready JPEGs. Go to the Window pull-down menu, scroll down to the word

DIGITAL PRINTING TIP

If you want to know what the largest print size (in inches) would be that would still maintain the highest quality that you can generate with your digital camera, divide the vertical and horizontal pixel counts of your camera (see your manual) by 200. For example, with my Nikon D2X the pixel count is 4288 x 2848. If I divide this by 200, I get a print size of roughly 21 x 14 inches.

Actions. The Actions window appears (probably on the right-hand side of your screen). Click on the Create New Action icon (the icon at the bottom of the Actions window that looks like a piece of paper with one corner turned up) to get to the New Action dialog box. Pick a name for your Action, for example "Web-ready images," and type it inside the box. Then click Record.

Now, as I mentioned, you must manually do the first conversion, using the same steps I described for just doing one conversion above; but this time, the Actions function/window is recording your every move. After you finish the first one, you simply click on the Stop button. Now,

return to your "Web-ready images" Action, and choose the Play button (the sideways triangle two buttons to the left of the Create New Action icon at the bottom of the Actions window). When you click on this button, Photoshop automatically converts each and every image in that folder to the same exact specifications that you did on the first conversion. And when you gather another folder of images that you want to convert to Web-ready JPEGs you can, once again, call on this Action that you saved as "Web-ready images" and merely click on this to start up the automated process all over again. Nothing could be easier!

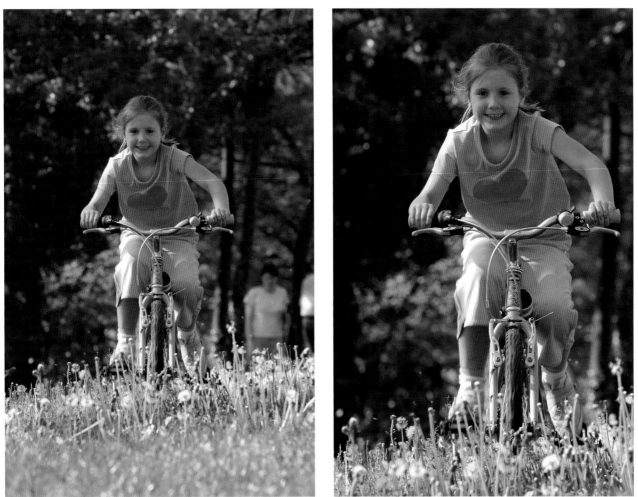

If ever there were an award for the biggest distraction that's sure to call attention from your intended subject, it would have to go to those "strangers" in the background. These strangers are common at city parks and theme parks, as every parent knows all too well. Try as you might to get a clean background, sometimes it just doesn't happen and cropping is the only solution.

Sharpening

What is, perhaps, the most *over used* tool in all photo-editing software? The sharpening tool! I can spot an over-sharpened image in the dark almost, since every oversharpened image *glows*, and I do mean it glows! And do you know why it glows? Let's take a look.

First of all, if you're looking to add one more thing to your get-it-right-in-camera list, you should put making a sharp image right at the top. *Optical sharpness* is, and will always be, about your lens and the quality of your sensor. In theory, the higher-priced lenses and the higher megapixel cameras will combine to create the best optical sharpness. But, all digital images require some degree of sharpening, which is where *software sharpness* comes in. Not to be confused with optical sharpness, normal software sharpening is meant to serve one purpose: to bring out more of the sharpness and detail you have *already captured*. You will never be able to *add* detail by sharpening if the detail isn't there to begin with, and therein lies the problem. In an attempt to compensate for a lack of sharpness when the image was recorded, photographers will ramp up the sharpening tool and end up oversharpening the image.

Truth be told, sharpening does nothing more than create additional contrast around each pixel, giving the illusion that it is sharper. This illusion of sharpness is actually a colored halo around each pixel, and the more you sharpen the more obvious each halo becomes—so much so that the halos take away from the quality of the picture.

So, what are the recommended settings for sharpening via software programs such as Photoshop without fear of halos? First of all, if you're shooting raw and saving to TIFF, or shooting straight to TIFF, the rules are the same: Only after you have made all of your adjustments, fine-tuning, layering, color corrections, spotting, cloning, and so on should you even think about adding some sharpness. Sharpening your image is the *last* thing you do.

The sharpening features in Photoshop can be found under Sharpen in the Filter pull-down menu and they are: Sharpen, Sharpen Edges, Sharpen More, and Unsharp Mask. Only Unsharp Mask offers you a choice of how much or how little sharpening you want to add since the other three choices do it for you within preset parameters—and I have yet to find anyone who knows what those parameters are. This is the biggest reason Unsharp Mask is the favored choice for most shooters, since you have complete control over how much or how little sharpness you wish to add.

If you're like me, the name Unsharp Mask conjures up anything but a tool that would be called upon to make an image sharp. In fact, its very name implies the opposite. Yet it is *the tool* that most shooters should call upon and one of the best tools to use when you work in Lab Color. I will get to that in a moment, but first let me give a quick primer on Unsharp Mask. When you open the Unsharp Mask dialog box, you will see three bars: Amount, Radius, and Threshold. Amount adjusts the intensity of the filter, while Radius determines the size of the halo around the edge of each pixel and, thus, is the most critical the three settings. Threshold controls contrast differences between pixels and lets the filter know how similar or how different the values need to be before putting down the sharpening effect.

LAB COLOR SHARPENING

Now here's where it gets interesting. Set Amount to around 80 percent, Radius to 1.4 pixels, and Threshold to 3 levels. Assuming you're all done with making whatever changes you deemed necessary, go to Mode in the Image pull-down menu and click on Lab Color. Now go to the Window pull-down menu and scroll down to Channels. In your Channels window (which probably comes up on the right of your screen) you see a small color thumbnail labeled Lab and a small black-and-white thumbnail labeled Lightness. Click on the Lightness channel to change the image on your screen to a halftone black-and-white version. Then go to Unsharp Mask, and with the settings I recommended above, apply the sharpening *twice*.

What you're doing is sharpening the image while the colors of the pixels are "sleeping." The pixels will not respond to sharpening (they will not be affected) in the Lightness channel, which means they won't show up in the final print wearing their halos either. After sharpening the image twice, click on the Lab thumbnail in the Channels window to return to a colored image in sharp detail without the halos. Pretty cool, eh?

Finally, return to Mode in the Image pull-down menu and select and switch from Lab Color back to RGB (or CMYK if you're making a photograph press-ready) and then save.

TURN OFF THE IN-CAMERA SHARPENING

Most digital cameras offer an in-camera sharpening feature that's tied to the sensor. Unless you're shooting in JPEG FINE, turn this feature off and add the small amount of sharpening your image will need on the computer. Since JPEG is a compressed file (and a lossy one at that, meaning it loses quality every time it's opened), you will want to add as much good stuff as possible *before* that file gets compressed. Adding sharpne later via the computer means opening it up once again losing data.

To sharpen this image of my daughter and a friend, I first switched the mode to Lab Color.

I then went to the Window pull-down menu to access the Channels window.

Next, I clicked on the Lightness channel thumbnail in the Channels window to render the image a black-and-white halftone.

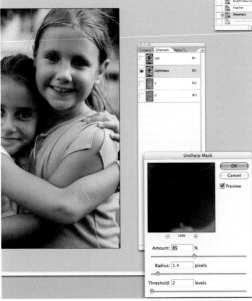

Then I called up the Unsharpen Mask dialog box from Sharpen in the Filter pull-down menu; chose my Amount (85 percent), Radius (1.4 pixels), and Threshold (2 levels) settings; and hit OK.

ack to color for the final image, I went to Mode ge pull-down menu again and chose CMYK (so mage was print-ready).

Appendix A:
Selling Your Photos as Stock

The term *stock photography* is used to describe the pictures that photographers or stock photography agencies sell to publishers of calendars, greeting cards, and textbooks, as well as to graphic design firms and advertising agencies for use in corporate brochures, annual reports, and even advertising campaigns.

The chief advantage to buying stock shots is that it is generally cheaper than hiring a photographer directly. For example, if I work at an advertising agency and need a shot of the Eiffel Tower, I can either call a stock photography agency or those photographers whose mailings have made me aware of their inventory of stock images. Most stock agencies have about two million pictures on file and represent anywhere from thirty to two hundred photographers. I decide to go with a particular agency and call in my request. Within several days, two dozen or so images of the Eiffel Tower are delivered. After choosing the one image that meets my needs, I call the agency to negotiate a price and arrange to return the other shots. The fee depends on several factors: how I intend to use the image, such as repeatedly for six months in a travel campaign or just once in a magazine or on its cover; what size the image will be, such as a full page or half a page; and the potential circulation of the image, which refers to the number of people expected to see the image.

Suppose I need the Eiffel Tower shot for the cover of American Airline's in-flight magazine. Since the image will appear on the full cover for one month and will be circulated to more than fifty thousand people, I might be charged between $500 and $700. If I were to hire a photographer to shoot a picture of the Eiffel Tower, I would have to pay a minimum of $350 per day plus expenses (film, processing, food, transportation). Of course, I would have no guarantee that the photographer would make the shot in one day. The weather might be bad, or the sky might not be colorful enough at dusk. Before I know it, I've spent more than $700 and still might not have the image that I could easily find through a stock agency. This is why there is such a big market for stock.

When I'm not busy working on assignments, I try to spend as much time as possible shooting stock images. This doesn't mean, however, that I can't generate stock while I'm on assignment. Many of my outtakes from a photo assignment do become stock shots, and depending on the client, I might use stock as a bargaining chip when bidding on the job. For example, several years ago, I was hired to photograph Germany's largest precious-metals plant. I knew that I would be afforded the opportunity to shoot plenty of gold bars of varying weights, so I reduced my assignment fee slightly in exchange for permission to keep numerous outtakes for my stock files. This was the right move because these pictures have generated more than $45,000 in stock income over the last ten years. And when you do assignment work for magazines, keep in mind that all of your pictures are returned once the article runs in the magazine. You are then free to use these images as stock.

To be really successful in the stock photography field, however, you need to approach it the way you would a full-time job—and you should make photographing people your primary focus. Stock shots of people—from infants less than a year old to individuals older than 85, at work or at play—account for more than 80 percent of stock sales worldwide. And much to the surprise of many newcomers in the marketplace, the greatest producers of stock income are pictures of people involved in very simple and "mundane" activities.

Although the subjects listed in the box below may seem ridiculously ordinary, they can be very profitable if you execute them well. That's the trick to successful stock photography. You can apply everything you've learned in this book to shooting stock images, such as framing a close-up study of a subject's face or hands, creating mood with different types of light, or changing your point of

POPULAR STOCK SUBJECTS

Some popular stock shots include the following subjects:
- A mother holding a sleeping baby
- A father and daughter fixing a bicycle
- A grandmother with her hot-from-the-oven cupcakes
- A grandfather and grandson fishing
- A young family posing in front of their yet-to-be-completed home
- A teenage boy washing and waxing his new car
- A girl giving her dog a bath
- A boy playing the piano
- A father and mother in their business clothes leaving the ball park with their son in his little league baseball uniform
- A family picnic
- A family building a tree house
- A grandmother surrounded by roses in her garden
- A grandfather asleep in a hammock
- A couple strolling on the beach
- A couple horseback riding
- A group of children riding a merry-go-round
- A man using a weeder

view. Most, if not all, of these principles are at work in almost every image in this book.

Finally, there's one very important aspect of photographing people that you must never forget: getting signed model releases for every person you photograph. Used in this context, the word *model* doesn't necessarily mean that the person is a professional model; it is simply a generic term that covers anyone featured in a photograph. Even if you don't currently have one iota of interest in selling your pictures for publication, get your subjects to sign model release forms! Suppose that two years from now you decide that you want to try your hand at marketing your photos. What are you going to do with your wonderful collection of people pictures for which you have no releases? Any reputable publisher, design firm, or stock agency won't even consider your work without model releases.

In a nutshell, a release simply states that the models featured in the photograph have given you a blanket permission to use the image in any way that you and a prospective client may deem necessary. Some model release forms are long, and others are short. My model releases fall somewhere in the middle. I used this model release form for each and every person in this book, and I've had the release printed in Chinese, French, German, Italian, Japanese, and Spanish. Contrary to popular belief, model releases are becoming the norm, rather than the exception, with publishers worldwide.

When you ask someone to sign a release, your explanation should be short and to the point. You might want to say something like, *I don't know if the photographs I am about to take of you will ever be published* (a true statement, by the way, whether you're on assignment or shooting stock) *but in the event that they are, the publishing world requires that I have you sign this permission slip.* Shift the blame off you and onto publishing. Whenever possible, I try to get my subjects to sign releases before I take the first picture for a few reasons; for example, the models might "get away" before I'm finished shooting, or they might feel they acted foolishly in front of the camera and be reluctant to sign anything before seeing the processed film (this can be a big problem when you must leave immediately for a new location five hundred miles away).

Whether you get the signatures before or after the shoot, be sure to get signed releases from everyone you feature in a photograph. Some photographers don't have friends or family members sign releases, but this can lead to disaster. Imagine this scenario. Three years after photographing your husband, you get divorced. He then sues you for selling pictures of him for stock without a model release. Similarly, your former in-laws sue you for selling shots of them on the local golf course because they never signed releases. Friend or foe, relative or stranger, get that model release signed right then and there. And every time you photograph friends and relatives, have them sign a new release that covers that specific shoot. Don't assume that five or ten different shots made over the course of several months or years are all covered by the same model release. They aren't.

Wherever your travels take you, whether just down the street or halfway around the world, you won't be lacking subject matter when your goal is to photograph people. As your experience grows with this inexhaustible supply of material, you'll learn to observe these subjects from a variety of perspectives. A simple portrait of a person's face will no longer be your only option. You'll discover that you can shoot just your subject's hands, or you can opt to shoot an entire profile. In some cases, you might suggest different attire or different hairstyles, or you might want to add props. You'll also want to try shooting from a variety of points of view, changing your lenses, and using a whole host of backgrounds. At other times, you'll want to experiment with illumination. Finally, you might want to direct your subjects in a number of ways, asking them to move left or right, or closer or farther away; you'll always have the option of having them look directly at the camera. Obviously, you have many choices—and subjects. And all this variety will help you when you consider trying to sell your photos as stock.

To really be successful in the stock photography field, you need to approach it like a full-time job—and you should make photographing people your primary focus.

Appendix B:
Digital Workflow

So what are we supposed to do with all of these digital files? I personally have no hard and fast rules for storing images except one: *Make backup copies of everything*! I was amazed to discover in a recent column written by John Owens at *Popular Photography & Imaging* that 74 percent of digital shooters store their images on their computer's internal hard drive! Yikes! In case you haven't heard, computer hard drives *crash*, and although not as often, even a Mac will crash. When a hard drive crashes, more often than not, everything is lost!

So, here's how I work. My current workhorse for all of my digital workflow is a Mac G5 with dual 1.8 GHZ processors, 2 GBs of RAM, a built in DVD burner, and two external 160 GB hard drives. In addition, when traveling on the road, I manage my digital workflow with my 15.2" Mac PowerBook, 1.5 GHz processor, 1 GB of RAM, and one external LaCie 8X DVD burner.

I shoot *everything* in raw format and always with a 1 GB or 2 GB compact flash card. On average, a one-day commercial shoot will usually generate 4 to 6 GBs of images. In the raw format, that's about 500 to 750 images with my Nikon D1X. If I'm out strictly shooting stock photography, I may end up shooting even more images if it's a production shoot (one involving models) or less if I'm simply shooting "catch as catch can."

Once I've attached the compact flash card via the USB card reader to my computer, I download all of these raw files into a folder on the computer's desktop. I give this folder a brief name and always a date, for example Shipyards-Charlotte NC-07-15-04.

I then view the images in this folder in Photoshop CS, which enables me to do an even tighter job of editing the photographs. I drag any pictures that don't make the grade to the trash, leaving only my keepers (still in their raw state, of course). I'm now ready to create *two sets* of color contact sheets of the images in the folder. Most photo-imaging software has an automated feature that generates contact sheets, and Photoshop is no exception. In Photoshop, it's called Contact Sheet II and it's found under Automate in the File pull-down menu. I simply choose the number of columns and rows I want in the Contact Sheet II setup menu. I always choose 3 columns and 4 rows (for 12 images per each 8 x 10-inch contact sheet), and I use the document resolution of 150 ppi (pixels per inch), as this gives me both a large and high-quality image for easy identification when I need to find a particular shot again.

Once the two sets of contact sheets are done, I make three copies of the image folder onto three DVDs and label each with the same name as the folder. (I choose DVDs simply because they hold considerably more data than CDs: 4.7 GBs versus the 700 MBs on a CD.) One set of contact sheets and one DVD are for the client, if there is one. The other set of contact sheets and two DVDs are for me, and I place them together in a hanging file folder in my filing cabinets. These are the same folders and cabinets I used for storing my slides, but the space that is now taken up is considerably less. With both the contact sheets and DVDs completed, I am ready to move the original folder to one of two 160 GB external hard drives.

Every time you insert a compact flash card into your camera and take a picture, the camera assigns a file number to that exposure (for example, DSC_102, DSC_103, DSC_104, and so on). If you don't change the counter to Continuous mode, you will record these same file numbers over and over again; and when you are compiling images from several folders (making a slide show with PowerPoint or a photo submission to a client, for example), you may compile images with the same number and, therefore, get a message telling you that that file number already exists and asking if you want to replace it with the one you are moving. Of course you don't, since that would literally eliminate the first image, overwriting the first image with the second of the same number.

So, set the frame counter of your DSLR to Continuous mode. Your particular camera model will determine how soon you'll have to worry about this problem coming up again, but most cameras on the market today have the ability to continuously number up to ten thousand or even twenty thousand images before the first number you started with comes back around. In addition, Continuous mode is a reminder of how many images you've taken since the first day you bought your digital camera—and that could prove invaluable when it comes to justifying your next DSLR or lens purchase. (*Honey, do you realize I shot 3,317 images just in the last year? Think of the money I've saved compared to shooting 3,317 images on color print film! It used to cost us an average of $12 for every roll of 24 exposures plus processing. That would have been almost 134 rolls of film times $12 per roll. That's a whopping $1,608 that I have personally saved us. So, I'm sure you won't mind me buying a new lens, right? I also thought that while I'm at the camera store, you might want to get that new _____ [fill in the blank] you've been wanting. . . .*)

Index